# LORCA, BUÑUEL, DALÍ

∽

Gwynne Edwards was until recently Professor of Spanish at the University of Wales, Aberystwyth, specialising in theatre and film. He has written extensively on Lorca, Buñuel and Pedro Almodóvar. His translations of Lorca's plays, as well as those of seventeenth-century and modern South American dramatists, have been published by Methuen, and many have been staged professionally.

# LORCA, BUÑUEL, DALÍ

∞

*Forbidden Pleasures and
Connected Lives*

GWYNNE EDWARDS

I.B. TAURIS
LONDON · NEW YORK

Published in 2009 by I.B.Tauris & Co Ltd
6 Salem Road, London W2 4BU
175 Fifth Avenue, New York NY 10010
www.ibtauris.com

Distributed in the United States and Canada Exclusively by Palgrave Macmillan,
175 Fifth Avenue, New York NY 10010

ISBN 978 1 84885 007 1

A full CIP record for this book is available from the British Library
A full CIP record is available from the Library of Congress

Library of Congress Catalog Card Number: available

Typeset by JCS Publishing Services Ltd,
www.jcs-publishing.co.uk

Printed and bound in Great Britain by
CPI Antony Rowe' Chippenham

FSC
Mixed Sources
Product group from well-managed
forests and other controlled sources
Cert no. SGS-COC-2953
www.fsc.org
© 1996 Forest Stewardship Council

# CONTENTS

# ILLUSTRATIONS

# INTRODUCTION

ᴇↄↄ

FEDERICO GARCÍA LORCA (1898–1936), Luis Buñuel (1900–83), and Salvador Dalí (1904–89) are without doubt three of the greatest and best-known Spanish creative artists of the twentieth century. Lorca's poetry and, in particular, plays such as *Blood Wedding*, *Yerma*, and *The House of Bernarda Alba* are universally acknowledged for their emotional and dramatic force and have been translated into many languages. The name of Luis Buñuel appears regularly in the list of the most accomplished film directors in the history of the cinema, especially in relation to Surrealism. And Salvador Dalí is, of course, recognised throughout the world not only for his extraordinary surrealist paintings, but also for his quite bizarre and often sensational way of life. But if these three individuals are known for their own particular work and have each been the subject of various exhaustive studies, the connections between them, which are many and varied, have rarely been considered.

In the following pages, titles of their works will be given in English except when these works are normally known by their non-English titles. In these cases, the foreign title will be followed by an English translation.

Born within six years of each other, they came from different parts of Spain: Lorca from the colourful and vibrant south, Buñuel from the much harsher northern province of Aragón, and Dalí from the coastal town of Figueras on the Costa Brava. But if their places of origin differed, their childhood circumstances were very similar, for all three enjoyed privileged backgrounds, markedly different from the poverty endured by many others in those regions of Spain. Lorca's father was, as we shall see, a prosperous farmer who owned a considerable amount of land and employed many

agricultural workers. Buñuel's father, having made his fortune in Cuba, owned two luxurious properties, and was so wealthy that on one occasion he was able to save a local bank from insolvency. And Dalí's father, although not quite in the same financial category as Buñuel's, was a well-known notary whose duties brought in a regular and considerable income. It was precisely on account of their privileged backgrounds that Lorca and Buñuel especially felt compassion for those less well-off than themselves and that later on they shared markedly left-wing views that would in turn profoundly affect their personal lives. Dalí too held extreme left-wing views as a young man; they were more a reflection of his father's own anarchist views than anything else, but it seems quite clear that when Lorca, Buñuel, and Dalí became close friends in the 1920s, they shared a similar political viewpoint.

A second and highly important connection concerns their sexuality. If this issue is dealt with extensively in the following pages, it is simply because it was something that played a crucial part in the personal and artistic lives of all three individuals, defining their relationships and expressing itself throughout their work. It is often argued that the personal lives of creative artists have little connection with their work, but there are clearly many whose plays, films, paintings, or music are the expression of their anguish and anxieties, and of whom it is safe to say that without those emotional problems that work would not exist. Tchaikovsky would not have produced his last symphony, the so-called *Pathétique*, had he not been plunged into deep despair. Nor would Strindberg or Tennessee Williams have written the plays they did had their personal lives not been marked by sexual, marital, and family traumas.

Lorca and Buñuel's sexuality was profoundly influenced by their Catholic background, and in Buñuel's case by his education by Jesuits. Although Lorca attended a fairly liberal school, the highly traditional and strongly Catholic society in which he grew up meant that his increasing awareness of his homosexual leanings created in him a crisis of conscience, a need to conceal his sexual nature from his family and others, and, in consequence, it led to a profound sexual frustration that would subsequently characterise most of his work.[1] Buñuel's exposure at school to the strict teachings of the Jesuits left him – as it did many other Spaniards who attended similar institutions – with the deeply ingrained belief that sex

was a sin, and therefore with a sexual reticence that affected him throughout his long life. In this respect, although he was strictly heterosexual, his Catholic background had as profound an effect on him as it did on Lorca.[2] It is an aspect of Buñuel's life and work that has not previously been studied in detail.

Although Dalí too attended a school run by priests – in this case Marist Brothers – his sexuality, which proved to be, if anything, more bizarre than that of Lorca and Buñuel, was probably shaped less by his education than by other factors that, as we shall see later, led to an aversion to physical contact with the opposite sex, to a predilection, despite a marriage of fifty-five years, for masturbation and voyeurism, and to a possible inclination towards homosexuality, whether or not it was put into practice. It was this that in part led to an extremely close relationship between Dalí and Lorca in the 1920s, as well as to the nature of some of the important work that both men produced at that time. If the earlier connection between them related to the circumstances of childhood and adolescence, it now became very precise indeed in both personal and artistic terms.[3]

A third and very important link between all three men relates to their arrival in Madrid around 1920 and the time that they then spent together at the celebrated Residencia de Estudiantes. There they not only became close friends but, crucially, were exposed to the new ideas and artistic movements that were transforming both the Spanish and the European cultural landscape. The Residencia was, as its name suggests, a hall of residence for male students attending courses at the University of Madrid, or, as in Dalí's case, the San Fernando Royal Academy of Fine Arts. Based on the Oxbridge system, the Residencia was also a place of considerable cultural enlightenment, visited, as we shall see, by individuals famous in their particular field of activity: writers, scientists, economists, or musicians. If they were not already familiar with some of the new ideas concerning, for example, psychoanalysis, Surrealism, and cinema, Lorca, Buñuel, and Dalí would have heard talks given by experts in those subjects. In addition, Madrid was a city that contained the Prado, important theatres, cinemas, and other cultural institutions, all of which acted as a stimulus to the creative imagination.

Although Buñuel left Madrid for Paris in 1925, Dalí moved to Cadaqués after his expulsion from the Academy of Fine Arts in

1927, and Lorca divided his time between Madrid and the family home in Granada, the separation did not mean that they lost touch with each other. On the contrary, Lorca visited Dalí in Cadaqués on several occasions and developed a strong physical attraction to him that, although Dalí has denied it, may well have been reciprocated to some extent. Indeed, as we shall see, a number of Dalí's paintings at this time contain the head of Lorca, while Lorca wrote important poems expressing his admiration for and attraction to Dalí. As for Dalí and Buñuel, their close association in the late 1920s, rooted in their mutual attraction to Surrealism, led to their dismissal of Lorca's work, which they regarded as far too traditional, and to his virtual exclusion from their growing friendship. Undoubtedly depressed by this, as well as by other aspects of his life, Lorca left Spain for a while, spending nine months in New York and three in Cuba in 1929 and 1930. But he continued to be a presence in the thoughts of both Dalí and Buñuel, both after his murder at the beginning of the Civil War in 1936 and for many years afterwards. Forty years later, for example, Dalí's painting, *The Hallucinogenic Toreador* (1969–70), contained specific visual references to Lorca. In 1946, Buñuel had planned to make a film of Lorca's *The House of Bernarda Alba*, though it was never realised, and in his autobiography of 1982 recalled the poet-playwright as the finest human being he had ever known.

Given the nature of their personalities and private lives, the work of all three men is at its best a fusion of autobiographical and cultural elements. Beginning with *The Butterfly's Evil Spell* in 1920 and ending with *The House of Bernarda Alba* in 1936, Lorca's theatre is deeply rooted in his personal life, the theme of frustrated passion central to almost every play. For the most part, however, he chose in his work to channel his frustration as a homosexual into relationships between men and women, as in the case of the Bride who in *Blood Wedding* (1933) abandons her husband for her former lover, and the young and fiery Adela who in *The House of Bernarda Alba* indulges in an illicit affair with her sister's fiancé. The only truly homosexual play was *The Public* (1930), which, for reasons of censorship and public taste, Lorca knew would never be performed in his lifetime. As for cultural influences, he drew on the traditions of puppetry and farce in such plays as *The Shoemaker's Wonderful Wife* (1930) and *The Love of Don Perlimplín* (1933), historical background in *Mariana Pineda*

(1927), Surrealism in *When Five Years Pass* (1931) and *The Public* (although he denied that his work was truly surrealist), and on Greek tragedy in *Blood Wedding, Yerma* (1934), and *The House of Bernarda Alba*. In his poetry, the autobiographical element also combines with cultural influences, as in the gypsy- and flamenco-inspired *Gypsy Ballads* (1928) and *Poem of Deep Song* (1922, published 1931), the surrealist *Poet in New York* (1930, published 1940), and *Diwan of the Tamarit* (1934, published 1940), indebted to Arab poetry. In general, Lorca's work is distinguished, despite its obsessive themes, by its great variety of subject and form and by his constant desire to try new things.[4]

During his eight years at the Residencia and for at least three years afterwards, Buñuel's creative efforts focused not on cinema but on poetry, to which Lorca had opened his eyes, and on short literary pieces that revealed the influence of such contemporary movements as Dada and its successor, Surrealism. Although he was interested in cinema and saw many films both in Madrid and Paris, Buñuel's active participation in cinema did not begin until the second half of the 1920s as the result of working with the famous French filmmaker, Jean Epstein, and coming to the conclusion that Epstein's rather Romantic style of filmmaking was not for him. Sharing Dalí's passion for Surrealism in all its aspects – its emphasis on the unconscious as well as its onslaught on bourgeois values – he collaborated with him in 1929 on the totally original and startling *Un chien andalou* (*An Andalusian Dog*), following it in 1930 with the more socially orientated *L'Age d'or* (*The Golden Age*) – to the script of which Dalí contributed various ideas – and in 1932 with *Las Hurdes* (*Land Without Bread*), in which the socially committed Buñuel, no longer working with Dalí, revealed in no uncertain manner the way in which the government had neglected the unfortunate inhabitants of the poorest part of Spain.

During the Civil War and for a number of years afterwards, Buñuel worked in Paris, New York, and Hollywood, mainly engaged with editing and dubbing rather than with making his own films. That opportunity did not arise until in 1946 he moved to Mexico, where he spent the rest of his life. Between 1946 and 1964 he made some twenty films, but the essentially commercial nature of the Mexican film industry meant that some of them were quite ordinary and that only in a handful – *The Forgotten Ones* (1950), *He* (1952), *The Exterminating Angel* (1962), and one or

two others – did he achieve his full potential, again combining his fascination with the surreal with his mockery of the bourgeoisie and the Catholic Church. This dual element lies at the heart too of the memorable and assured films that Buñuel made in Spain and France in the last twenty years of his life and which include *Viridiana* (1961), *Diary of a Chambermaid* (1964), *Belle de jour* (1966), *Tristana* (1970), and *That Obscure Object of Desire* (1977), all a final flowering of his genius.

Buñuel's films, like Lorca's poetry and plays, are rich in autobiographical touches, not only in terms of their political emphasis but also with regard to the sexual inhibition and other associated factors that marked his personal life. Sexual inhibition in one form or another is a central element in *Un chien andalou*, *Viridiana*, and *Belle de jour*; jealousy and possessiveness in *He* and *Tristana*; and a powerful assault on bourgeois values in all of them, as well as in *The Exterminating Angel*, *Diary of a Chambermaid*, *The Discreet Charm of the Bourgeoisie* (1972), and *That Obscure Object of Desire*.

Dalí's close friendship with Lorca and Buñuel meant that, for a time at least, he collaborated closely with both of them: with Lorca on the stage design for the premiere of *Mariana Pineda* in 1927 and a few years later with Buñuel on the two surrealist films. Dalí was, however, too much of a narcissist and self-publicist for any long-term collaboration, and after his first encounter with his future wife, Gala, in 1929, his obsession with her and his absorption with his own work signalled a movement away from his two close friends. Dalí's character, in particular his sexual problems and other anxieties, made him, though – like Buñuel and, to a certain extent Lorca – an ideal candidate for the assimilation and expression of that aspect of Surrealism that focuses on the inner life. His greatest paintings, which belong to the late 1920s and the 1930s – *The Great Masturbator* (1929), *The Lugubrious Game* (1929), *The Old Age of William Tell* (1931), *The Persistence of Memory* (1931), *Metamorphosis of Narcissus* (1936–7) – all depict, in one way or another, the sexual inhibition created by his upbringing and education and his anguish at the prospect of a sexual relationship with a woman. Subsequently, however, in tandem with accumulating wealth and fame, the quality of Dalí's creative work went steadily downhill, in contrast to Buñuel's, and his life increasingly revolved around eccentric acts of self-publicity.

Asserting that Gala had positively altered the course of his life and been his saviour, he began to represent her in paintings of the late 1940s as the Madonna, which went hand in hand with his stated newfound allegiance to the Catholic Church and his championing of the Spanish dictatorship after General Franco's victory in the Spanish Civil War. During the 1950s the self-revelatory paintings of the 1920s and 1930s became the huge and largely empty paintings often on a religious or historical theme: *The Last Supper* (1955), *Saint James the Great* (1957), *The Discovery of America by Christopher Columbus* (1958–9), and *The Ecumenical Council* (1960). Such paintings often earned the Dalís large sums of money, but did little to enhance the painter's artistic reputation.

Dalí's obsession with wealth, which led André Breton to describe him wittily as 'Avida Dollars', also involved him in the 1950s and 1960s in various fraudulent activities. Nothing could be further removed from Lorca and Buñuel's compassion for the poor and their virulent denunciations of the lack of concern for such people on the part of the well-to-do.

The Dalís' fascination with and moral corruption by wealth was also paralleled in the latter part of their lives by sexual excess and perversion. As he grew older and more wealthy, Dalí became addicted to voyeurism, paying couples to indulge in sexual performances of various kinds in his presence. As for Gala, she had always been sexually active, an aspect of her character that, if anything, became more exaggerated and grotesque, leading her even in her late sixties and seventies to numerous affairs with much younger men. By this time she and Dalí were spending much of their time apart, Gala in the castle at Púbol on the Costa Brava that he had bought for her and where she could entertain her lovers for months on end.

By the early 1980s the Dalís were experiencing growing health problems, as well as a serious deterioration in their relationship. Dalí was frequently depressed, in no small measure on account of the mixture of drugs that Gala fed him. Gala experienced gall-bladder problems, broke her leg, became deeply depressed and died in 1982. Dalí lived on for seven more years, beset by depression and other problems. In 1984 a fire in his bedroom left him with serious burns to his body and in the years that followed he experienced increasing heart and lung problems, which led to his death in 1989.

As the preceding remarks suggest, the personalities and outlook of Lorca, Buñuel, and Dalí were shaped by their childhood and adolescence. The connections between them at that point may seem little different from the similarities between many other creative artists, but what is quite unique in the case of these three individuals is the fact that, when they coincided in Madrid, and indeed even afterwards, the characteristics that they already and individually possessed had the effect of drawing them together in close friendship, in considerable intimacy in the case of Lorca and Dalí, and also of stimulating important artistic collaborations that, together with their individual projects, reflected both their separate personalities and the points at which these merged and overlapped. The picture is complex and fascinating, composed of different threads, many of which have not been previously addressed at length. The aim of this book is to do precisely that.

## NOTES

1   See Ian Gibson, *Federico García Lorca: A Life*, London: Faber and Faber, 1989; Gwynne Edwards, *Lorca: Living in the Theatre*, London: Peter Owen, 2003.

2   See Luis Buñuel, *My Last Breath*, trans. Abigail Israel, London: Vintage, 1994; John Baxter, *Buñuel*, London: Fourth Estate, 1994; Gwynne Edwards, *A Companion to Luis Buñuel*, London: Tamesis, 2003.

3   See Salvador Dalí, *The Secret Life of Salvador Dalí*, London: Vision Press, 1968; Ian Gibson, *The Shameful Life of Salvador Dalí*, London: Faber and Faber, 1997; Meryle Secrest, *Salvador Dalí: The Surrealist Jester*, London: Weidenfeld and Nicolson, 1986.

4   For translations of the plays into English, see *Lorca Plays: One*; *Lorca Plays: Two*; *Lorca Plays: Three*, London: Methuen, 1987, 1990, and 1994; and the individual editions, with commentary and notes, of *Blood Wedding*, *Yerma*, and *The House of Bernarda Alba*, London: Methuen, 1997, 1998, and 2007. All the translations are by Gwynne Edwards, with the exception of Peter Luke's version of *Yerma* in *Lorca Plays: One*, and Henry Livings's *The Public* in *Lorca Plays: Three*.

# *1*

# CHILDHOOD

∞

FEDERICO GARCÍA LORCA, two years older than Luis Buñuel and six years older than Salvador Dalí, was born on 5 June 1898 in the village of Fuente Vaqueros, some ten miles from Granada in south-east Andalusia. Fuente Vaqueros was one of several villages in the fertile plain to the west of Granada that was fed by the river Genil and its tributary, the Cubillas. By the time of Lorca's birth, the plain, known as the Vega, was an extremely rich agricultural area in which, from around 1880, sugar beet became an important product. Factories for its processing quickly appeared and landowners soon became prosperous. They included Lorca's father, Federico García Rodríguez, who had himself been born in the village in 1859.

A practical and sensible man, he had purchased at the age of thirty-seven a number of properties near Fuente Vaqueros, including a large estate called Daimuz, a fertile area that became the source of his considerable wealth. Lorca's father was, in short, a rich man, though not bourgeois in the sense that his wealth allowed him to lead a life of idleness and pleasure. Indeed, he appears to have been a serious and dignified man who treated his workers with consideration and was highly respected in the region. He also played the guitar quite well, inheriting from his forebears a musical ability that was shared by his three brothers and five sisters. Luis, for example, was a fine pianist who subsequently became a friend of Manuel de Falla, and one of his sisters, Isabel, was an excellent singer who accompanied herself on the guitar.

A love of music was something that was clearly passed on to the future poet-dramatist.

Lorca's mother, Vicenta Lorca Romero, was García Rodríguez's second wife, the first having died suddenly in 1894. Eleven years younger than her husband, Vicenta was a short, dark-haired woman, with a roundish face and a rather melancholy expression. An only child, her early life had been hard – her mother had become a widow just before Vicenta's birth and money was in short supply. At the age of thirteen she attended a convent school for poor children and five years later trained to become a schoolteacher, a career that at least offered some financial security. In 1892 she was appointed to a post in the girls' primary school in Fuente Vaqueros, where, of course, she met her future husband. Like most women at that time, she gave up work after their marriage in 1897, but her interest in the arts and education continued and would clearly influence her children. Lorca subsequently observed that she read admirably to her husband's workers and the household servants, something he himself later did in relation to his poetry and plays.[1] In addition, Vicenta was a religious woman, though not excessively so, and often took the young Federico with her to church. Greatly moved by the rituals of the Church, and particularly so by the sound of the organ, he would enact the Mass at home, dressed in clothes recovered from the attic. From an early stage, acting was in his blood.

Lorca's relationship with his mother was extremely close. His physical defects – he had flat feet and one leg was slightly shorter than the other – meant that, unable to participate in sports demanding speed and nimbleness, he spent more time at home with her than would otherwise have been the case. While the stories of a childhood illness that prevented him from walking are probably untrue, his physical problems undoubtedly meant that his parents shared a concern for his well-being, which would have been exacerbated by the death of their second child, Luis, from pneumonia in 1902. In one sense, the death of an infant son links Lorca's childhood to that of Dalí, but Lorca's parents did not compensate for the loss of one child by unduly cosseting another, as did Dalí's. Rather, Vicenta encouraged her son's evident love of music and of artistic things in general. Later on he would pay tribute to her influence: 'I owe her everything I am and everything I will ever be.'[2] And, when in Argentina in 1933 he was asked if

he would ever marry, he replied, significantly: 'I belong to my mother.'[3] During this time in Buenos Aires, at the age of thirty-five, he constantly received letters and telegrams from her.

As a child, Lorca was also surrounded by other women. Dolores Cuesta had been a wetnurse to his younger brother, Francisco, in Fuente Vaqueros, and worked as a servant to the family for a considerable time, doting on Federico as much as he did on her. Aunt Isabel García Rodríguez had given him his first guitar and was much loved by him. He had two younger sisters, María and Isabel. And then there were his female cousins, all of them some years older. Aurelia González García, Matilde Delgado García, and Clotilde García Picossi all lived in Fuente Vaqueros and the younger Federico was frequently in their company. This is not to say that he lacked male company – he had forty cousins in the village – but it seems likely that the presence of so many women in his early life played its part in the development of what would now be described as his feminine side and contributed too to the deep understanding of women revealed in his mature work.

It is important too to emphasise the impact his physical surroundings had on him, in particular the fertile countryside that surrounded Fuente Vaqueros. He acquired there the deep love of and identification with the natural world that is evident throughout his work, describing it in the following way:

> I love the countryside. I feel that I am emotionally connected to it. My oldest childhood memories have the taste of the earth. The meadows and fields have done wonders for me. The wild animals in the countryside, the livestock, the people who live on the land, all of them have a fascination that few people appreciate. I can recall them now exactly as I knew them as a child. If I could not, I would not have written *Blood Wedding*.[4]

On the other hand, rural life also presented a young boy born into a well-to-do family with the sad spectacle of those far less fortunate than himself. Around Fuente Vaqueros, as in many other parts of Spain in the first decade of the twentieth century and for years afterwards, many people lived in considerable poverty. As a child, Federico befriended a little girl whose father worked as a labourer despite severe arthritis, and whose mother endured the after-effects of many pregnancies, as did so many women in rural Andalusia, where a strong Catholicism forbade

the use of contraceptives. Many of the children went around in rags and, on the occasions when their clothes had to be washed, were obliged to stay indoors in a state of virtual nakedness. These were people who were frequently ill and who often died an early death, something that deeply affected the sensitive child that Federico was. His acute awareness of his own privileged life and of the severe disadvantages of others clearly sowed the seeds of the left-wing views he would embrace in adult life. In 1936 he would say:

> The day when hunger is finally banished will witness the greatest spiritual explosion the world has ever seen. We can never imagine the joy that will erupt when the Great Revolution comes. I'm talking like a genuine socialist, aren't I?[5]

His exposure to rural life also developed in him a strong sense of a vibrant popular culture. Through his mother, the family servants, the villagers, and the people who worked on his father's estate, he became familiar with the popular poetry, the ballads, the songs and dances, and the vigorous character of local speech, all of which would inform his later creative writing. As a child, he was also witness to the arrival in Fuente Vaqueros of a travelling puppet show, which so enthused him that, at the age of seven, he began to mount puppet shows at home, utilising old clothes and cardboard figures made by his mother. With all this he sought to entertain members of his family, the servants, and the local children, anticipating the theatre director that he would later become.

In 1907 García Rodríguez moved his family from Fuente Vaqueros to the village of Asquerosa (later called Valderrubio), a relatively short distance away – today both villages can be easily reached by bus from Granada. Smaller than Fuente Vaqueros, Asquerosa also stands in the middle of the fertile plain of the Vega and therefore provided the young Federico with the same kind of landscape and people that he already knew. But two years later the Lorca family was on the move again, this time to the city of Granada itself. It marked the beginning of a new phase in Federico's life – he was now eleven – but his connection with the countryside did not come to an end, for his father retained the house in Asquerosa, and the family subsequently spent many summers there, away from the bustle of the city.

ෆණ

Two years younger than Lorca, Luis Buñuel was born on 22 February 1900 in the small town of Calanda, its population then around 5,000, in the north-eastern province of Aragón, at the opposite end of the country and very different from Lorca's Andalusian birthplace. This is a region of Spain that in winter is bitterly cold and in summer intolerably hot, and which, at the beginning of the twentieth century, was extremely backward. Far less fertile than the Vega of Granada, and in general much more isolated from the main centres of civilisation – the region is still described in the brochures of travel companies as 'undiscovered Spain' – the inhabitants of Calanda found life hard and unrewarding. But Buñuel's circumstances, like Lorca's, were rather different.

Buñuel's father, himself a native of Calanda, had run away from home at the age of fourteen in order to join the army and had later gone to Cuba, where he worked as an army clerk during the Spanish–American War. Subsequently, he opened a successful hardware store and, when Cuba achieved its independence from Spain in 1899, sold his share in the store to his two partners and returned to Calanda, a rich man at the age of forty-three. There, Leonardo Buñuel rebuilt the original family house and also constructed an even more lavish property, La Torre, three kilometres away, on the bank of the river. One year later, soon after the birth of Luis, he moved the family to the city of Zaragoza, where he rented a large apartment. He retained the Calanda houses, though, and, just as the Lorca family returned during the summer to their property in rural Asquerosa, so the Buñuel family spent several months in their Calanda retreat during Easter and the summer months.

The extent of Leonardo Buñuel's wealth may be gauged from his son's account of the family houses and his father's lifestyle. The house in Calanda itself was a 'monument to art deco', filled with expensive furniture; the house on the river bank was 'surrounded by a superb garden' in which the family 'often dined . . . under the soft glow of acetylene lamps';[6] the Zaragoza apartment occupied the whole of the second floor of a building that had formerly been the police headquarters and had as many as ten balconies. Even more revealing is the fact that on one occasion Leonardo Buñuel's wealth was such that it had saved the Zaragoza Hispano-American bank from ruin.

Of his father's daily routine, Buñuel has stated that he 'did absolutely nothing'.[7] It consisted, usually, of getting out of bed, taking a bath, having breakfast, reading the newspaper, checking on the arrival of his Havana cigars, undertaking a few errands, lunching at home, taking a siesta, visiting his club, and playing cards with his friends until it was time for dinner. This, quite clearly, was the typical day of a wealthy bourgeois and decidedly different from that of Lorca's hard-working and energetic father. From this point of view, then, young Luis Buñuel enjoyed an even more privileged childhood than did Federico, and it doubtless played a part, as we shall see, in the rejection of that background in favour of Communism in later life.

Buñuel's mother, María, was only eighteen when she married the forty-three-year-old Leonardo after his return from Cuba. The daughter of the owner of a Calanda inn, she was remarkably beautiful: tall, broad-boned, and with an aristocratic bearing that still managed to turn heads when she was more than sixty years of age. Unlike the early life of Lorca's mother, María's had not been beset by difficulties, and she quickly settled into the bourgeois environment provided by her new husband. Buñuel described her as a devout woman who regularly attended church and devoted herself to family life, producing three boys and four girls. She ensured that her children were brought up according to the moral conventions of the time, which, in a staunchly Catholic community, were obviously strict. Later on she would keep a photograph of Luis on an improvised altar in a wardrobe, surrounded by other photographs of the late Pope. In terms of her religious values and beliefs, María was not unlike Lorca's mother, but her cultural and educational interests were evidently much more limited, and she played little part in encouraging the young Luis's artistic interests.

In contrast to Lorca, the young Luis was extremely fit and strong. Later on he would take great pride in physical conditioning, devoting himself to exercises that included running, boxing, and wrestling. And as a child he already demonstrated the spirit and independence of mind that would characterise his adult life. His sister, Conchita, has described how Luis and his mother 'waged their daily battle over his refusal to wear his student cap', and how, having asserted that at school he had found an undershirt in his soup, he defied his father in refusing to deny the allegation.[8]

In short, Luis was in no way a child over whom his parents fussed unduly.

On the other hand, there were other aspects of Buñuel's childhood that paralleled Lorca's, not least his love of nature. Calanda, as we have seen, was an isolated place, surrounded by olive groves and vineyards, less fertile than Fuente Vaqueros, but nevertheless providing ample opportunity for close contact with the natural world. Conchita Buñuel has stated that, as children, 'We could walk through a forest crawling with wild animals.'[9] She has described too not only how the Buñuel house was filled with animals but also the considerable care her brother lavished on them:

> At one time or another, we had monkeys, parakeets, falcons, frogs and toads, grass snakes, and a large African lizard which the cook killed with the poker in a moment of terror . . . Luis also had a hatbox filled with tiny grey mice he allowed me to look at once a day . . . Most of our pets belonged to Luis, and I never saw any who were better cared for . . .[10]

This early love of and fascination with animals, and also with insects, would lead him in the future to become a student of natural science, which in turn explains the presence of animals and insects in his films. But while in the poems and plays of Lorca, nature is frequently portrayed as an inescapable force in the lives of human beings, Buñuel's observation of the activities of animals and insects is seen to be more analytical, their behaviour closely related to that of men and women, all placed under his microscope and studied just as closely.

As a child in Calanda, Buñuel, like Lorca, was also exposed to the spectacle of people who were far less privileged than himself. He has described, for example, how poor children, between eight and ten years of age, used to gather open-mouthed outside the door of the Buñuel house in the town, dazzled by its luxurious interior. And on their way to the other house on the river bank, the Buñuel family would often encounter on the road children who were undernourished and dressed in rags, whose fathers struggled to scratch a living from back-breaking jobs and whose mothers slaved at home to prepare meals from the scraps they could lay their hands on. Because poverty of this kind often led to illness and even death, the sight of a corpse laid out in a wretched coffin

before the door of the church, the face covered by a veil, was a frequent one. Buñuel has suggested that life in Calanda had, by the first decade of the twentieth century, changed little from the Middle Ages, though at the time he accepted it without question. Nevertheless, just as his awareness of his privileged background shaped his subsequent political views, so did his awareness of utter poverty in rural Spain, exposed so ruthlessly in his third film, *Las Hurdes*.

Apart from the fact that his mother was a religiously devout woman, Catholicism played its part in the young Buñuel's childhood in other ways. He acted as an acolyte for an uncle known as Tío Santos, one of Calanda's priests, and he also sang and played the violin as a member of the Virgin of Carmen choir. Such was his enthusiasm for religion at this point that, as Lorca did as a child, he acted out the Mass at home, dressed in an alb – the white garment worn by priests over the cassock – surrounded by religious artefacts and assisted by his sisters, of whom his favourite was Conchita. In his memoirs, he has spoken of the extent to which he and his friends were deeply imbued with Catholicism and never doubted the universal truths it sought to teach.[11]

Buñuel's performance of the Mass also points, of course, to another link with the young Lorca: a penchant for theatre. Indeed, just as Federico thrilled to the travelling puppet show and entertained others with his home-made puppets, so Luis put on performances for his sisters and for local children in the toy theatre given to him by his parents. His childhood enthusiasm for theatrical performance anticipates therefore the adult Buñuel, who, with Lorca, regularly staged José Zorrilla's nineteenth-century play, *Don Juan Tenorio*, at the Residencia de Estudiantes. It anticipates too the way in which, as a film director, he would later control his actors, just as Lorca did his student theatre company, La Barraca, in the 1930s.

In comparison, the case of Salvador Dalí is very different and much more extreme, though certain similarities with Lorca and Buñuel can still be perceived. Dalí was born on 11 May 1904 in the family house in Figueras, situated in the north-east corner of Catalonia, a mere twenty-five kilometres from the French border. Much larger than either Fuente Vaqueros or Calanda, Figueras was a town of some 11,000 inhabitants, a relatively prosperous

and sophisticated place with its clubs, music societies, a theatre, a good artistic, literary, and scientific tradition, and, because of its geographical position, a marked French influence.

Dalí's father, Salvador Dalí Cusí, was born in the Catalan fishing village of Cadaqués and in 1900 was appointed to the position of notary in Figueras, some twenty-five kilometres inland. The holder of such an office is, in effect, a public servant who has the authority to draw up contracts, wills, deeds and the like, and who, in consequence, is guaranteed a steady income and a respected position in society. Dalí's father was, therefore, a man of considerable means, less wealthy than Buñuel's or Lorca's but, it would appear, more sophisticated and cultured than either. Many found him to be erudite and intelligent, as well as amusing, but he was also capable of considerable aggression. It has been said of him that he 'always attacked, utilising sarcasm and gestures which echoed throughout the region . . . He was always militant.'[12] This aspect of his character manifested itself in relation to many things, but in particular with regard to his support for the rights of the Catalan people, then ruled over by a Madrid-based central government. In this respect Dalí senior was not unlike many other professionals in Catalonia, an anarchist sympathiser who, despite his position and wealth, would not have included himself in a bourgeoisie that suppressed protests, demonstrations, and strikes against the power of the Right. But if this was one aspect of his character that would influence the young Salvador, so did his large library and the lively debates that took place in the household on politics, literature, and philosophy. In one way or another, then, Dalí's father proved to be an important influence in his life.

His mother, Felipa Domènech Ferrés, a smallish, pretty, dark-haired young woman from Barcelona and two years younger than her husband, was the daughter of a haberdashery importer. As a young girl, she had worked with her mother in the establishment that the latter had inherited from her own father and which specialised in making tasteful decorative objets d'art. Felipa, it seems, was artistically quite gifted, a talent she would pass on to Salvador himself. In his writings he makes very few references to her, but what is quite clear is that her excessive cosseting of him had a profound effect.

In this respect, the key event in his parents' life was the death of their first child in August 1903, at twenty-two months, from what

the death certificate described as an infectious gastro-enteritic cold. During the child's short life they had doted on him, and when their second child, the future painter, was born the following year, he effectively became a replacement for the first. The fact that they also called him Salvador, the name initially given to his dead brother, was not in itself unusual – it was and is common enough in Spain for fathers and sons to have the same Christian name – but it seems to have confirmed the second Salvador's belief that his parents regarded him as a substitute for his brother and the saviour of their own childless existence rather than as an individual in his own right. Dalí's cousin, Ramón Guardiola, has said that 'They compared the two every day. They gave him the same clothes and the same toys. They treated him just as if he were the other one, and so Dalí came to the conclusion that he did not exist.'[13] This belief was reinforced by the fact that in their bedroom the parents kept a large photograph of the first Salvador and by their constant concern that the second Salvador should not suffer the same fate. In cold weather his mother would invariably remind him to wrap himself in a scarf, or 'you'll die like your brother'.[14] And when they walked past a particular spot, his parents would say 'The other one sneezed when he walked past here, take care!'[15] Dalí's belief that he was his brother rather than himself has often been dismissed as pure fantasy, the product of an over-active imagination, but it is not too difficult, given his unusual character, to accept that such an idea took root in his mind as a child. At all events, the second Salvador seems to have made the decision to be as different from the first as possible.

Because his parents so frequently lauded the virtues of their dead son to the new Salvador, the latter went out of his way to demonstrate the opposite. His tantrums from the age of two onwards were more often than not deliberate, for he was aware that, given his parents' anxiety over his well-being, they were unlikely to punish his behaviour. On the contrary, they indulged him, and his mother was more than willing to grant his every wish. As for his father, young Salvador knew only too well how quickly he could lose his temper and therefore took a particular delight in driving him to distraction. On one occasion, for example, his father bought him a tricycle that he would be allowed to have on condition that he refrained from wetting the bed. Until he did so, the tricycle would remain on top of a wardrobe, out of Salvador's reach. But

the boy, rather than behave in a way that would guarantee him the gift, preferred to pee on the bed in order to enrage his father.

The consequence of what has been described as 'smothering attention' was that Dalí fell into 'a state of infantile dependence, denied the forays into autonomy and self-reliance normal for his age'.[16] In short, he could do little for himself, including tying his shoelaces or turning the knob or handle of a door in order to open it. In his failure to perform such ordinary tasks there is a certain parallel with Lorca, who claimed to be unable to distinguish right and left and had no sense of direction. But Dalí was evidently much worse, and the circumstances in which he developed such dependency were much more extreme.

While his mother's cosseting, in particular, made him utterly dependent on her, it seems likely that the presence and influence of various women in his life also had a clear effect on his character. In the Dalí household there were, apart from his mother, four women of significance: his grandmother, Maria Anna Ferrés; her daughter, Carolina; his nurse, Llúcia Gispert de Montcanut; and his sister Ana María, four years younger than himself. And then, of course, there were also the maids and the cooks. Rather than allow her little boy to be exposed to the dangerous world at large, Felipa Dalí preferred to keep him at home, entertaining him with silent films or with entertainments of her own making. As in Lorca's case, it is hardly surprising that the predominance of women at home and the attention they constantly bestowed upon him should have left its indelible mark. As an adult, his life would, as we shall see, be controlled by his wife of many years.

As far as Dalí's interest in the natural world was concerned, Figueras was less important than Cadaqués, his father's birthplace, where the family spent the summers. Facing the sea to the east, the narrow streets of the village climb the hill to the rear, though the Dalí house itself is some distance away, on a shingle beach known as the Playa d'es Llaners. Here Salvador and his sister led an idyllic existence, playing on the beach and, in particular, being taken on boat trips around the cliffs and rocky headlands that are such a marked feature of this coastline. The headland known as Cape Creus, just to the north-east of Cadaqués, has been worn over time into the most fantastic shapes, suggesting now a strange bird, now an animal, now a face, now some kind of vegetation. It is not surprising to discover that Antoni Gaudí, the great architect

of Barcelona's Sagrada Familia cathedral, with its façade of fantastic stone shapes, was himself influenced by Cape Creus and the surrounding area. It would certainly loom large in Dalí's adult work. On the other hand, Dalí's portrayal of the natural world in his paintings is to be distinguished from the way in which it was presented by both Lorca and Buñuel. The point has been made already that, for Lorca, nature was often an elemental force linked to the destinies of men and women, while for Buñuel the behaviour of insects frequently paralleled that of human beings. In Dalí's case, nature would serve merely as a background or backdrop to the representation of his particular obsessions, while, as we shall see, insects – particularly grasshoppers – produced in him feelings of anguish and terror.

While Lorca and Buñuel's theatrical interests revealed themselves in childhood in their presentation of puppet shows, Dalí's early love of costume had a rather different significance. He had received from one of his uncles the present of an ermine cape, a crown, and a sceptre, which allowed him to dress as a king, parading on the terrace of the house and addressing his imaginary subjects. Unlike Lorca and Buñuel, he therefore preferred to indulge his own fantasies than entertain others, an aspect of his character that was further encouraged by the way in which his parents regularly dressed him. A photograph of him at the age of three or four shows him wearing a long cloak, a ruffle and gloves, and carrying a walking stick. Alternatively, he would wear short trousers, a blouse with a sailor collar, and a large beret. Because he was the only child at school to appear in such regalia, he naturally regarded himself as unique and came to see the importance of image as a way of impressing that uniqueness on others. From this point on, that element of exhibitionism that became an integral part of his adult life clearly became established. If he was a king in his own eyes, others must see him as that too. In adult life, Buñuel too liked to dress up, often disguising himself as a priest or a nun. But while Dalí was mainly concerned with drawing attention to himself, Buñuel was largely motivated by his scorn for religious institutions and a desire to shock others.

Perhaps surprisingly, given his cosseting, Dalí was, rather like Buñuel, a fit and active child, good at swimming and so proficient in jumping that he was the best high- and long-jumper in his school class. But once again, he used this particular ability either to

terrify his parents or as part of his exhibitionism. On one occasion, for example, he threw himself down a flight of steps to gain his father's attention.[17] On another he leapt off a flight of stairs at school in order to amaze his classmates.[18] In almost every respect, his childhood activities reveal him to be an attention seeker of the first order.

In Fuente Vaqueros, Lorca attended the local primary school, but in his account of his time in the village describes his classes as extremely boring: 'How many hours of boredom and irritation did I spend in the village school!'[19] By the time he entered the school, the standards set by an earlier teacher, Antonio Rodríguez Espinosa, a friend of the Lorca family, had evidently declined, but young Federico's dissatisfaction was also a sign of a lack of interest in academic work that would colour his education for many years. In 1907, as we have seen, the family moved to the village of Asquerosa, and Lorca attended the primary school there for one more year, but there is no evidence of his progress or lack of it. No doubt his mother, as a former primary school teacher, attempted to compensate at home for any shortcomings the schools may have had. As for his classmates, he seems to have befriended some of the poorer ones, and they in turn protected him against bullying. Well aware of their often wretched circumstances, he felt a deep compassion for them that would later develop into an equally intense dislike of bourgeois wealth and pretentiousness.

At the age of ten, when he came to the end of his primary school education and would normally be expected to commence his secondary education in Granada, his parents decided to send him to school in the town of Almería, some 160 kilometres to the south-east. There, Antonio Rodríguez Espinosa, the former teacher at Fuente Vaqueros, took in a small number of boarders, whom he coached privately prior to their enrolment at one of the local schools – in Lorca's case the Almería Institute. No doubt his parents felt that the lack of interest he had shown in primary school might disappear under the tutelage of Antonio Rodríguez, but his stay in Almería was cut short in the spring of 1909 when he became seriously ill with a throat and gum infection, and his parents, always concerned about their children's health, took him back to Asquerosa. The Almería experience was, then, less than successful. Apart from falling ill, Lorca had never before been

away from home. At the institute he felt lonely and isolated, and homesick for his family.

At six years of age – Lorca was then eight and Dalí two – Luis Buñuel entered the School of the Brothers of the Sacred Heart of Jesus in Zaragoza, but after just one year moved to the Jesuit School of the Saviour, where he remained for seven years. The pattern of his early education was therefore rather different from that of most children, who began their secondary education at the age of ten. Furthermore, while Lorca's early education was not controlled by clerics, Buñuel's certainly was. The later years of his schooling by the Jesuits, as well as its effect upon him, will be considered later, and for the moment it will suffice to consider the nature of the education that he and the other pupils received.

This education was characterised in particular by the strict rules and the iron discipline imposed by the teachers. The day commenced with Mass at 7.30 and ended with evening prayers. During the winter, which was extremely cold in northern Spain, only one of the classrooms was heated, and the pupils, wearing thick clothes and scarves, were forced to endure freezing conditions. In the classroom, the dining room, and the chapel, complete silence had to be observed, while outside no one was allowed to run to the courtyard for recess until the ringing of a bell permitted it. As for the curriculum, religion was obviously paramount, and the children also studied apologetics – the area of dogmatics dealing with the proofs of Christianity –the catechism, the lives of the saints, and Latin. The ideas of those who had sought to undermine traditional Christian beliefs – the philosophical ideas of Descartes and Kant, the theories of Darwin on the origin of man, and so on – were, of course, ridiculed and treated with contempt.

The teaching methods also involved a great deal of discipline, for they were based on the kind of scholastic argumentation and rigour that had been to the fore in the Middle Ages. One such practice involved two pupils in a kind of challenge, a *desafío*, whereby one would question another on any aspect of the daily lessons, at the end of which the teacher would declare one of the pupils the winner. For a child between the ages of seven and ten, the conditions were evidently much more demanding than those that had surrounded Lorca's much more liberal early education, but it was also an education that gave Buñuel a deep knowledge of the Bible and of Catholic dogma, both of which became a feature

of his films. It also gave him a sense of discipline that was later evident in many aspects of his behaviour. He proved, indeed, to be an intelligent pupil who received good marks in French and Latin, though in mathematics he was far from satisfactory. He was also commended for piety, politeness, and neatness.[20]

Salvador Dalí began his primary education at the age of four, when he began to attend the Figueras Municipal Primary School, an institution for poorer children run by the eccentric Esteban Trayter Colomer, a man whose waist-length beard was divided into two plaits, who always wore a top hat, and who was frequently asleep during his classes. While it would have been more usual for a well-to-do family to send a child to a private institution, Salvador Dalí Cusí's choice of school was, of course, influenced by the fact that, as an anarchist sympathiser and a declared atheist, he refused to patronise the richer schools of Figueras, all of which were staunchly Catholic. At all events, young Salvador appears to have learned very little in the two years he spent at Trayter's school. As far as his relationship with the other pupils was concerned, the fact that his mother sent him to school in such outfits as a sailor suit and silver-buttoned shoes meant that he stood out like a sore thumb and was inevitably bullied. But there was one fair-haired and blue-eyed boy called Butchaques on whom he seems to have had a crush and whose buttocks, he later claimed, were a source of both fascination and shame. Whether or not Dalí exaggerated the nature of this relationship in hindsight, as he did so many things, is uncertain, but it is certainly true that in his paintings buttocks came to be an obsessive motif.

If the young Dalí acquired little academic knowledge at Trayter's school, his already heightened imagination may well have been stimulated by the objects that the teacher kept at home, which the boy was sometimes invited to inspect. One such object was a huge rosary brought from Jerusalem; another a statue of Mephistopheles with an arm that moved; yet another a desiccated frog. There were also strangely shaped medical instruments. But the most fascinating object of all was a large box, possibly a French stereopticon or 'optical theatre', which, when Dalí looked inside, transformed one coloured image into another. In later life the painter observed that in Trayter's machine, 'I saw the images which were to stir me most deeply for the rest of my life.'[21] Shifting, dream-like images are, of course, the very stuff of Surrealism,

and the double image, whereby one object becomes another, is characteristic of many of Dalí's paintings.

After two years at Esteban Trayter's institution, Dalí was enrolled by his father, despite the latter's atheism, at the College of the Christian Brothers in Figueras, where he remained until he was twelve. Because the teaching was entirely in French, he soon acquired considerable fluency in the language, but there are hardly any records to suggest how well or badly he performed in other respects. It seems quite likely that the laziness he had displayed at his first school continued here, for we know that he was kept back in the lowest class for another year, and that, because he spent much of his time staring out of the window, he was moved to another part of the classroom. His behaviour was doubtless intended to be provocative, as much of a challenge to his teachers as his behaviour at home was part of his defiance of his father. But the curriculum at least included art, and to some extent the young Dalí took an interest in the drawings done by one of the teachers, which the pupils were then required to colour. By the time he left the school, a clear pattern of behaviour was well established.

## NOTES

1   In a letter to a friend in 1932. Unless stated otherwise, all translations into English are my own.
2   Ibid.
3   See Gibson, *Federico García Lorca: A Life*, p. 378.
4   See Federico García Lorca, *Obras completas*, ed. Miguel García Posada, Barcelona/Valencia: Galaxia Gutenberg/Círculo de Lectores, 1996, vol. 3, p. 526. Unless stated otherwise, all quotations are from this edition.
5   Ibid., p.632.
6   See Buñuel, *My Last Breath*, pp. 16–17.
7   Ibid., p. 25.
8   Ibid., pp. 34–5.
9   Ibid., p. 37.
10   Ibid.
11   Ibid., p. 12.
12   See Josep Pla, *Homenots. Quarta sèrie*, Barcelona: Edicions Destino, 1975, pp. 163–4.
13   See Secrest, *Salvador Dalí: The Surrealist Jester*, p. 25.

14  See Dalí, *Dalí by Dalí*, New York: Harry N. Abrams, 1970, p. 5.
15  *Sunday Times*, 19 May 1980.
16  Secrest, *Salvador Dalí: The Surrealist Jester*, p. 37.
17  Ibid., p. 43.
18  Ibid.
19  See Federico García Lorca, 'Mi pueblo', in the Fundación Federico García Lorca Archive, Madrid.
20  See Edwards, *A Companion to Luis Buñuel*, p. 115.
21  See Dalí, *The Secret Life of Salvador Dalí*, p. 41.

# 2

# ADOLESCENCE

❦

I N 1 9 0 9, A S we have seen, the Lorca family moved to Granada, where Federico would spend the next ten years. It was a city that, in the first decades of the twentieth century, had around 75,000 inhabitants, a colourful history, many reminders of its past, a strong Catholic tradition, and a marked provincial outlook. These were all significant factors, both in Lorca's adolescence and in his future work. Granada was a city he came to love and hate in equal measure.

Above all, Lorca was fascinated by Granada's Moorish heritage. The Muslims had initially set up the sultanate of Granada in 1235; shortly afterwards the first of the Nasrid rulers, Ibn-al-Ahmar, began the construction of what we now know as the Alhambra, the 'Red Fortress', on one of the hills above the city. Over the next century and a half or so, the various palaces that today constitute the complex were developed by other Muslim rulers, until in 1492 the Muslims were defeated by the Christians in what proved to be the very last stage of the Reconquest, the Christian campaign to recover the territory they had previously lost and drive the Muslims out of Spain.[1] As well as the Alhambra, other parts of Granada also contain much architectural evidence of the long Muslim occupation, notably the area to the north of the Alhambra known as the Albaicín.

Federico particularly loved the delicate and intricate character of Moorish craftsmanship, of which there is so much evidence in the rooms and gardens of the Alhambra, and he delighted too,

of course, in its atmosphere of mystery and legend. During the nineteenth century especially, those were aspects of the Alhambra that had been celebrated by many famous writers and musicians. Among the former, Victor Hugo, Chateaubriand, Disraeli, Gautier and Dumas stand out, while Washington Irving's *The Alhambra*, published initially in 1832 and in an expanded form in 1851, became one of the best-known works on the subject and has continued to be published to this day in both English and Spanish. As far as music is concerned, Claude Debussy had composed in 1901 the work for two pianos known as *Lindaraja*, originally the name of a Moorish princess who had lived in the Alhambra, and, two years later, *La Soirée dans Grenade*. In 1910 *Ibéria* received its premiere. The same year saw the publication of his first book of préludes, in which *La Sérénade interrompue* strongly evokes Andalusia, while the second book of préludes, published in 1913, contains *La puerta del vino*, named after one of the Moorish gateways in the Alhambra. Granada had also been celebrated in many of the piano works of Isaac Albéniz, while Manuel de Falla's *Nights in the Gardens of Spain*, premiered in Madrid in 1915, contained a first movement inspired by the Generalife gardens of the Alhambra. As a keen musician and pianist, the adolescent Federico eagerly responded to all these works that evoked so magically the Alhambra he knew so well and loved so much.

Increasing familiarity with the Moorish heritage of Granada was paralleled by Federico's visits to the caves of the Sacromonte, an area to the north of the Alhambra that for centuries had housed the city's gypsy community. Here, as in other important gypsy localities in the south, flamenco had developed over four centuries into a powerful mixture of song and dance that the young Lorca found to be immensely appealing.[2] As a child in Fuente Vaqueros, he had known several gypsy families. Furthermore, many of his ancestors on his father's side were, as suggested earlier, musically very gifted. One of his father's uncles, Federico, sang in a famous flamenco café in Malaga; Baldomero, another of Lorca's father's uncles, and an expert in folksong and flamenco, often performed at weddings and other festivities. Inheriting his ancestors' love of this musical tradition, the adolescent Federico came to know the singers and dancers who lived in the Sacromonte caves. His enthusiasm for their kind of music would later lead to his friendship with another enthusiast, the celebrated composer

Manuel de Falla, and pave the way too for the songs and ballads in his mature poetry and theatre work.

At the age of eleven, Lorca began his secondary education at the College of the Sacred Heart of Jesus, a small private school run by one of his mother's cousins. Despite its name, this was not a religious institution and its effect on Lorca in this respect was clearly not as damaging as that experienced at school by Buñuel. At the same time, as was common practice for other pupils, he also attended classes at the Granada General and Technical Institute. He continued to be, though, a less than outstanding student who, unlike both Buñuel and Dalí in this respect, showed little interest in his classes and whose attendance was far from exemplary. During his five years at the Institute, the records indicate that he sat twenty-eight examinations, failed four times, managing to pass the re-sits, and that he received only twelve grades of 'Good' but never an 'Excellent'. His mother, it seems, nagged at him constantly in an effort to make him work harder and emulate the success of his brother, a brilliant student.

At the primary schools in Fuente Vaqueros and Asquerosa, Federico had been seen as the son of a rich father, and in that sense as superior to his much poorer classmates. In Granada, in contrast, many of the pupils at the Institute were more sophisticated and saw him as the boy from the country. They made jokes about him and, because he avoided sporting activities involving speed and agility, regarded him as effeminate and called him 'Federica'. Apart from the shame and discomfort that this must have caused, he also incurred the wrath of one of the teachers, who invariably sent him to sit at the back of the class, something that may well have been recalled later in one of the poems in *Poet in New York*, 'Double Poem of Lake Eden':

> I want to weep because I want to,
> As the children weep at the back of the class.[3]

Already, then, he was beginning to be aware of being something of an outsider figure, which in part explains his sympathy for the Muslims in the past and the gypsies in the present, both marginalised and persecuted by an intolerant majority.

What must have been an unhappy part of a sensitive boy's experience was, however, balanced by the emergence of an

outstanding musical talent that, for a number of years in Granada, was encouraged under the guidance of a well-known teacher of music. In 1910, when Lorca was twelve years of age, Antonio Segura Mesa was already sixty-eight, but with his tutelage the young boy acquired both a sound knowledge of folk music and an excellent piano technique. Indeed, Lorca delighted in playing the piano and similarly delighted many others with his performances, at home and outside it. Such was his virtuosity that his ambition was to pursue a career in music, but the opposition of his parents thwarted that particular objective, diverting it in the end into the direction of literature.

In 1914 Lorca, yielding to his parents' wishes that he pursue a serious profession, undertook a preparatory course for entry into the Faculty of Philosophy and Letters – the equivalent of a British faculty of arts – and the Faculty of Law at the University of Granada. He succeeded in passing the three subjects studied – Spanish Language and Literature, Fundamental Logic, and Spanish History – but his grades were no better than those he had achieved at school and anticipated the lack of application that came to characterise his university education as a whole. After a relatively successful first year in the two faculties, he did little academic work, preferring to concentrate on his musical interests and, at the same time, showed clear signs of becoming a writer.

In this context he was influenced in no small measure by Martín Domínguez Berrueta, Professor of the Theory of Literature and the Arts at the University. A man of strong liberal inclinations, Berrueta condemned the lack of contact between teachers and students that had for so long been the norm in Spanish universities, and, as part of his attempt to break down such barriers, was responsible for organising and supervising student trips to different parts of Spain. In the summer of 1916, therefore, Lorca was one of a group that travelled to Baeza, in northern Andalusia, and then proceeded to Cordoba and Ronda. In the autumn of the same year, a second trip took in eleven towns and cities in central and north-west Spain, including Madrid, Avila, Salamanca, Santiago de Compostela, and Burgos. Two more trips would take place in the spring and summer of 1917, but already, after the second, Lorca had produced a piece of poetic prose entitled 'Symbolic Fantasy', in which he sought to capture the spirit and personality of

Granada.[4] It would be the first of many pieces in which Granada figured prominently.

Another academic who played a significant part in Lorca's life both now and later was Fernando de los Ríos Urruti, Professor of Political and Comparative Law in Granada. Above all, de los Ríos was a committed socialist who believed that education was the answer to Spain's future. He was to become a Member of Parliament for Granada, and in 1931, when the seven-year dictatorship of Miguel Primo de Rivera gave way to the Second Spanish Republic, he became, first, Minister of Justice and then Minister of Education. During Lorca's time at the University of Granada, de los Ríos, then in his late thirties, took him under his wing. It was a friendship that would continue throughout Lorca's lifetime and one that undoubtedly helped to consolidate his left-wing sympathies.

A key element during Lorca's adolescence was his association with Granada's Café Alameda, situated in the Plaza del Campillo, not far from the cathedral, and now a restaurant and bar called Chikito. In the morning, the customers who frequented the Café Alameda tended to consist of workmen from the local abattoirs and markets. In the afternoon and evening they were very different: small-time bullfighters, flamenco singers, dancers, and guitarists from the nearby Café La Montillana, individuals who patronised the red-light area, La Manigua, and members of the audience from the nearby Cervantes Theatre. It was little wonder that the establishment gained a rather dubious reputation in the minds of the majority of Granada's inhabitants, for in the early twentieth century they were extremely conservative and intolerant of any behaviour that seemed to flout their narrow-minded principles. At the rear of the café there was also a small area, the *rinconcillo* or corner, where a group of journalists, writers, and creative artists of different kinds – most of them associated with a monthly magazine, *Granada* – met to discuss and exchange ideas. They enthusiastically debated the provincialism of Granada and its highly conservative literary establishment, advocated socialist policies, innovation and experimentation in the arts, and discussed the latest artistic movements that were developing in other European countries. It was a youthful group of enormous intellectual energy, which, because of the location of its meetings, itself became known as the Rinconcillo, and continued to frequent

the café for about seven years from 1915. Many of the members were sufficiently bizarre and bohemian to become a source of gossip for the good people of Granada. Lorca became a part of the group almost from its inception.

One of the leading lights of the Rinconcillo was Francisco Soriano Lapresa. Five years older than Lorca, he dressed extravagantly, a true dandy in appearance and manner. His tastes were somewhat exotic, part of his extensive library consisting of a collection of erotic literature, and it was rumoured that at home he was in the habit of organising rather bizarre orgies. The journalist Constantino Ruiz Carnero, Lorca's senior by eight years, was small, fat, bald, and decidedly homosexual, as was the extremely camp quantity surveyor, José María García Carrillo. There were others, of course, who were not homosexual: the writer Melchor Fernández Almagro, the future Mayor of Granada Antonio Gallego Burín, and the painter Manuel Angeles Ortiz. These and others contributed greatly to the lively intellectual discussions that took place every evening at the café, and they were sometimes joined by foreign visitors to Granada as distinguished as H.G. Wells, Rudyard Kipling, Artur Rubinstein, and Wanda Landowska. The intellectual activities of the Rinconcillo were clearly considerable, but the Granada public at large were much more interested in the bizarre dress and behaviour of many of its members. There can be little doubt that, just as he had been singled out at school for being 'different' from his fellow pupils, Lorca was now included in the gossip surrounding the group to which he belonged. It was something that would prove significant in later years.

During the course of his adolescence, Lorca's increasing exposure to the kind of ideas that were discussed by the Rinconcillo influenced him a great deal, as indeed did his visits with Berrueta to other parts of Spain. An incident that would profoundly influence his thinking took place, for example, at the Benedictine monastery of Santo Domingo de Silos during one of the student trips. Lorca had encountered there a monk who had renounced his passionate love of music in favour of the spiritual life. On the one hand, the incident reinforced in Lorca's mind the question of the freedom of the artist, a topic much to the fore in the discussions of the Rinconcillo. It convinced him of his need not only to give himself entirely to his art but also to rebel against those things that stood between the individual and his ability to express himself fully and

honestly. On the other hand, the monk's sacrifice revealed the repressive nature of the Catholic religion, and Lorca's attitude towards it soon became one of serious questioning of its teachings in general. Increasingly aware of the anguish and suffering to which human beings are exposed, he began to see God not as a loving Father but as a tyrant who delights in manipulating and punishing people, including his own Son. As for the official agents of God on earth, he started to believe that the Church, from the Pope down, had done infinite harm to its followers by betraying the love embodied in Christ. In this particular context, one need only consider the activities of the Inquisition, or the terrible slaughter of native tribes carried out in the name of the Catholic faith by the *conquistadores* in South America. And then, of course, there was the attitude of the Church towards the kind of freedom embodied in sexual love. First, it considered sexual activity to be truly permissible only for purposes of procreation; secondly, it condemned out of hand any kind of sexual relationship that did not involve a man and a woman. Although Lorca differed from Buñuel and Dalí in the sense that he did not attend a school run by clerics, the influence of the Catholic Church still permeated his childhood. As a consequence, the awakening of sexual awareness and desire in his teenage years was inevitably accompanied – as was and is the case with many Catholics – by feelings of shame and guilt. In Lorca's case, this process was undoubtedly aggravated by uncertainty over his true sexual orientation.

In 1917 he seems to have been strongly attracted to María Luisa Egea González, the beautiful blonde daughter of a wealthy businessman. She was four or five years older than Lorca, and was an extremely good pianist. Whether or not he revealed his feelings to her is unclear, but he certainly described her as 'cold', which indicates a resentment on his part that she did not respond to him.[5] In any event, her lack of interest in him is suggested by the fact that not long afterwards she moved to Madrid. In the following year, Lorca became friendly with another attractive young woman, Emilia Llanos Medina, ten years older than he was. At first they met almost every day and he gave or loaned her books, including *Hamlet*, Ibsen's *Wild Duck*, Juan Ramón Jiménez's *Platero and I*, and his own *Impressions and Landscapes*. This, the result of Lorca's travels with Berrueta, was Lorca's first book, published in April 1918 and consisted of his evocations of Castile and Baeza,

together with impressions of Granada and various descriptions of gardens. The gift marked the beginning of a lasting friendship, but did not amount to more than that, though after Lorca's death Emilia regarded him as her lost love. It seems likely that Lorca's failure to commit himself to a woman who showed an interest in him lay in the end in an inability to respond to the female sex in the deepest sense. It was an aspect of his character that he would draw upon in some of his plays. Interesting too, of course, is the fact that both young women were older and presumably more mature than he was, which suggests perhaps that in actuality he was seeking the kind of intimacy and support that had until then been provided by his mother.

The reality of Lorca's sexual dilemma in 1918 emerges more clearly in a letter to Adriano del Valle y Rossi, a young Andalusian poet with whom he had begun to correspond. No sooner has Lorca described himself as 'a sad companion' than he goes on to observe that he is 'a simple young man, passionate and silent, who almost, almost like the marvellous Verlaine, carries within him a lily that cannot be watered'.[6] The reference to Verlaine is, of course, to the French poet's homosexuality, and Lorca, well aware of contemporary attitudes to homosexuals, goes on to note that 'Ahead I can see many problems, many eyes that will imprison me, many difficulties in the conflict between heart and head.' In saying this, he may well have been referring to the Granada public's attitude to the group who met at the Café Alameda, and anticipating too the hostility towards him that would become a fact of life in his later years. He realises that this is a problem that will not disappear, which is inexplicable, and which brings with it deep feelings of despair: 'We have to carry on because it's our fate to grow old and die, but I do not wish to listen to the phantom urges . . . and with every passing day I have another doubt and another cause for despair, despair at the enigma of oneself!'

The emotional turmoil of these years is reflected too in Lorca's early poems, in which the theme of unfulfilled love is much to the fore:

> The white veil of a bride covers
> The bride I shall never see.
> She was sweet, vague and sensitive,
> The sacrament that contained my life,

> But then one night, when all was silent and asleep,
> Like a princess in a fairy-tale, she left . . .[7]

While he projects his feelings into a situation involving himself and a woman, as he would do in his later play, *When Five Years Pass*, this could equally apply to a homoerotic relationship, deliberately concealed in order to deceive those eyes that would 'imprison' him. Written in 1918, the poem reflects the despair of an adolescent moving into early manhood, but it is also a despair that can be seen from time to time throughout Lorca's adult life.

Luis Buñuel, as we have seen, attended the Jesuit School of the Saviour in Zaragoza for a period of seven years, well into adolescence. The strict discipline of the school and the religious emphasis of the teaching have already been mentioned, and there can be no doubt that both left an indelible mark upon him. His adult life, as we shall see, would be characterised by a strong element of discipline and asceticism – he frequently slept on planks of wood and preferred a very simple diet – while a preoccupation with Catholic religion and dogma is to be found throughout his films. Although the Jesuits sought to fill their pupils' heads and hearts with strict religious dogma, the young Luis soon began to have serious doubts about the Church's teachings:

> I was about fourteen when I began to have doubts about this warm, protective religion. They started with the problem of hell and the Last Judgement, the two realities I found inconceivable. I just couldn't imagine all those dead souls from all lands and ages rising suddenly from the bowels of the earth, as they did in medieval paintings, for the final resurrection. I used to wonder where all those billions and billions of cadavers could possibly be; and if there was such a thing as a Last Judgement, then what good was the judgement that was supposed to come right after death and which, theoretically, was rumoured to be irrevocable?[8]

And, crucially for an adolescent, there was the Jesuit attitude to the question of sexual pleasure.

Like the majority of young teenage boys, Buñuel and his friends were increasingly interested in girls and in the mystery that they represented for the opposite sex. The boys played doctors and

nurses; they were fascinated by the anatomy and sexual behaviour of animals. In the summer afternoons when most people were taking a siesta, Buñuel and his companions would meet in a local store and, behind closed doors and drawn curtains, eagerly pore over the so-called erotic magazines passed to them by one of the assistants. The pictures contained in them may have revealed little more than 'an ankle or the top of a breast',[9] but it was enough to fire the youngsters' imaginations and desires. As well as this, they sometimes went to the seaside resort of San Sebastián where, through a hole made in the partition of a bathing hut, they were able to watch the female bathers undressing. Even after the women became aware of the practice and stuck hatpins through the hole as a deterrent, the boys would fill the hole with a piece of glass and continue to watch, such was their sexual excitement.

While this might constitute the normal sexual, emotional, and psychological development of Buñuel and his companions, they encountered at school the implacable opposition of the Jesuits to any kind of sexual pleasure or activity. With regard to something as commonplace as going to the toilet, boys were obliged to go singly, never together, were observed by a priest as they went along the corridor, and by another priest while they were inside the toilet. They were also expected to urinate without touching their penis. And when those who were boarders went to bed in the dormitory, they were required to sleep with their arms folded across the chest, thereby avoiding all contact with their genitals. In this context, they were constantly reminded by their teachers that masturbation was a sin that would be punished with eternal damnation, and that sex would attract the most severe suffering. Thomas Aquinas, a key figure in the development of Catholic doctrine, had even proclaimed that the sexual union of husband and wife was a venal sin and that, if it were to occur, it should be devoid of desire and intended solely to produce more servants of God.

This repressive attitude towards sex was something that profoundly affected many who attended Jesuit schools. The poet Rafael Alberti, who was a pupil at the Jesuit School of San Luis Gonzaga in El Puerto de Santa María has described his teachers' utter condemnation of the act of masturbation. They would remind a guilty pupil: 'If you could see your soul, you would die of horror.' If the pupil denied that he had masturbated, the warning was more severe: 'You sin and refuse to admit your error. You are

thus committing a double sin.'[10] As for Buñuel, he has stated very clearly that the Jesuits 'never ceased to remind us that the highest virtue was chastity, without which no life was worthy of praise'.[11] Given such indoctrination, it is easy to imagine the extent to which it conflicted with an adolescent boy's growing awareness of sexual pleasure, be it in the form of masturbation or attraction to members of the opposite sex. Looking back on his own experience, Buñuel effectively summed it up:

> Men of my generation, particularly if they're Spanish, suffer from a hereditary timidity where sex and women are concerned. Our sexual desire has to be seen as the product of centuries of repressive and emasculating Catholicism, whose many taboos – no sexual relations outside of marriage (not to mention within), no pictures or words that might suggest the sexual act, no matter how obliquely – have turned normal desire into something exceptionally violent.[12]

Buñuel's inner conflict in this respect was, of course, rather different from Lorca's, but there can be no doubt that in both cases it was a source of considerable anguish.

At the age of fifteen, Buñuel left the Jesuit School of the Saviour, in spite of the fact that his academic work was of a high order. He was doubtless increasingly unhappy with its teaching, but his decision to leave was precipitated by the fact that the study hall proctor kicked him for no apparent reason and then called him an idiot. His refusal to return, even though his mother did her utmost to make him change his mind, is another example of that independence of mind and intransigence that would be much in evidence throughout his life. For the next two years he attended the local secondary school, the Institute, and there he was introduced by a law student to writers and thinkers he would never have encountered at the School of the Saviour. His encounter with the works of Rousseau, Marx, and Darwin confirmed the doubts that he had already begun to entertain concerning Catholic teaching about the creation of the world, the origin of man, and the nature of social justice, and led him to abandon what little faith he still had left.

Buñuel's adolescence provides evidence too of his growing artistic abilities and interests. His childhood habit of acting out the Mass and of entertaining family members and local children

with theatrical entertainments points to an acting ability that continued into his teenage years; Conchita Buñuel has described the day on which, at a celebration of a civic event at the Institute, her brother appeared on stage as 'part gypsy, part bandit, brandishing an enormous pair of barber's shears'.[13] This love of costume and disguise was but one early example of something that would develop into a life-long habit, anticipating the disguises Buñuel would adopt in civilian life and the parts he played in his films – in both *He* and *The Phantom of Liberty* he appeared as a priest. In Zaragoza, his theatrical instinct was also stimulated when he accompanied his parents to performances at one of the city's four theatres; his father had a box at the largest theatre. There, Buñuel was able to see operas, plays, and concerts. Such was his enthusiasm that he saw one particular *zarzuela*, or light opera, half a dozen times.

His love of music was also evident at an early age. He could play the piano and the ocarina and, from the age of thirteen, began to study the violin. His sister Conchita has described how, when she and her sisters had gone to bed, Buñuel would go to their bedroom and tell them the outline of a story that he would then illustrate on his violin.[14] During the summers in Calanda, he would also form an orchestra that performed such pieces as Perosi's *Mass* and Schubert's *Ave Maria* in the local church. By the age of sixteen, he had acquired a taste for the music of Wagner, and has since observed that Beethoven, César Franck, Schumann, and Debussy were among his favourite composers. As a teenager, he looked forward with barely contained joy to the concerts given in Zaragoza by the Madrid Symphony Orchestra. This music figured in his later films: Wagner's *Tristan and Isolde* in *Un chien andalou*, extracts from Wagner, Mozart, Beethoven, Mendelssohn, and Debussy in *L'Age d'or*, Brahms in *Las Hurdes*, Wagner in *Wuthering Heights* (1953), Handel in *Viridiana*, and Wagner again in *That Obscure Object of Desire*. Although he was not as expert as Lorca as a performer, Buñuel clearly possessed a considerable aptitude for classical music. In this respect both were very different from Dalí, who appears to have had very little interest in music.

As far as cinema is concerned, Buñuel has stated that he was introduced to films around the age of eight, at a theatre in Zaragoza called the Farrucini, a makeshift building with wooden benches and a roof consisting of a tarpaulin. Both the condition

of the building and the films shown there were, of course, rather primitive, but young Luis evidently felt a typical child's enthusiasm and excitement for the moving image. He has recalled how thrilled he was by the first cartoon he ever saw, though he does not mention what it was called – the tale of a singing pig that had around its waist a three-coloured sash.[15]

Later on, by the time Buñuel was fourteen, the number of cinemas in Zaragoza had risen to four, all showing silent films. As was the custom at the time, each cinema had a pianist who accompanied the on-screen action, and a narrator who stood to the side and described the events taking place. We can well imagine the extent to which audiences of the time were amazed at and could be terrified by the images they witnessed, as in the case of a head that, through the use of a zoom, came closer and closer until it filled the entire screen. Although Buñuel would not make his first film for another fifteen years, the imaginative and visual power of cinema had impressed itself on him long before.

As for the films he recalls seeing in his teenage years, he mentions in particular those of George Méliès and Max Linder.[16] Méliès was a French filmmaker and producer who, between 1896 and 1912 made 498 films, of which 137 have survived. Many of them contained elements of illusion, comic burlesque, and pantomime. In *The Man with the Rubber Head*, made in 1902 – this could well be the enormous head referred to above – Méliès depicted a head that expands to a monstrous size until it finally explodes. In *Voyage to the Moon*, made in the same year and which Buñuel greatly admired, acrobats play the Selenites and dancing girls sit on the stars. And in *The Merry Frolics of Satan*, an animated skeleton puppet-horse is much to the fore. Max Linder was a French actor and filmmaker who was extremely popular between 1910 and 1914 on account of his comic films, which were often compared to those of Chaplin. Buñuel makes no reference to having seen any of Chaplin's silent films in Zaragoza, but it seems quite possible that early exposure to the comic antics of Linder sowed the seeds of a liking for the elements of irreverent farce that was later consolidated by the Hollywood silent comics and which the surrealists, including Buñuel and Lorca, came to admire to such an extent. Buñuel also recalls having seen Italian melodramas starring Francesca Bertini, a beautiful and temperamental actress who appeared in such films as *Tristan*

*and Isolde, Francesca da Rimini, Salome,* and *the Dame of the Camelias,* all made between 1911 and 1915. He refers too to romances and action-packed serials containing the American actors Count Hugo and Lucilla Love. Later on, especially in Mexico, Buñuel would make a considerable number of powerful melodramas, which may well reflect his film-going experience during his adolescent years.

While the more sensitive side of Buñuel's personality was reflected in his growing artistic interests, the tougher aspect of his character, not unlike that of Hemingway, was to be seen in his love of guns and boxing. When, for example, he was only fourteen years of age, he succeeded in getting hold of one of his father's handguns, which he secretly carried with him.[17] And when, on one occasion, two individuals began to push Buñuel and a friend off a bench, he suddenly produced the gun and aimed it at them, forcing them to back down. He has also described how he learned to use a gun, using a friend for target practice by persuading him to raise his arms and hold a tin can or an apple in either hand. This adolescent fondness for guns was to continue into adult life; in his house in Mexico, Buñuel had a collection of Winchesters, Mausers, Lugers, Smith and Wessons, small Astras, and duelling pistols, all of which he loved to clean and polish.

His love of boxing was but one manifestation of his interest in physical fitness. Conchita Buñuel has described how Luis fought and defeated the toughest boy in Calanda, subsequently arranged a series of fights, and adopted for himself the title of the 'Lion of Calanda'.[18] His brother, Alfonso, has stated that Luis was extremely strong at elbow-wrestling, and that, at the age of nineteen, he fought in Madrid for the amateur heavyweight championship of Spain but lost on points.[19] Whether or not this specific claim is true is unclear, but he certainly fought in the ring on a couple of occasions. The impression we form of Buñuel during these years is that in physical terms he was very different from the unathletic Lorca. He was already developing too that uncompromising toughness of spirit evident throughout his films.

After six years at the College of the Christian Brothers, Dalí moved on at the age of twelve to the Figueras Institute and also attended classes at the College of the Marist Brothers, which supplemented the Institute's teaching and provided extra coaching. At the

Institute, the adolescent Dalí proved to be a clever and assiduous pupil, obtaining good or excellent grades in many subjects and encountering difficulties only in arithmetic, geometry, algebra, and trigonometry. Above all, he had at the Institute an extremely proficient art teacher, Juan Núñez Fernández, who was a graduate of the famous Academy of San Fernando in Madrid, and who also ran evening classes at the Municipal Drawing School in Figueras, of which he was director. Recognising that in the young Dalí he had an extremely promising pupil, Nuñez offered encouragement and guidance to which the boy duly responded, later claiming that his former art teacher was the person from whom he had learnt most. So pleased was Dalí's father with his progress during the first year of secondary education that he organised an exhibition of the boy's recent paintings, strongly influenced by the Impressionists, in the family home.

Dalí remained highly sensitive and self-conscious. While Lorca frequently concealed his real feelings from others and Buñuel reacted aggressively to any insult, Dalí often countered his embarrassment by performing outrageous acts. This, however, had its counter-productive side: by drawing attention to himself, he often became the object of his classmates' jokes, one of which involved locusts, the Catalan *llagosta de camp*, the field or country locust, which is several centimetres long. Aware of Dalí's fear of these insects, which in Figueras had horse-like heads, they would suddenly produce one, present him with it, or even throw one at him. Repeated persecution of this kind meant that the locust became an obsession in his life from this point on. It appears in many of his later paintings and, significantly, is sometimes associated with his father, who was often the torment of his life and whose presence Dalí frequently saw as extremely oppressive and obnoxious.

As for Dalí's sexual development during these years, interesting parallels can be drawn with that of both Buñuel and Lorca. There can be no doubt that, like Buñuel, he was interested in girls. At the Municipal Drawing School, when he was fifteen, he was attracted to a girl he later described as 'the beautiful Estela', with whom he exchanged notes and occasionally met – under the watchful gaze of her grandmother.[20] Not long afterwards, his attentions moved to a tall, good-looking blonde girl, Carme Roget Pumerola, who attended a private school opposite the Dalí residence and was also

a student at the Municipal Drawing School.[21] A female pupil at the Institute acted as a go-between, passing Dalí's notes and letters to Carme, who, it seems, soon fell in love with him, though his feelings for her were much less passionate. He evidently enjoyed playing a game with her, toying with her affections, attracting her but keeping her at a distance, delighting in the fact that he could command a beautiful girl and at the same time keep his independence. Certainly, there was little if any sexual contact.

Unlike Buñuel, Dalí does not refer in his writings to the damaging effect of the Catholic teaching on his or his fellow pupils' sexuality. Even so, the curriculum clearly contained a strong element of religious instruction and observances, including warnings to the students on the evils of sexual activity; it is most unlikely that someone as sensitive as Dalí would not have been affected by them. But if this was the case, the problems that he began to experience in this regard also had another source, much closer to home.

Although we only have Dalí's word for it, it seems that, in order to warn his children of the dangers of sexually transmitted diseases, his father kept a medical book on top of the piano that illustrated extremely graphically the effects of syphilis and other associated conditions. At all events, the photographs contained in the book induced a state of complete terror in the impressionable young Dalí and may well have led him to conclude that penetration of a female in the usual way carried with it the most appalling risks. But, as well as this, Dalí was constantly preoccupied by the small size of his penis, which he compared with those of his classmates and which they undoubtedly ridiculed. At a time, then, when adolescent boys are more and more aware of their bodies and of their potential sexual prowess in relation to the opposite sex, Dalí began to feel only inadequacy and a deep sense of shame, something that would become a lifelong concern. The desire to avoid ridicule, combined with his fear of venereal disease, led him therefore to indulge in the solitary pleasure of very frequent masturbation. Even though the moral climate of the time meant that sexual relations between teenage boys and girls were far less likely than they are in the twenty-first century, Dalí's situation was more extreme than most.

He began to masturbate in the lavatories at the Figueras Institute, but, as he has observed, the pleasure he experienced was

invariably accompanied by subsequent guilt: 'I felt sexually excited. I went to the lavatories. I experienced great pleasure. But afterwards I felt depressed and full of self-disgust.'[22] In this context, we recall Buñuel's account of the way in which the teachers at the School of the Saviour warned their pupils that masturbation was a sin that would be severely punished in the afterlife. The Marist Brothers may not have been as severe in that respect, but they must have included in their lessons at least some reference to the sinful nature of sexual pleasure. And then, of course, one has to bear in mind contemporary attitudes to masturbation. In Victorian England the activity was described as 'self-abuse', and medical opinion suggested that frequent indulgence led to convulsions, epilepsy, madness, and even death. Little wonder, then, that Dalí's masturbatory pleasures were accompanied by negative feelings. But, as we have already seen, he was from childhood someone who counteracted his fears by means of often reckless acts. His response to warnings of the evils and dangers of masturbation was, therefore, to masturbate even more, to the point where it became a habit that he practised throughout his adult life. As an adolescent, he would frequently stimulate himself on the rooftop terrace of the house in Figueras, while observing the tower of the church of San Pere, where he had been baptised. The fulfilment of a sexual pleasure in full view of a religious building was a typical act of rebelliousness and defiance, reminiscent of Buñuel's statement that when sexual desire succeeds in overcoming the obstacles placed in its way, in particular the religious obstacles, 'The gratification is incomparable, since it's always coloured by the sweet secret sense of sin.'[23] Dalí's psychological make-up was in many respects very different from Buñuel's, but both possessed a strongly rebellious streak.

During his adolescence, Dalí's relationship with his father continued to be difficult. On the one hand, as we have seen, Salvador Dalí Cusí's pleasure in his son's success at school led him to organise an exhibition of the boy's paintings. On the other, the father's volatile and unpredictable nature, together with the young Dalí's resolve to stand up to him, led to confrontations that were much more frequent and violent than those between either Lorca or Buñuel and their respective parents. Ana María Dalí has graphically described such arguments:

When, during one of these outbursts, he is wrong, he utterly refuses to admit it or to back down. He defends his viewpoint with the stubbornness of a child, looks for a thousand ways out, a thousand unlikely explanations to give the impression that his extravagant conduct is merely a sign of his brilliant wit and temperament . . . And so his arguments become aggressive and make any kind of discussion quite impossible.[24]

It seems that Dalí's father struck him on two occasions at least: first of all, when, rushing to a window in order to see a comet passing overhead, the boy ran into his sister and accidentally kicked her on the head; and secondly, when, having persuaded his father to take him to see a particular film, he suddenly walked out of the cinema. In addition, further confrontations arose as the result of Dalí's incompetence in handling money. If, for example, he attempted to buy a theatre ticket, he would hand over the money but return without the ticket. And if he happened to have money in his pocket, he would unthinkingly distribute it to his friends. Little wonder, then, that his father became so exasperated by his son's behaviour. But if Dalí's inability to carry out quite ordinary tasks can be attributed to the fact that, as a child, everything was done for him, it can also be seen as part of his deliberate intention to show his parents that he was indeed different from the perfect dead brother he was so often reminded of, which in turn drew attention to his own uniqueness.

The negative aspect of Dalí's relationship with his father needs, though, to be set against the latter's more positive influence, not least the intellectual stimulus that he provided. In the first place, Salvador Dalí Cusí, clearly much more cultured and erudite than either Lorca's or Buñuel's father, possessed an extremely large and well-stocked library in which young Salvador spent a great deal of time. There he immersed himself in and was affected by the anti-clericalism of Voltaire's *Philosophical Dictionary* and Nietzsche's advocacy of the superman in *Thus Spake Zarathustra*, claiming, typically, that one day he would be an even greater superman than Nietzsche's. He enjoyed too the writings of Kant and Spinoza, whose ideas he absorbed and vigorously discussed with his father. In addition, the latter had collected, from 1905 – when they first appeared – the series of Gowans's Art Books, which were available in both English and French. Each of the fifty-two

volumes contained sixty black-and-white illustrations of the Great Masters. The painters in question included Rubens, Rembrandt, Raphael, Titian, Tintoretto, Michelangelo, Velázquez, and Goya. Later on, Dalí would acknowledge his debt to these books:

> These little monographs which my father had so prematurely given me as a present produced an effect on me that was one of the most decisive in my life. I came to know by heart all those pictures of the history of art, which have been familiar to me since my earliest childhood, for I would spend entire days contemplating them.[25]

As well as this, of course, we should not forget that during these important years Dalí's tastes were being influenced by his art teacher at the Figueras Institute and the Municipal Drawing School. Juan Núñez Fernández admired, among others, Velázquez, Rembrandt, and José Ribera, and at his home, to which he invited his pupil, he possessed an original Rembrandt engraving. In terms of his artistic interests, the teenage Dalí was evidently making important strides.

As for his own artistic endeavours, the exhibition of his paintings that his father had earlier organised at the Dalí home was followed in 1918 by the first public exhibition of his work, along with that of two other local painters, in the rooms of the Societat de Concerts in the Teatre Principal in Figueras. According to the art critic of the newspaper *Empordá Federal*, Dalí's paintings and drawings, which included *The Drinker* and *The Bastion*, stood out and, in his opinion, already pointed to a great future:

> We should not talk of the boy Dalí because this boy is already a man . . . We should not say that he shows promise. Rather, we should say that he is already producing . . . We salute this new and original artist and feel quite sure that in the future our words will prove to be prophetic: Salvador Dalí will be a great painter.[26]

As well as being the recipient of such praise, Dalí also had two of his paintings bought by a wealthy businessman, Joaquim Cusí Fortunet, a friend of his father. It was already becoming clear, as the art critic of *Empordá Federal* had suggested, that the fourteen-year-old Dalí's artistic future was assured.

An important influence in this respect was the painter Ramon
Pichot, whose family lived in Figueras and also had a house in
Cadaqués. The Pichot family contained many talented individuals:
Ramon the painter, Pepito a highly talented horticulturist, Ricard
a brilliant cellist, Lluís a violinist, and Maria a successful opera
singer. Furthermore, the Pichots had a wide circle of bohemian
friends whom they regularly invited to Cadaqués. Dalí's father
was a particular friend of Pepito Pichot and, as a result of that
friendship, rented the property in Cadaqués where the Dalí family
too spent their summers and which the adolescent Salvador
came to love so much. His association with the Pichot family was
therefore very close.

As for the particular influence of Ramon Pichot, who spent
most of his time in Paris rather than in Cadaqués, it seems likely
that Dalí had seen an exhibition of his work in Figueras when he
was only nine years of age. Three years later, when Maria Pichot
bought a large property just outside Figueras called Molí de la
Torre, Dalí encountered there a number of paintings by Ramon
Pichot that were influenced by Impressionism and pointillism. He
would later recall the experience:

> I did not have eyes enough to see all that I wanted to see in
> those thick and formless daubs of paint, which seemed to
> splash the canvas as if by chance, in the most capricious and
> nonchalant fashion. Yet as one looked at them from a certain
> angle and squinting one's eyes, suddenly there occurred that
> incomprehensible miracle of vision by virtue of which this
> musically coloured medley became organized, transformed into
> pure reality . . .
>
> But the paintings that filled me with the greatest wonder were
> the most recent ones, in which deliquescent impressionism ended
> in certain canvases by frankly adopting in an almost uniform
> manner the *pointilliste* formula. The systematic juxtaposition
> of orange and violet produced in me a kind of illusion and
> sentimental joy like that which I had always experienced in
> looking at objects through a prism, which edged them with the
> colours of the rainbow.[27]

As we have already seen, Dalí's early painting was in the style
of the Impressionists, and his exposure to Ramon Pichot's work
further encouraged that tendency, but by the time Dalí was

seventeen Pichot had suggested to him that the future lay in a different direction. Dalí's love of the Impressionists continued, but a gift from Pichot of an illustrated Futurism publication opened his eyes to the new directions in which European painting was now moving.

It would be wrong, however, to assume that the young Dalí's artistic gifts were only those of a painter. During the autumn of 1918, for example, he and four other students at the Institute drew up plans for a school magazine which they called *Studium* and which was issued for the first time in January of the following year. The magazine consisted of only six pages, but it had a certain literary quality. For each issue Dalí wrote a piece on a great painter – El Greco, Goya, Dürer, Leonardo da Vinci, Velázquez, and Michelangelo – which revealed not only his considerable insight into their work but also his literary ability. He also contributed several literary texts, including a piece of poetic prose called 'Twilight' and a poem about two lovers that, in its lyrical and evocative quality, is reminiscent of the French Symbolist poets, in particular Paul Verlaine. Around this time, Dalí was also writing other things. *My Impressions and Intimate Memories* is a diary in which he recorded the details of his life in Figueras between the ages of fifteen and sixteen, focusing on his love of Cadaqués, his struggle with his weaker subjects at school, his growing political interests and the delight he took in painting. *My Life in this World* takes the story forward one more year, and another volume, written a year later, also looks back to his early life and his experiences at school. And finally, a sixteen-page manuscript, written in 1922 and entitled 'Doodles. Essays on Painting. A Catalogue of my Paintings with Notes', provides, as its title suggests, information on his artistic progress. These early autobiographical pieces anticipate the topics of Dalí's adult writings and point to the narcissistic concerns that would dominate in them.

In the light of his involvement with Buñuel in the surrealist films on which they collaborated in 1929 and 1930, it is not surprising to discover that during his childhood Dalí had developed a strong interest in the cinema. The Dalí family possessed a home projector on which he remembered having seen *The Fall of Port Arthur*, a documentary film about the Russo-Japanese war, and a film entitled *The Enamoured Student*. But there were clearly other films too, among which the silents of Charlie Chaplin and Max

Linder figured, the latter having also been part of Buñuel's early cinematic experience. Later on, in Madrid, Lorca, Buñuel, and Dalí would continue to applaud Chaplin, Buster Keaton, Harold Lloyd, and others, seeing their comic behaviour as irrational and therefore surrealist. As for public cinemas, Figueras opened its first one in 1914, which meant that from the age of ten Dalí was able to see films on a regular basis.

His father, as we have seen, was an anarchist sympathiser, a supporter of Catalan nationalism, and an enemy of the Madrid-based central government. Given the young Dalí's habit of opposing his father's views, it is somewhat surprising, then, to see that in this respect he shared them. With the loss of Cuba, Puerto Rico, and the Philippines, the last of its American colonies, in 1898, Spain had experienced the last stages of a political and territorial decline that had really commenced in the seventeenth century and had subsequently gathered pace. For the adolescent Dalí, there was only one answer to what appeared to be an endless process of stagnation and control by a fossilised middle and upper class: out-and-out revolution. Although he did not at this time join the Communist Party, he certainly shared its views, identifying with the workers, hating capitalism, and believing that, if revolution was required to bring about a true democracy, so be it.[28] In this respect he shared the ideals of one of his collaborators on *Studium*, Jaume Miravitlles, whose father was an anarchist imprisoned for his activities, and he was probably influenced too by an older communist and friend of Miravitlles, Martí Vilanova. During his teenage years, then, Dalí was as strongly committed to left-wing views as was Buñuel, and rather more so than Lorca. Later on, he was to abandon them completely.

## NOTES

1   On the history and architecture of the Alhambra, see Robert Irwin, *The Alhambra*, London: Profile Books, 2004.
2   On the development and character of flamenco, see Gwynne Edwards, *Flamenco!* (with photographs by Ken Haas), London: Thames and Hudson, 2000.
3   During his nine-month stay in the United States in 1929–30, Lorca spent two weeks in Eden Mills, Vermont. For the poem, see *Obras completas*, vol. 1, p. 538.

4   See Federico García Lorca, *Obras completas*, ed. Arturo del Hoyo, Madrid: Aguilar, 1966, pp. 3–5.

5   In a letter to José Fernández-Montesinos, now lost. The latter's reply, contained in the Lorca Archive in Madrid, refers to Lorca's belief that María Luisa was 'cold'.

6   See Federico García Lorca, *Epistolario, I*, ed. Christopher Maurer, Madrid: Alianza, pp. 16–19.

7   The poem, entitled 'Romanzas con palabras' ('Romances with Words') can be found in the Lorca Archive.

8   Buñuel, *My Last Breath*, p. 29.

9   Ibid., p. 15.

10  See Rafael Alberti, *The Lost Grove*, trans. Gabriel Burns, Berkeley: University of California Press, 1959, p. 56.

11  Buñuel, *My Last Breath*, p. 14.

12  Ibid., p. 48.

13  See 'Conchita's Memories', in Buñuel, *My Last Breath*, p. 36.

14  Ibid., p. 35.

15  Ibid., p. 31.

16  Ibid., p. 32.

17  Ibid., p. 26.

18  'Conchita's Memories', p. 36.

19  See Francisco Aranda, *Luis Buñuel: A Critical Biography*, trans. David Robinson, London: Secker and Warburg, 1975, p. 22.

20  See Salvador Dalí, *Un diari: 1919–1920. Les meves impressions i records íntimes*, ed. Fèlix Fanés, Fundación Gala-Salvador Dalí, Edicions 62, Barcelona, 1994, pp. 26, 28–30, 42, 48, 49, 59, 72–3, 74, 88–9, 92, 93, 99, 124–5, 141–2, 161.

21  See Gibson, *The Shameful Life of Salvador Dalí*, pp. 74–8.

22  Dalí, *Un diari*, p. 98.

23  Buñuel, *My Last Breath*, p. 48.

24  See Ana María Dalí, *Salvador Dalí vu par sa soeur*, Paris: B. Artaud, 1960, p. 61.

25  See Dalí, *The Secret Life of Salvador Dalí*, p. 71.

26  In 'Notes d'art. L'exposició de la Societat de Concerts', *Empordà Federal*, Figueras, no. 415, 11 January 1919.

27  In Dalí, *The Secret Life of Salvador Dalí*, p. 81.

28  See Dalí, *Un diari*, pp. 27, 37, 38, 46, 50.

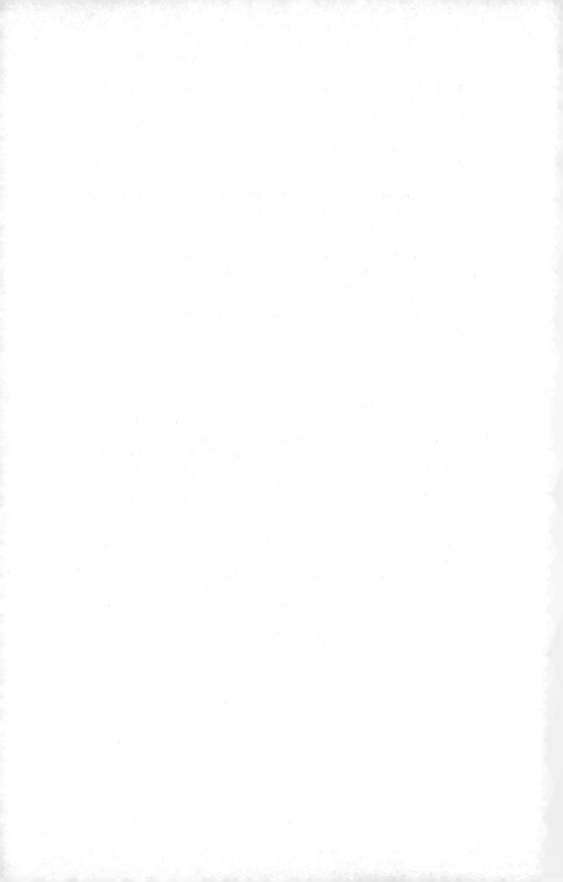

# 3

# THE RESIDENCIA DE ESTUDIANTES

‹∽›

ALTHOUGH THERE WERE clear parallels between Lorca, Buñuel, and Dalí during their childhood and adolescence, these connections became more important and mutually influential during their years together at the Residencia de Estudiantes in Madrid. In 1917 Luis Buñuel left home for the capital, as did Lorca in 1919 and Dalí in 1922, all three moving into accommodation in the renowned Residencia, where they became close friends. Buñuel remained there until 1925 and Dalí until 1926, while Lorca retained his links with the institution for several more years. It would prove to be a period in which they were all influenced by the cultural world of Madrid and of the Residencia, and in which they deeply affected each other both in terms of their personalities and their artistic interests. But what kind of place was the Residencia?

Opened in 1910, it was, as its name suggests, a student hall or hostel that provided accommodation for students taking courses at the University of Madrid or, in Dalí's case, the Academy of San Fernando. At the time of its opening, the Residencia had been quite small, for it then had only fifteen bedrooms and accepted only seventeen students. In the years that followed, as the demand for places increased, a new complex of buildings was constructed at the northern end of the Paseo de la Castellana, the last of the five new blocks opening in 1916, just one year before

Buñuel's arrival, providing accommodation for 150 students. In choosing them, the Residencia's director, Alberto Jiménez Fraud, took care to ensure that they were interested in the sciences and the humanities, though it has to be said that they did not in all cases fit both categories. As far as teaching was concerned, the Residencia offered unofficial tutorial advice, had an excellent library and science laboratories, and it also encouraged sporting activities. Most of the student residents were medical students and students of engineering. Catholics mixed with non-Catholics, suggestive of the liberal, unprejudiced character of the institution. There were inevitable accusations of elitism in the sense that – like Lorca, Buñuel, and Dalí – most of the students came from well-to-do families, but the policy of the Residencia ensured that talented individuals of lesser economic means were also accepted.

An important aspect of Jiménez Fraud's resolve to broaden his charges' education involved inviting men and women distinguished in their particular field of activity to lecture there. These speakers included such luminaries as H.G. Wells, G.K. Chesterton, Hilaire Belloc, John Maynard Keynes, Albert Einstein, Louis Aragon, François Mauriac, Paul Claudel, Paul Valéry, Marie Curie, and Le Corbusier. Famous composers and performers were also invited, such as Manuel de Falla, Andrés Segovia, Wanda Landowska, Darius Milhaud, Maurice Ravel, Francis Poulenc, and Igor Stravinsky; John Trend, who would later become Professor of Spanish at the University of Cambridge, lectured on music. This star-studded list of people gives some idea of the intellectual and artistic atmosphere in which Lorca, Buñuel, and Dalí found themselves.

When Buñuel arrived at the Residencia, he was accompanied by his parents, for they were determined to find him acceptable accommodation.[1] The boarding-houses or *pensiones* that they inspected offered frugal meals, little comfort and even less hygiene, and were rejected by Buñuel's mother. A helping hand arrived in the form of a recommendation to the Residencia from a family friend. Doña María enthused, in particular, over the institution's austere and scrupulously clean environment, so different from that of the boarding-houses. The furniture was largely made of wood, the bedrooms were reminiscent of a monk's cell, the rules governing student behaviour were strict, and alcohol was prohibited. But if Buñuel's

parents were hopeful that these circumstances would encourage their son to lead a disciplined, vice-free life, they were, as we shall see, to be disappointed. Buñuel initially enrolled in the University of Madrid's Department of Agricultural Engineering, soon switched to Industrial Engineering, then to Entomology, and finally obtained a degree in History. But from the outset he did little academic work, preferring to spend his time in the Madrid cafés and acquiring a taste for alcohol that would continue throughout his life.

Lorca's first visit to the Residencia in the spring of 1919 was purely exploratory; he would not commence his studies at the University until the following autumn. Unlike Buñuel, who had no friends in Madrid when he first arrived, Lorca was eagerly welcomed by several members of the Granada Rinconcillo who were already living there. In the course of this initial visit, he visited the Residencia at least once, giving a reading of some of his work, and it seems likely that he took advantage of the excellent piano housed in the lecture room. As well as this, his Rinconcillo associates were able to introduce him to a wider circle of literary acquaintances and to the avant-garde literary movements that were then in the ascendancy. Of particular importance in this respect was *ultraísmo*, a Spanish equivalent of a broader European reaction against Romantic sentimentality that held the view that art should express the technological and practical spirit of the modern world. Like so many artistic movements in the early part of the twentieth century – Cubism, Futurism, and so on – *ultraísmo* was essentially anti-traditionalist and iconoclastic, and although Lorca did not embrace it as wholeheartedly as did Buñuel and others, it undoubtedly influenced him in the sense that, from this moment on, his poetry became less florid and exuberant. At all events, his first visit to the capital proved to be a great success, anticipating the popularity he would enjoy when he settled there permanently. It seems probable that he also met Buñuel, though there are no accounts of the circumstances in which they did so.

Back in Granada for the summer of 1919, Lorca experienced two events that would deeply affect his future. In the middle of June he participated in a reception at the Granada Arts Club, as a result of which he was asked by one of the distinguished guests to give a private poetry reading. Gregorio Martínez Sierra was a well-known dramatist, novelist, poet, and theatre impresario who ran the Teatro Eslava in Madrid, putting into practice his belief in 'total

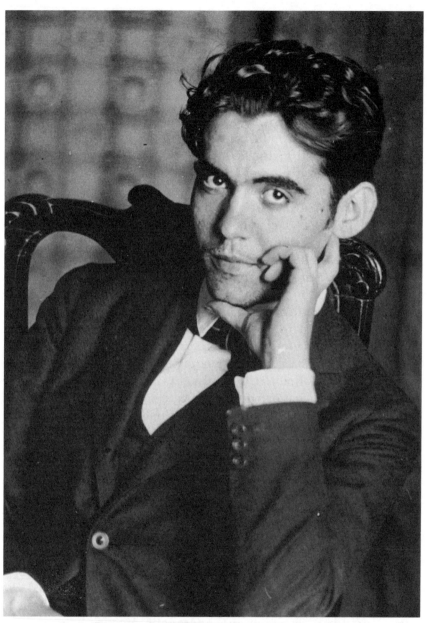

1. Lorca in Granada in 1919, aged twenty-one

theatre' as opposed to naturalism, and therefore staging works in which dialogue, music, dance, and expressive stage design were closely interwoven. Having listened to Lorca recite several poems, one of which told the story of an injured butterfly that was cared for by cockroaches, and which aroused the passions of a young cockroach to whom the butterfly proved indifferent, Martínez Sierra and his lover, Catalina Bárcena, were overwhelmed. They suggested to Lorca that, if he were able to turn this poem into a play, they would immediately stage it at the Teatro Eslava. Lorca was overjoyed. It would be his first adventure in the theatre, and was in the capital, no less. Quite clearly, the reaction of Martínez Sierra to Lorca's performance of poetry illustrates both the power of the young man's personality and his ability to make the written word come alive. It was something that would continue throughout his life, deeply affecting many other listeners.

Several months later, before his departure for the Residencia, Lorca also had his first encounter with the great Spanish composer, Manuel de Falla. By this time Falla had acquired a worldwide reputation as a musician. He had already composed the one-act opera *La vida breve* (*Life is Short*) (1913), the ballet *Love the Magician* (1915), the piece for piano and orchestra *Nights in the Gardens of Spain* (1916), and the ballet *The Three-Cornered Hat* (1919), in many of which the influence of Granada is very strong. Indeed, Falla was greatly attracted to the city, and after the death of his parents in 1919 he made the decision to settle there. A preliminary visit to Granada in September resulted, therefore, in his first meeting with Lorca, twenty-two years his junior. The encounter could well have occurred when Lorca recited a poem at the villa of Fernando Vílchez in the Albaicín. In any case, it marked the beginning of a friendship and a rewarding artistic association that would last until Lorca's premature death seventeen years later.

When he began his university course in Madrid in November, Lorca enrolled in the Faculty of Philosophy and Letters but, like Buñuel, did little academic work. Instead, he delighted in the varied social life that the city and the Residencia offered him: visits to art galleries, attendance at public lectures, excursions with friends, and involvement in the literary gatherings and discussions known as *tertulias*. In no time at all he became, as the result of his recitals of poetry, his brilliant performances at the

piano, and his witty and brilliant conversation, the leading light of the Residencia. Again there is no documentary evidence of how and when Lorca and Buñuel struck up a friendship that would soon become very close, but, as we shall see, that friendship began almost immediately.

In many respects, the differences between the two young men were substantial. As we have seen, Buñuel delighted in physical exercise, for which the Residencia provided ample opportunity. He could be seen regularly, in shorts and vest, running, doing press-ups, shadow-boxing, hitting a punch-ball, and general toning up his muscular body. His physical strength was also accompanied by a toughness and independence of spirit, and, as one might expect in someone given to sporting activities, a concern with *machismo* or manliness. Lorca, on the other hand, had never taken part in any kind of sport, for the reasons outlined earlier. His was an essentially literary and musical life. Even if Buñuel had a certain musical aptitude, his gifts in that respect could never be favourably compared with Lorca's, but Buñuel had unusual gifts of his own that undoubtedly drew attention to him at the Residencia. They included hypnotism, magic, and what Buñuel refers to as prophecy, which may be more accurately described as telepathy.

Buñuel has claimed that he was able 'to put people to sleep quite effortlessly',[2] and in support of that claim has described an incident involving a prostitute called Rafaela. In the presence of a group of medical students in the Café Fornos, Buñuel focused his mind on the girl in question and ordered her to leave the nearby brothel and join him in the café. She duly appeared, in a trance-like state, and woke up when he commanded her to do so. As for magic, he has suggested that he was able to make tables float in mid-air, and, with regard to prophecy, to have had a group of people choose from among themselves an imaginary assassin, a victim, and a weapon, all unknown to him, but which he could then, even though blindfolded, identify. If such claims were true, they would clearly have combined with the spectacle of Buñuel's physical fitness routines to create for him a certain aura at the Residencia, and this would have been enhanced even more by his involvement in a kind of game known as *chulería*, an activity characterised by aggressive and insolent behaviour towards others, which perfectly suited his naturally aggressive and assertive temperament. In this context, he has described an occasion at the Palacio del Hielo, the

Ice Palace, when he marched up to a 'mustachoed, bespectacled gentleman' who happened to be dancing with a girl whom Buñuel admired, and brusquely ordered him to find another partner. To Buñuel's astonishment, the man immediately did as he was told.[3]

Acknowledging the differences between them, Buñuel has described himself as 'a redneck from Aragón' and Lorca as 'an elegant Andalusian' who was 'brilliant and charming, with a visible desire for sartorial elegance', and whose 'dark, shining eyes . . . had a magnetism that few could resist'. But they 'liked each other

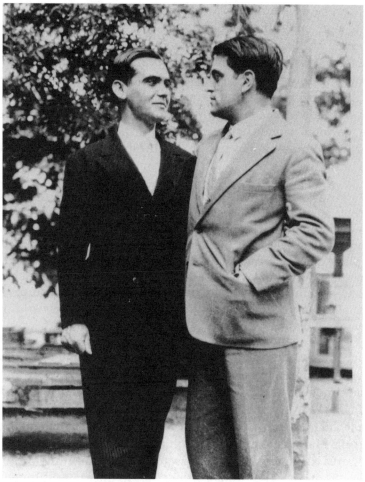

2. Lorca and Luis Buñuel at the Residencia de Estudiantes, 1922

instantly'.[4] In particular, Lorca introduced Buñuel to Spanish poetry, including his own poems, which he would read aloud when in the evenings they sat on the grass behind the Residencia. It seems perhaps rather odd that someone of Buñuel's temperament and decidedly avant-garde taste should have been affected by the lyrical nature and emotional impact of Lorca's poetry, but it is quite possible that beneath Buñuel's tough exterior there was a gentler side that responded to Lorca's reading of poetry, which was always, as many others have stated, indescribably moving. In any case, Buñuel now began to write his own poems, and he shared with Lorca an interest in puppet plays, which, as we shall see later, became an important strand in Lorca's theatre. The two young men made the acquaintance of a man called Mayeu who presented children's shows in the Retiro Park and subsequently themselves gave performances of a similar kind at the Residencia. Buñuel's musical interests must have been stimulated too by the brilliant piano recitals that Lorca regularly gave there.

From time to time, both at the Residencia and afterwards, there were periods when their friendship cooled, but, looking back, Buñuel would pay Lorca one of the finest tributes any man could hope to receive:

> Of all the human beings I've ever known, Federico was the finest. I don't mean his plays or his poetry; I mean him personally. He was his own masterpiece. Whether sitting at the piano imitating Chopin, improvising a pantomime, or acting out a scene from a play, he was irresistible. He read beautifully, and he had passion, youth and joy. When I first met him, at the Residencia, I was an unpolished rustic, interested primarily in sports. He transformed me, introduced me to a wholly different world. He was like a flame.[5]

Such sentiments were, as we shall see, completely at odds with Dalí's later comments on his one-time friend.

One thing of which at first Buñuel seems to have been unaware was, however, Lorca's homosexual inclinations. When a rumour to that effect began to spread around the Residencia, fuelled by a certain Martín Domínguez, Buñuel was so taken aback that he took Lorca aside and, in his characteristically blunt manner, said to him: 'Is it true that you're a *maricón* [a queer]?'[6] Stunned and humiliated by the question, Lorca replied that their friendship

was over and walked away, but such was the strength of that friendship that by the end of the day they were once more on good terms. Quite why Buñuel failed to recognise Lorca's homosexuality and continued to question its existence much later on is difficult to comprehend, though it is quite possible that his own abhorrence of homosexuals was so great – in his time at the Residencia he was in the habit of attacking them as they emerged from public toilets – that he found it difficult to see it in such a close friend. Given the strict moral climate of that time, it is also true and understandable that Lorca, like many others, tried desperately to conceal his sexual nature beneath an outer mask. Some of his friends, it seems, did not suspect him of being 'different', or at least claimed that they did not. Others, according to José Moreno Villa, were aware of it: 'Not all the students liked him . . . Some of them sensed his failing and kept their distance.'[7] But there is little evidence to suggest that Lorca was involved in any homosexual relationship at this time, even if his friendship with the extremely sensitive poet, Emilio Prados, was for a while very close.

Although Buñuel was to become known essentially as a film-maker, he has stated that, rather than having to be involved in the complex process that making a film demands – dependence on money, involvement with producers, technicians, actors, camera-men, editors, and the like – he would have enjoyed much more the isolated life of a writer, and there is certainly evidence of such ambitions in the early 1920s.[8] Although Surrealism had not yet come to the fore, Madrid was alive at this time with anti-tradition and anti-establishment movements. By 1919 the influence of Dada – essentially iconoclastic and opposed to all traditional values in art – which was already strong in Barcelona and which had inspired the publication there in 1916 of the Dada magazine *391*, had spread to Madrid, where literary debates and discussions about the European avant-garde abounded. In the Café Pombo they were led by the influential and eccentric Ramón Gómez de la Serna, who kept a female dummy as a companion. De la Serna, who on one occasion delivered a lecture from a trapeze, urged his contemporaries to experiment with new forms of writing, including *ultraísmo*, which Buñuel, as we have seen, embraced with enthusiasm. In 1922, for example, he published in the magazine *Ultra* a short prose work, 'Downright Treachery', which in its striking and unusual images – 'priests . . . transformed into upside-down umbrellas . . . streets and

houses . . . turned into Himalayas capped by clouds' – has all the hallmarks of the avant-garde. There were other pieces too: in 1922, 'Instrumentation', a dialogue for musical instruments published in the journal *Horizonte*; 'Suburbs', a short prose piece in the same journal in 1923; and 'Why I Do Not Use a Watch', another prose piece that appeared in *Alfar*, also in 1923. These early writings bear the imprint of Buñuel's tough and rebellious personality, as well as the love of the irrational that would distinguish his films.[9]

Buñuel's literary activities at this time cannot, however, be compared with Lorca's in sheer creative energy. Although Lorca was rather slow in completing the script of his first play, *The Butterfly's Evil Spell*, which already reflected in its characters and staging his opposition to the unadventurous and conservative theatre of the day, it received its premiere at the Teatro Eslava on 22 March 1920, while he was still in his first year at the Residencia. As in the case of the poem that inspired the play, its characters were insects: cockroaches, glow-worms, a vicious scorpion, and, of course, a butterfly, all of them played not by puppets, as Martínez Sierra had originally suggested, but by actors. The lead actors were, indeed, performers of distinction: Catalina Bárcena in the role of the young cockroach who falls in love with the butterfly, and the famous dancer, Encarnación López Júlvez, 'La Argentinita', in the role of the butterfly who leaves him with a broken heart. The music that accompanied the butterfly's dance was by Grieg, and the sets by Fernando Mignoni were extremely attractive. But the play was not to the taste of many in the audience, who were accustomed to more traditional fare. From the moment the actors appeared in their insect costumes, there were outbursts of booing, laughter, catcalls, and stamping of feet. On the following day the critics largely damned the play. It closed after four performances. But even if *The Butterfly's Evil Spell* was a commercial failure, its themes were deeply embedded in Lorca's personal experience and would become the central issues of all his work, plays and poems alike. Lorca is, in effect, the passionate young cockroach, whose love for the butterfly is as frustrated as Lorca's feelings for María Luisa Egea González and Emilia Llanos Medina had been just a few years earlier (interestingly, María Luisa attended the premiere). From this point of view, *The Butterfly's Evil Spell* is the first step in a line of plays that would end with the magisterial *The House of Bernarda Alba* sixteen years later, in which the themes of

passion and frustration are equally resonant.[10] Furthermore, *The Butterfly's Evil Spell* suggests in Lorca's loving treatment of his insect characters that love of nature that he had in his childhood and which he shared with Buñuel.

Just over a year later, on 15 June 1921, Lorca's first volume of poetry appeared in print. *Book of Poems* contained sixty-eight poems selected from the many he had written between 1918 and 1920 and highlighted the themes of nostalgia for childhood, love, death, and nature, and, as the following lines from one of those poems, 'If My Hand Could Remove the Petals', suggests, the painful experience of love that had characterised his adolescence:

> I speak your name
> In this dark night,
> And your name sounds to me
> More distant than ever.
> More distant than any star,
> More sorrowful than the gentle rain.

The publication of the volume was financed by Lorca's father who, though still very dubious about his son's literary aspirations, recognised his commitment to creative writing. With the exception of a few favourable reviews, the volume did not sell well, but despite his family's and his own disappointment, Lorca pressed on with a new poetic venture, a series of poems he called *suites*. During the summer of 1921, he completed some seventy-five short poems, which he arranged in thematically linked groups or *suites* reminiscent of the musical suites of the seventeenth and eighteenth centuries. The themes were essentially those of *Book of Poems*, but the form is more original and the expression more concise. His plan to publish the poems did not, however, come to fruition. Although individual poems appeared in print, the volume was not published until 1983.

Lorca's endless creativity is well illustrated by the fact that, while he was writing the suites, he was also involved in other projects. He commenced work on a puppet play, *The Tragicomedy of Don Cristóbal and Señorita Rosita*, which he would complete in the following year. But his energies were largely spent in the autumn of 1921 on the composition of a series of poems inspired by *cante jondo* or flamenco 'deep song' and on the arrangements for a great festival of 'deep song' to be celebrated in Granada in the

summer of 1922. Manuel de Falla had by this time moved into a house high above the city, close to the present-day Alhambra Palace Hotel, and he and Lorca, given their mutual interest in Spanish folk music, played an important part in the organisation of the festival, which was intended to revive interest in a flamenco song tradition that was in rapid decline. Consequently, Lorca delivered a lecture entitled 'Cante jondo. Primitive Andalusian Song' at the Granada Arts Club in February 1922 and Falla published a piece on the same topic just before the festival commenced. At the same time, Lorca's flamenco-inspired *Poem of Deep Song*, consisting of some fifty-five poems, sought to evoke the settings and the sources from which the anguish of 'deep song' arises.[11] The point has been made earlier that, as a consequence of his own sense of marginalisation, Lorca was able to identify with the marginalised people of Granada, not least the gypsies, who in their songs focused on such issues as persecution, imprisonment, lost love, betrayal, and death. In his own flamenco-inspired poems, therefore, he found a vehicle matching his own mood and a form that allowed him to express his love of one type of traditional Spanish poetry. The poem entitled 'Road' is a good example:

> A hundred horsemen in mourning.
> Where are they going,
> Through the low-lying sky
> Of the orange-grove?
> They will reach
> Neither Córdoba nor Seville.
> Nor Granada who sighs
> For the sea.
> Those dreaming horses
> Will bear them,
> To the labyrinth of crosses
> Where the song trembles.
> Pierced by seven 'ays',
> Where do they go,
> The hundred Andalusian horsemen
> Of the orange-grove?

We can well imagine the anguish of this poem being expressed by a flamenco singer. It was a poetic style that would strongly colour later plays such as *Blood Wedding* and *Yerma*.

As for the Festival of Deep Song, it duly took place on 13 and 14 June in the the Plaza de los Aljibes (Square of the Wells) in the Alhambra. The organisers had, though, made the mistake of allowing only amateur singers to take part, which meant that the best flamenco singers of the day were either excluded or that they formed the panel of judges. At the end of the two-day event, the two principal prize-winners were Diego Bermúdez Cañete, an old flamenco singer who had walked some eighty miles from his hometown in order to compete, who sang well on the first day but suffered from the effects of drink on the second, and the eleven-year-old Manolo Ortega, who, as Manolo Caracol, would subsequently become one of the truly great flamenco singers. In some respects the festival was a success, for it had at least succeeded in drawing attention to flamenco song. Falla, though, was upset by a disagreement over what should be done with the profits. As for Lorca, the festival confirmed his affinity with Andalusia.

Lorca's friendship with Falla led the two men to consider taking the now completed *The Tragicomedy of Don Cristóbal and Señorita Rosita*, for which Falla would write the music, on a visit to the Alpujarras, the mountainous region near Granada. Nothing came of their plan, but, as compensation, they decided to organise a puppet show for children and adults on 6 January 1923 in the Lorca family's large flat in Granada. The show consisted of Cervantes's short play, *The Two Talkers*; a short puppet play of Lorca's, *The Girl who Waters the Pot of Basil and the Inquisitive Prince*; and the thirteenth-century *Mystery Play of the Three Wise Men*. A small orchestra under the direction of Falla provided the accompaniment, which included music by Stravinsky, Albéniz, Debussy, and Ravel. To the delight of both Lorca and Falla, who was at the time working on his own *Master Peter's Puppet Show*, based on an episode in Cervantes's *Don Quixote*, the evening was a great success. The show received three favourable newspaper reviews, two in the influential Madrid daily *La Voz*. After the failure of *The Butterfly's Evil Spell*, Lorca had found in the puppet tradition a theatrical form that worked and which would subsequently become an important strand in his work. His use of that tradition can be explained in several ways. It clearly owes something to the fact that, as a child, he had performed puppet shows at home, as well as to the popularity of the puppet tradition in Andalusia.

But as well as this, the use of puppets allowed the dramatist to escape from star actors who demanded that he write specific parts for them, and also to a certain extent from the control of theatre impresarios who, for commercial reasons, would only stage certain kinds of play. And finally, the lack of inhibition in the puppet show in relation to both behaviour – the action was often violent – and language – it was frequently crude – was in strict contrast to the refinement of the drawing-room play that Lorca so detested. They were freedoms that he thoroughly enjoyed.

Despite his relative literary successes, Lorca's parents were insistent that he complete his university course. Indeed, his academic performance in Madrid had been so poor that, after the summer vacation of 1921, they obliged him to enrol at the University of Granada, where he abandoned a degree in literature for a more practical course in law. This he managed to complete in January 1923, at which point his father allowed him to return to Madrid after an absence of a year and a half. At the age of twenty-five, he was able to dedicate himself fully to a literary life.

Lorca's return to Madrid and the Residencia occurred some four months after the arrival there, in September 1922, of Salvador Dalí, who had been accepted as a student at the city's distinguished San Fernando Royal Academy of Fine Arts. During the previous year, however, his life had been rocked by several unexpected events. The death of his mother from cancer on 6 February 1921 at the age of forty-seven had been a savage blow, and this had been followed in July by the sudden death of Pepito Pichot, who had become a virtual second father to the adolescent Dalí. Although his mother's death caused him enormous grief, it also made him all the more determined to focus on his public image and the pursuit of fame. When he arrived at the Residencia, therefore, he cut a quite extraordinary figure. He had grown his hair almost down to his shoulders; his sideburns were extremely long; he wore a wide-brimmed hat, a bow tie, a jacket that reached his knees, a long cape, and leather leggings. Little wonder that he created an impression on his fellow students. But if his appearance had that effect, he was still overwhelmed by that sense of shame and timidity that had marked his earlier years, and in his first few weeks at the Residencia kept himself to himself, barely speaking to anyone.

Before very long, though, Dalí began to shed his reserve and was initiated into the life both of the Residencia and the city,

not least by Buñuel. During Dalí's first term at the Residencia, Buñuel introduced him to the literary discussions that were held at such places as the Café Pombo, presided over, as we have seen, by Ramón Gómez de la Serna, and he undoubtedly took him on nocturnal excursions through Madrid, for Buñuel knew the city intimately. But before he returned to Figueras for the Christmas vacation, Dalí must have heard from his fellow students stories about the exploits and personality of a certain Federico García Lorca who was soon to return to Madrid. By this stage, as we have seen, Lorca was not only a leading light at the Residencia but he was also the author of poems and plays, an outstanding pianist, and a brilliant conversationalist. Given Dalí's desire to shine, on the one hand, and his deeply ingrained timidity on the other, the imminent arrival of someone who was already a star and who was likely to eclipse his own must have been a source of considerable apprehension.

When Lorca finally returned to the Residencia, Dalí was completely dazzled by him, as he later admitted:

The personality of Federico García Lorca produced an immense impression on me. The poetic phenomenon in its entirety and 'in the raw' presented itself before me suddenly in flesh and bone, confused, blood-red, viscous and sublime, quivering with a thousand fires of darkness and of subterranean biology, like all matter endowed with the originality of its own form.[12]

They soon became friends, but Lorca's prominence in the group at the Residencia, and indeed among people outside it, created such a sense of envy and inferiority in Dalí that he withdrew into himself:

I avoided Lorca and the group, which grew to be his group more and more. This was the culminating moment of his irresistible personal influence – and the only moment in my life when I thought I glimpsed the torture that envy can be. Sometimes we would be walking, the whole group of us, along El Paseo de la Castellana on our way to the café where we held our usual literary meetings, and where I knew Lorca would shine like a mad and fiery diamond. Suddenly I would set off at a run, and no one would see me for three days.[13]

Given Dalí's love of exaggeration, it is difficult to know whether or not he actually resorted to such extremes, but there can be no doubt, as so many other people have stated, that Lorca possessed a personality that was truly magnetic. It was to be summed up later by Jorge Guillén, who knew him well: 'The eminence [of Federico] was not solely due to his brilliance in conversation, in poetry, music and painting. He possessed something inside him, something fundamental from which it all came. The most important thing in Federico was . . . to be Federico.'[14]

Despite all this, Lorca, Buñuel, and Dalí threw themselves into the social and artistic life of the capital. They frequented the elegant Rector's Club at the prestigious Palace Hotel where the Jackson Brothers, a black jazz-band from New York, played regularly. All three became enthusiastic fans and Dalí also took lessons in the Charleston and the tango, becoming something of an expert in both. They spent a good deal of their time in the Madrid cafés, they regularly attended the theatres, in particular the performances of the light operas, *zarzuelas*. There was also, of course, every opportunity to see the latest films. As far as academic work was concerned, Lorca had already completed his degree and was able to focus on his writing. Dalí, despite the social activities mentioned above, worked hard at his studies and his painting, and Buñuel, as was his wont, did as little as possible.

Buñuel was, however, along with Lorca and several others, one of the founders of the 'Noble Order of Toledo', whose aim was to celebrate and promote the city of Toledo, some fifty miles to the south of Madrid and at one time the capital of Spain. Within the Noble Order its members were divided into various categories or ranks. Buñuel was the Grand Master, while the others ranged from Knights to Squires and, at the very bottom, Guests of the Guests of the Squires. In order to be a Knight, one had to have a deep love of Toledo and be prepared to wander its streets in a drunken state for one whole night. Anyone who wanted to go to bed early inevitably belonged to a lower category. The activities of the Order were largely of the undergraduate kind. The members stayed in Toledo at an inn called 'The Inn of Blood', paid a regular visit to the tomb of Cardinal Tavera, which would later figure in Buñuel's *Tristana*, and some indulged in dressing up, Buñuel frequently disguising himself as a priest. They also climbed to the bell tower of the famous cathedral, which again appears in *Tristana*, or

wrapped themselves in bed-sheets as they wandered through the narrow streets. On one occasion, one of the female members of the Order was grabbed by two passing cadets, who regarded her as rather sexy. Buñuel, availing himself of his boxer's strength and experience, rushed to her rescue and knocked them down with some well-aimed punches.[15]

Although Dalí's first year at the Academy of Fine Arts was a great success, his second proved to be a complete disaster, but not for academic or artistic reasons. It began with the election of a new Professor of Open-Air Painting, in which the students supported the claims of a well-known artist, Daniel Vázquez Díaz. The appointing committee clearly had different ideas, failed to agree, and the position in question therefore remained vacant. Uproar ensued in the hall of the Academy, the police were summoned, and on the following day Dalí was accused of being a leading light in the troubles of the previous evening. Asked to name the other ringleaders, he refused, and on 22 October 1923 was suspended from the Academy for one year and denied permission to sit the end-of-year examinations.

Back home in Figueras for most of 1924, he was soon in trouble with the authorities for a very different reason. On 15 May King Alfonso XIII paid an unexpected visit to the town, and the authorities, panic-stricken by the possibility of opposition to someone who had supported the military coup headed by Primo de Rivera a year earlier, drew up a list of potential troublemakers. Dalí found himself under arrest and placed in the town's jail on 21 May and then moved to the prison in Girona just over a week later. He was finally released without charge on 11 June. Quite why such action should have been taken against him remains unclear, but it seems quite possible that the Right really wished to punish Dalí's father – a known anarchist supporter and an enemy of the monarchy – through his son. Whatever the cause, Dalí, himself an advocate of social revolution, took great pleasure in becoming a victim of the dictatorship. It both satisfied his political beliefs and guaranteed that, when he returned to the Residencia, he too would be a celebrity, different in that respect from Lorca, but still a celebrity.

In the meantime, Lorca was hard at work on various projects. For a large part of 1923 he was writing the libretto for a comic

opera, *Lola, the Actress*, for which Manuel de Falla had agreed to write the music. It appears that he never did, in spite of many promises to complete the score. Similarly, plans to stage a new puppet play with music by Falla, and to perform *The Tragicomedy of Don Cristóbal and Señorita Rosita* at the Teatro Eslava, came to nothing. But such disappointments were never able to halt the flow of Lorca's vibrant creative imagination, and he now became freshly interested in the story of Mariana Pineda, a real-life figure in the history of Granada who, in 1831 and at the age of twenty-seven, had been executed for her support of liberal opposition to the harsh and tyrannical rule of King Ferdinand VII. Mariana's story had been a popular one in Granada for many years. Lorca had known it from childhood, but in 1923 he was motivated to write a play on the subject for two reasons in particular. First, he was able to embody in the tragic figure of Mariana his favourite themes of passion, frustration, passing time, and death. One wonders if, in Mariana's relationship with Pedro de Sotomayor, the lover who abandons her, Lorca dramatised in some way his own feelings for Emilia Llanos Medina, with whom he was still friendly, or if indeed he had begun to experience the attraction to Dalí that was soon to become very evident. Secondly, though, the story of a young liberal crushed by a dictatorial ruler bears an uncanny similarity to the dictatorship of Primo de Rivera who, with the compliance of King Alfonso XIII, had seized power in September 1923. Work on *Mariana Pineda* had commenced much earlier in the year, but since Lorca did not complete it until after the military coup, it seems quite possible that he intended his play to be seen as a reflection of current political events.[16]

By the summer of 1924, he was at work on another major project: the collection of poems entitled *Gypsy Ballads* that would finally be published in 1928. As we have seen, Lorca's fascination with Andalusian gypsy culture had already revealed itself both in *Poem of Deep Song* and in his involvement in the Granada Festival of Deep Song. As far as the new project was concerned, he had certainly written, by the end of the summer of 1924, four of the eighteen poems that would form the collection: 'Ballad of the Moon, Moon', 'Ballad of Black Anguish', 'The Gypsy Nun', and 'Sleepwalking Ballad'. By this time, however, the Andalusian gypsy had come to mean much more to him than merely the crea-tor of flamenco. Rather, as Lorca would state some years later, he

saw the figure of the gypsy as symbolic of the tragic history of Andalusia, and although the characters of the poems in the collection are in most cases gypsies, the true protagonists are, in fact, Anguish and Granada itself. In this context, 'Ballad of the Moon, Moon' and 'The Gypsy Nun' can be said to evoke Granada's Albaicín; 'Sleepwalking Ballad' the Alhambra Wood and the Generalife gardens; and 'Ballad of Black Anguish' the Sacromonte area where the gypsies lived. In her deep but unexplained feeling of anguish, Soledad Montoya, the female protagonist of 'Ballad of Black Anguish', suggests the doom-laden mood of the poems in general, and points yet again to the way in which Lorca identified with the suffering of others.[17] His creative work in these years reveals, then, how his personal preoccupations and his identification with Granada and Andalusia were already being interwoven in a way that anticipates his later writing. And a comparison may be made with Dalí who, as we shall see, often placed the images of his own concerns in the landscape of Cadaqués and the surrounding area. Buñuel, on the other hand, would tend to project personal issues into less specific settings, or into locations where he happened to be living at the time, be it Spain, Mexico, or France. His films are certainly less tied to the region in which he grew up.

Not satisfied with working only on his poems, Lorca also started writing his 'violent farce', *The Shoemaker's Wonderful Wife*, which would become one of his most popular plays. Lorca was once more inspired by the Andalusian puppet tradition, but the characters, often shouting, gesticulating and stamping in the manner of puppets, would be played by actors. The plot of the play is the traditional one of the elderly husband married to a young, attractive, and lively wife, music and passages of verse belong to folk tradition, and the language is often the traditional language of rural Andalusia. But into this framework Lorca also introduced many personal elements. The young wife, frustrated in her marriage and dreaming of true passion, is another example of a familiar theme. Her childlessness and its attendant feeling of loss may well point to Lorca's awareness that he too, given his sexual inclination, would never have a child of his own, while the Boy of the play also evokes the innocence of childhood now disappeared. As well as this, the malicious gossip of the villagers concerning the childless couple and the wife's attraction to other men reminds us of the way in which Lorca and the members of

the Rinconcillo had been the object of the Granada bourgeoisie's attention some years earlier. These are topics that in future years would feature strongly in such plays as *Yerma* and *The House of Bernarda Alba*.[18]

In May 1923, Buñuel's father died of pneumonia at the age of sixty-eight. During the night spent at his father's bedside, Buñuel thought that, like Hamlet, he saw his father's ghost looking at him angrily, arms outstretched. Otherwise, life went on at the Residencia much as it had done previously, the three friends inseparable. Lorca and Dalí spent hours in Buñuel's room listening to the jazz records he had recently bought, and in Lorca's room Buñuel, Dalí, and others drank tea, talked, smoked, produced nonsense poetry and played games, including competitions to see who could fart the most. In the city they continued to engage in the social activities mentioned previously, dropping in at cafés and clubs, going to the cinema, visiting art galleries, and often becoming involved in literary debates.

As for creative work, Buñuel appears to have written little after the pieces published in 1922 and 1923, but his love of theatre and acting revealed itself once more in the Residencia's annual production of José Zorrilla's nineteenth-century Don Juan play, *Don Juan Tenorio*, in which he specialised in playing Don Juan; he and Lorca often alternated as director and designer, and Dalí was also involved as an actor. Their love of this particular play – it was the only work Buñuel ever directed in the theatre, in Mexico around 1960 – clearly had much to do with the fact that Don Juan is a rebellious character who defies Catholic orthodoxy, something with which Buñuel, Lorca, and Dalí could all identify. Nevertheless, the productions of the play were often parodies designed for their own amusement, as well as that of the other students. In the role of Don Juan, to which his irreverent and rebellious character particularly suited him, Buñuel would appear in football boots and produce a typewriter on which to write amorous messages to his many female admirers.

In contrast to their more light-hearted behaviour at the Residencia, all three were linked by their fascination with death and putrefaction. As a child, Buñuel had seen a dead donkey pecked at by vultures, the corpse split open and stinking, and he had witnessed too a post-mortem on a shepherd in which a saw

ground through the skull and ribs.[19] Similarly, rotting donkeys appear in many of Dalí's paintings, though it is unclear whether he had come across one in real life. As for Lorca, he had, in childhood, observed the laying out of the corpse of Salvador Cobos Rueda, who worked for his father, and he never forgot the incident. His particular fascination with death is, indeed, illustrated by his statement in a lecture entitled 'Play and Theory of the *Duende*', where he stated 'A dead man in Spain is more alive . . . than in any other place in the world.'[20] Furthermore, at the Residencia and elsewhere Lorca would enact his own death in an extraordinary performance that Dalí later described:

I remember his death-like, terrible expression as, stretched on his bed, he parodied the different stages of his own slow decomposition. In this game the process of putrefaction lasted for five days . . . Then, when he was sure that he had provoked in us a sufficient unease, he would jump up and break out into wild laughter . . .[21]

It was, on the surface, a game, but there is throughout Lorca's life and work a preoccupation with death that in the end became strangely self-fulfilling.

This obsession with death and putrefaction was also related to a painting by the seventeenth-century Spanish artist Valdés Leal, entitled *Finis Gloriae Mundi*, which depicts the rotting corpse of a bishop in all his worldly finery, and which was alluded to at the Residencia as 'The Rotting Bishop'. It was an image of decay and decomposition that clearly intrigued Lorca, Buñuel, and Dalí and which often appears in different forms in their work. In *L'Age d'or*, on which, as we shall see, Buñuel and Dalí initially worked together, a group of bishops appear in the rocks in full regalia and are then transformed into skeletons; in Buñuel's much later *The Milky Way* (1969) there is also a decomposing bishop. In Buñuel and Dalí's *Un chien andalou*, rotting donkeys are draped over a grand piano, ants crawl from a hole in a hand trapped in a door, as if it were dead flesh, a young woman prods an amputated hand lying in the road, and, at the end of the film, two lovers are buried to the waist in sand, scorched by the sun and devoured by insects. In the same film there is also a clear reminder of Lorca's performance of his own death when the film's male protagonist is seen to be

stretched out, death-like, on his bed. In Lorca's own work, death is always a major theme. In the last act of *Blood Wedding*, for example, Death becomes a character who plans the final moments of the Bridegroom and his rival Leonardo, whose corpses are then borne on the shoulders of young men to be wrapped in the sheets that await them at home. In the earlier *When Five Years Pass*, a dead child and a dead cat express their terror as they wait to be buried in a black hole. As for Dalí, as we shall see, the severed head of Lorca appears in various paintings of the second half of the 1920s, together with other putrefying items. In this context, it is rather ironic that Dalí should have become in old age a grotesque figure hovering on the edge of death, staring wildly, an oxygen tube in his nose. Buñuel, given the horror of bodily decomposition, chose to be cremated.

Having completed his degree in Madrid, Buñuel left for Paris in January 1925, leaving Lorca and Dalí at the Residencia, to which the latter had returned in September 1924. Not long after Buñuel's departure, two exhibitions of Dalí's paintings marked his growing success as a painter. In the first of these, which opened on 27 May in the Retiro Park in Madrid, Dalí exhibited eleven works, seven in his Cubist style and four in his more 'realistic' manner. One of the Cubist paintings is of Lorca giving a reading of his work at the Residencia, while *Portrait of Luis Buñuel* belongs to the more 'realistic' group. By the autumn, Dalí had decided to take time off from the Academy of Fine Arts and was focusing his attention on another exhibition, which opened on 14 November at the Dalmau Gallery in Barcelona and which displayed twenty-two of his paintings and drawings, including eight portraits of his sister, Ana María. If the Madrid exhibition had singled out Dalí as a fine painter, the Barcelona show was an even greater success, though it was quite clear from both that his work was not yet influenced by Surrealism.

Earlier in 1925 Dalí had invited Lorca to spend Holy Week with his family in Cadaqués. By this time, Lorca was becoming more and more attracted to Dalí and, after a week in Cadaqués, they both went off to Barcelona before returning to Madrid. By the summer, when Dalí had returned to Figueras and Cadaqués and Lorca to Granada, the latter had begun work on his *Ode to Salvador Dalí*, which was published the following year, and which

bears witness to Lorca's admiration for his Catalan friend. On the one hand, the poem expresses his strong feelings for Dalí:

> Above all, I sing of a common way of thinking
> Which joins us in the dark and golden hours.
> Art is not the light which blinds our eyes.
> First come love, friendship or fencing . . .

On the other, Lorca was also attracted by Dalí's concern in his painting with an objectivity and precision influenced by Cubism:

> A desire for forms and limits possesses us.
> The man who measures with the yellow ruler approaches.

The departure of Buñuel had clearly drawn the two men much closer, though the situation was one that would change substantially in the course of the next few years.

Lorca's emotional preoccupations were reflected too in various other projects on which he worked during that same summer. *The Dialogue of the Philadelphia Bicycle*, which would soon be renamed *Buster Keaton's Spin*, is a short play, undoubtedly influenced by cinema, in which Buster, having killed his four children, rides his bicycle through a depressing urban landscape. His pursuit of butterflies points to his search for happiness, while the prostitute who propositions him represents the harsh reality he cannot escape. Similarly, *The Love of Don Perlimplín*, on which he was also working, is, like *The Shoemaker's Wonderful Wife*, the traditional story of an older man married to a young and passionate wife, but, more than that, a study in fear of women and sexual frustration. Somewhat like Lorca, Perlimplín is someone whose life has been strongly influenced by his mother and who, through his inexperience of other women, is both afraid of them and unable to respond to them. His failure to consummate his marriage to the young and beautiful Belisa leads him to disguise himself as a young lover for whom she declares her love. But, having succeeded in obtaining from her this affirmation, Perlimplín kills himself, realising that he can only make her love him by pretending to be what he is not. When Lorca showed the play to Dalí, who was delighted by it, the painter must surely have recognised that the sexual problems experienced by Perlimplín were as much his own as they were the playwright's.[22]

In Paris, Buñuel missed his two close friends, complaining in a letter to Lorca that he had forgotten him and suggesting that he come to visit him:

It's such a pity that you can't come and at least have a change of air. Of everyone I know, you would benefit most. At least I could see you all the time and we could renew our friendship. I always remember the intense moments we shared for several years.[23]

Buñuel, though, was far from idle. In the cafés he mixed with the Spanish painters and writers who were already living there, including Picasso, whom he initially considered friendly but also selfish and self-centred, though later on they saw each other quite frequently. Buñuel wrote poems, attended jazz sessions, and, of course, had the opportunity of seeing many films, which seem to have convinced him that his career should be in cinema. Indeed, in late 1925 he met the renowned film director, Jean Epstein, who encouraged him to enrol in his newly founded film school and shortly afterwards gave him a job as assistant director – in reality, glorified messenger boy, stunt man, and bit-part actor – on the film, *Mauprat*. A few years later, Buñuel would also be involved with Epstein in the shooting of *The Fall of the House of Usher*, based on the Edgar Allan Poe story, but he disliked this director's emphasis both on melodramatic subjects and the creation of beautiful lyrical effects:

The fact is that I learned very little from Epstein . . . When I watched Epstein direct, he frequently made me think – with the temerity of every newcomer – that this was not the way to do it, that the placing of the camera, lights or cast ought to be in such or such another way. Epstein was patient with me. Above all, I learned by mentally elaborating the picture being made, seeing it in a different fashion.[24]

In contrast, he was entranced by the films of Fritz Lang, in particular by *Destiny* (1921) and the two-part *The Nibelung* (1923). Lang's emphasis on violence and criminal types, on revenge and the abuse of power was something that appealed to Buñuel, and he responded too to the stark simplicity of the German director's photography. In just a few years' time Buñuel's first film, one of

the most disconcerting in cinema history, would explode on the cinema screen.

## NOTES

1   Buñuel, *My Last Breath*; chapter 3 consists of an account of his time at the Residencia.
2   Ibid., pp. 67–9.
3   Ibid., pp. 65–6.
4   Ibid., p. 62.
5   Ibid., p. 158.
6   Ibid., p. 62.
7   See Gibson, *Federico García Lorca: A Life*, p. 95.
8   See Agustín Sánchez Vidal (ed.), *Luis Buñuel: obra literaria*, Zaragoza: Ediciones de Heraldo de Aragón, 1982, p. 18.
9   Ibid., pp. 85–92, 95–8.
10  On *The Butterfly's Evil Spell*, see Edwards, *Lorca: Living in the Theatre*, pp. 15–17.
11  For an English translation of Lorca's lecture, see Federico García Lorca, *Deep Song and Other Prose*, trans. and ed. Christopher Maurer, London: Marion Boyars, 1980, pp. 23–41.
12  Dalí, *The Secret Life of Salvador Dalí*, p. 176.
13  Ibid., p. 203.
14  See Jorge Guillén, 'Prologue' to *Obras completas*, ed. Arturo del Hoyo, pp. xvii–xviii.
15  Buñuel, *My Last Breath*, pp. 71–3.
16  On *Mariana Pineda*, see Edwards, *Lorca: Living in the Theatre*, pp.17–19.
17  See *Federico García Lorca, Gypsy Ballads*, trans. Robert Havard, Warminster: Aris & Phillips, 1990.
18  On *The Shoemaker's Wonderful Wife*, see Edwards, *Lorca: Living in the Theatre*, pp. 21–4.
19  Buñuel, *My Last Breath*, p. 11.
20  García Lorca, *Deep Song and Other Prose*, p. 47.
21  See Gibson, *Federico García Lorca: A Life*, p. 146.
22  On *The Love of Don Perlimplín*, see Edwards, *Lorca: Living in the Theatre*, pp. 24–6.
23  The letter can be found in the Archive of the Fundación Federico García Lorca in Madrid.
24  See Aranda, *Luis Buñuel: A Critical Biography*, pp. 34–5.

# 4

# CHANGING PARTNERS

❧

S INCE HIS ARRIVAL in Paris, Buñuel had made every effort to persuade Dalí to visit him, and in April 1926 Dalí did so, even if, accompanied by his sister and his father's new wife, Catalina, the visit lasted only four or five days. Buñuel met them at the station and introduced Dalí to the colony of Spanish painters who frequented the well-known Montparnasse café La Rotonde. They included Hernando Viñes, Ismael González de la Serna, and Francisco Bores. Through Lorca's close friend, Manuel Ángeles Ortiz, Dalí met Picasso, whose work he greatly admired but who spent most of the time ostentatiously showing the visitor his own paintings. Dalí also paid a visit to the Louvre, admiring above all the paintings of Raphael, Leonardo da Vinci, and Jean Ingres. For all its brevity, the Paris visit undoubtedly matched Dalí's expectations and fired his ambitions to make his name there, though his plans would not in fact materialise for several years.

In the following month Dalí returned to the Royal Academy of Fine Arts after his extended absence and in readiness for the end-of-year examinations. By this time, Lorca was more attracted to him than ever and the relationship between them became much more intense. Many years later, Dalí claimed that Lorca attempted to sodomise him:

He attempted on two occasions to sodomise me. That annoyed me because I was not a pederast and had no intention of submitting.

What's more, it hurts. So nothing occurred. Of course, I was flattered in relation to my personal prestige. I inwardly told myself that he was a great poet and that I owed him a bit of the Divine Dalí's arsehole . . .[1]

He suggested too that, because he resisted Lorca's advances, the poet satisfied his sexual longing with a substitute lover, a passionate and boyish-looking girl, whom he later revealed to be Margarita Manso, a student at the Academy of Fine Arts. It was, according to Dalí, Lorca's first sexual experience with a woman.[2] Because Lorca's side of the story has never been told, there is nothing to substantiate Dalí's claim. But if it were in any way true, it points to the possibility of Lorca being at least capable of a sexual relationship with a woman. Indeed, we should not forget in this context his contact with Dalí's sister, Ana María, who was seventeen years of age when Lorca first met her in 1925. Although there is no suggestion of a physical relationship between them, Lorca certainly found her extremely attractive and, after their encounter in Cadaqués, frequently wrote to her. As far as Dalí's boast of rejecting Lorca is concerned, it clearly boosted his ego to have become the object of the famous writer's attentions. And to be able to claim that he resisted his advances would seem an even greater triumph. But there was more to it than this, as we shall soon see.

On 14 June Dalí appeared before the board of the Academy in order to undergo the end-of-year oral examination on the various subjects studied during the year. Asked to pick out one or more numbered balls, each representing a theme, and to choose the theme on which he wished to be examined, he pointedly refused, just as the aggressive Buñuel might have done, informing the board that all teachers at the Academy were incompetent to judge him. A week or so later they arrived at a unanimous decision to expel him. It was a decision that undoubtedly upset Dalí's father, but Dalí was himself delighted to have done with an institution that he despised for its traditional ways. After his visit to Paris, his heart had become set on pursuing his career there.

In late April or early May 1927, Lorca travelled to Barcelona, where *Mariana Pineda* was to open in June, and from there went to Figueras in order to spend a few days with Dalí. It was the first time they had met since Dalí's expulsion from the Academy, and

3. Salvador Dalí in Cadaqués, 1927

both men were excited by the forthcoming production, for which Dalí was to design the costumes and sets. After much persuasion, the famous actress Margarita Xirgu had decided to stage Lorca's play, and it finally opened on 24 June at the Teatro Goya to considerable acclaim. The following October *Mariana Pineda* also opened her season in Madrid and was again much praised by the critics. Lorca had achieved his first real success in the theatre at the age of twenty-nine.

The Lorca–Dalí relationship in 1926 and 1927 was, to say the least, a complicated one. While Dalí's claim to have rejected Lorca's sexual advances may or may not be true, it is certainly the case that he was at this time increasingly fascinated by the martyred figure of Saint Sebastian. As well as being the patron saint of Cadaqués, Saint Sebastian was regarded as the unofficial protector of homosexuals. In this respect, he was for Lorca – who in 1926 was preparing a lecture on 'The Myth of Saint Sebastian' – an attractive young man whose body, pierced by arrows, had a strong homoerotic resonance. For Dalí, in contrast, that association was seemingly less important than the impassivity and tranquility evident in Saint Sebastian's expression, which in turn suggested the objectivity and the strict avoidance of sentimentality that the painter now sought in his life and work. In 1927 he published in the journal *L'Amic de les Arts* a prose piece entitled 'Saint Sebastian', in which his thoughts on the matter were clearly stated.[3] Given Lorca's passionate feelings for the painter, Dalí's stance, also expressed in his letters, must have been a considerable disappointment.

Even so, many of Dalí's preparatory sketches and paintings at this time refer to his relationship with Lorca, posing the question of the true extent to which his demand for objectivity affected his private life as opposed to his art. In previous years, his sister Ana María had been the subject of many of his paintings, but she was now being replaced by Lorca. *Still Life (Invitation to Sleep)*, completed in 1926, contains for the first time Lorca's head in the form of a sculpture lying on its side, and in the same year Dalí produced two more paintings along the same lines. In *Still Life by Moonlight* the decapitated and joined heads of Lorca and Dalí are placed on a moonlit table alongside a guitar, a painter's palette, some fish and a fishing net. The same objects also appear in *Still Life by Mauve Moonlight. Composition with Three Figures (Neo-*

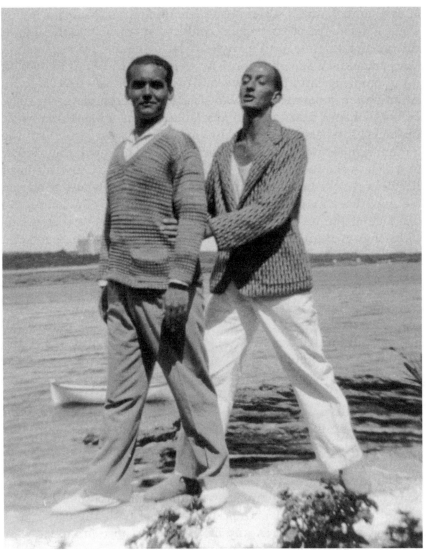

4. Lorca and Salvador Dalí in Cadaqués, 1927

*Cubist Academy*), first exhibited in 1927, has a version of Saint Sebastian as its central figure, while the plaster-cast head fuses the faces of Lorca and Dalí. In the foreground are two female figures, one of whom, clothed in a transparent shift, is extremely erotic and looks in the direction of the saint. The combination

of the saint, Lorca, Dalí, and the female figures creates a highly suggestive image of the sexual conflicts at work in Dalí's life at this particular time, and many of these elements are repeated in the preliminary sketches for – as well as in the final version of – the painting initially known as *Wood of Gadgets* and later re-titled *Honey is Sweeter than Blood*, which was completed in 1927. In the painting, now lost and available only as a black-and-white photograph, a beach is covered by various kinds of debris. Near the bottom right-hand corner is the severed head of Lorca, the shadow of which is the head of Dalí, both once again fused. Lorca's head lies between the headless form of a naked woman whose head and feet have been amputated, and the rotting carcass of a donkey. To one side of the naked female is a mummified corpse that seems to be that of Buñuel, who, although in Paris, was corresponding with Dalí and attempting to separate him from Lorca. On the left-hand side of the painting, stretching along the beach into the distance, is a forest of vertical, pin-like gadgets. While the various elements point in particular to the Lorca–Dalí relationship, the title may also suggest Dalí's life-long preference for masturbation over sexual intercourse, for 'honey' is probably an allusion to the pleasure of ejaculation, while 'blood' refers to the pain of sexual intercourse, particularly anal penetration, which, as Dalí would later say, 'hurts'.

Masturbation is, indeed, the central subject of *Gadget and Hand (Apparatus and Hand)*, also completed in 1927. In this painting, a tall inverted triangular form is topped by a trembling red hand. To the bottom right of the triangle is a young woman in a bathing costume, to the left, suspended in mid-air, the half-body of a female with breasts and abdomen exposed. The red, trembling hand is a clear representation of both the excitement inherent in masturbation and of that deep sense of shame that had been inculcated at school in relation to any sexual activity. In another painting of 1927–8, initially called *The Birth of Venus*, then *Sterile Efforts*, and finally *Little Ashes*, the heads of Lorca and Dalí appear once more, surrounded by a variety of female forms that emphasise breasts and bottom. Undoubtedly, the painting suggests male impotence in relation to women. Lorca's eyes are, significantly, closed to the female forms around him.

In all these ways, then, Dalí's so-called 'Lorca' paintings portray both the relationship between the two men and the sexual problems

affecting them. But, in addition, the bright light by which the sculptured forms within the paintings are illuminated suggests that objectivity and aversion to sentimentality that, as we have seen, were now central to the artist's thinking.

In the course of 1927 Dalí also published two drawing whose theme is his relationship with Lorca. *The Beach*, accompanied by poems by Lorca, appeared in the literary magazine, *Verso y prosa*, and displays very clearly the severed head of Lorca and the silhouette of Dalí's, together with a severed arm and several small triangular gadgets with a hole, similar to the large triangular form of *Gadget and Hand*. *The Poet on the Beach at Ampurias*, published in *L'Amic de les Arts*, has Lorca standing, at his feet his severed head and an amputated arm, and once more the small gadgets of the other drawing. The prevalence of severed hands and, indeed, heads in Dalí's work both now and later relates in one sense to the dire warnings of punishment for sexual indulgence issued by the teachers at religious schools and bring to mind the Muslim retribution for various criminal acts.[4] The image is one that suggests psychological as well as physical disintegration, pointing to the anguish and guilt involved in the practice of frequent masturbation and the failure to become involved in 'normal' physical relationships with women.

Lorca's relationship with Dalí was reflected too in some of the twenty-four drawings that Lorca himself exhibited at the Dalmau Gallery in Barcelona between 25 June and 2 July. In *The Kiss* Dalí's head is superimposed on Lorca's, their lips meeting in a kiss. If this can be seen as fanciful on Lorca's part, the fact that their fused heads appear so often in Dalí's paintings surely suggests that Dalí's denial of a sexual relationship between them may not be entirely true. In another drawing completed in the summer of 1927, which may have been part of the same exhibition, Lorca portrayed Dalí at the foot of a tower, holding an artist's palette. The finger appearing through the hole has clear phallic implications. It seems undeniable that at this particular time of their lives their attraction to each other was as intense as the bond that joined Castor and Pollux, twin sons of Zeus, who were considered by Lorca and Dalí to be twin souls.

Away from both of them, Buñuel was offered in 1926 the opportunity to be involved in a puppet production of Manuel de

Falla's *Master Peter's Puppet Show*, to take place in Amsterdam a little later in the year. He accepted eagerly, given that the music was to be played by the Concertgebouw Orchestra under the baton of the world-famous conductor, Willem Mengelberg, and the voices for the puppets would be sung off stage by singers from the Opéra Comique. In the event, the production, for which Buñuel acted as 'scenic director', was a considerable success, playing to full houses, though he has admitted that on the first of the two nights he forgot about the lighting, leaving the stage in semi-darkness.[5]

Otherwise, Buñuel continued to write. The year 1927 saw the composition of several typical Buñuelian pieces. 'Palace of Ice', published two years later in *Helix*, is particularly striking, looking forward in its startling and unusual images to the surrealist *Un chien andalou*:

> Close to the window is a man who has been hanged and who swings over the abyss, surrounded by eternity and howled at by space. It is I. It is my skeleton, of which nothing remains but the eyes. At one moment they smile, at another they cross, at another **THEY GO TO EAT A CRUMB OF BREAD IN THE INTERIOR OF THE BRAIN.** The window opens and a woman appears, polishing her nails. When she believes they are properly filed, she plucks out my eyes and hurls them into the street.[6]

*Hamlet*, a short play written in 1927 and performed by a group of friends in the Café Select, owes something to the surrealist plays of the time, such as Apollinaire's *The Breasts of Tiresias*. A much shorter piece, *La Sancta Misa Vaticanae*, suggests an idea for a film in which, on the word 'go', priests would compete to recite the Mass as quickly as possible, collapsing one by one from exhaustion, the winner being awarded a monstrance as his prize. Buñuel was working too on a book of narrations called *Polisaños*, which means 'Multi-isms', and on two film scripts: *Goya* and *The World for Ten Cents*, the latter with Ramón Gómez de la Serna. Such activity suggests that Buñuel was still struggling to find his way, but his commitment to the cinema was becoming ever more clear. In late 1927 he was assistant director on a film called *The Siren of the Tropics*, directed by Henri Etievant and starring Josephine Baker, suddenly elevated from chorus girl to star. Playing a West Indian girl who stows away on a ship and follows her lover to Paris, where she dances in music halls, Baker behaved appallingly off

set, frequently turning up late and indulging in frequent displays of temper when her demands were not met. At the same time, Buñuel was also contributing to the Madrid film scene, not least as film editor and critic for *La Gaceta Literaria*, the ultraist journal founded by Ernesto Giménez Caballero. In this capacity, he kept his Spanish readers in touch with the films being shown in Paris and published articles both by himself and by other important figures, including Jean Epstein, Léon Moussinac, Eugenio Montes, and Robert Florey, the future director of *The Beast with Five Fingers*. In 1928, moreover, Giménez Caballero founded the Cineclub Español, to which Buñuel regularly sent important films, such as René Claire's *Entr'acte* (1924), Eisenstein's *The Battleship Potemkin* (1925), Fritz Lang's *Metropolis* (1926), and Abel Gance's *Napoléon* (1926). There were also visiting speakers, including Gómez de la Serna, the poet Rafael Alberti, Lorca, and Buñuel himself. Visits to Madrid allowed him, of course, to keep in touch with Lorca but, in spite of the extremely close friendship they had once enjoyed, Buñuel was increasingly intolerant of anything that smacked of traditional values, which, in his view, included most of the poetry that Lorca had written to date, and certainly plays with traditional subjects such as *Mariana Pineda* and *The Love of Don Perlimplín*. His corresponding advocacy of all that was iconoclastic and forward looking meant, therefore, that he now began to distance himself from his one-time friend. By this time he had also met the young woman who would become his wife.

Buñuel first met Jeanne Rucar in 1926 when she was eighteen years old. The family home was in La Madeleine, around five kilometres from Lille; the family circumstances were financially quite comfortable, and the moral climate of both the home and the region was predictably conservative. Jeanne's father worked as an accountant at a local factory, while her mother stayed at home and, with the assistance of a family servant, cared for her two daughters and two sons. Soon after the end of the First World War, the family settled in Paris and Jeanne attended for four years a school run by nuns where instruction in the Catechism went hand in hand with classes on the Scriptures and morality. In short, her education was extremely traditional, designed to produce a child of sound moral values and solid Catholic beliefs. Because she did not enjoy school, was rather timid, and was regarded by her classmates as none too bright, Jeanne left school at the

age of thirteen and began to study gymnastics and movement at an academy where she was taught by a Madame Poppart. She immediately felt at home and made such good progress that she was chosen to take part in the Paris Olympic Games of 1924, at which she won a bronze medal. Despite such exposure, Jeanne remained, like many young women at that time, rather naive and unworldly, not least in matters concerning sexual relationships. Such things had never been mentioned at home. When she was born, her sister and her brothers thought that the doctor had produced her from his black bag, and even at the age of seventeen Jeanne believed that a kiss between a man and a woman was sufficient to make a woman pregnant. Tall, slim, and in general physically attractive, Jeanne was, in short, the traditional 'good', middle-class girl when she met Buñuel.

Their courtship lasted for eight years. Buñuel was a frequent visitor to the Rucar household, in the kitchen she taught him to dance the tango, and they sometimes went to the cinema, invariably – on her parents' instructions – chaperoned by her elder sister Georgette. In many ways, then, theirs was a highly traditional courtship, but even if we accept that Jeanne was rather unsophisticated and that this was a time in which sexual relations between courting couples were frowned upon and were far less common than they are now, the degree of abstinence between Jeanne and Buñuel was not only surprising but also an aspect of their relationship that would persist throughout their lives.

After Buñuel's death, Jeanne published an account of their life together that seems remarkably frank and reveals that, during their long courtship, he 'respected' her, which clearly means that sex had no part in their relationship.[7] In short, Buñuel's adult inhibition in this respect was in some ways as crippling as Dalí's and, as we have already seen, can be attributed to his time at the Jesuit School of the Saviour in Zaragoza. In a conversation with Max Aub some sixty years later, Buñuel made a remarkable confession: 'For me, throughout my life, coitus and sin have been the same thing,' and in his autobiography claims that, like many other Catholic men, he was 'a victim of the most fierce sexual repression in history'.[8] Much has been made of his frequenting of brothels both in Madrid and Paris, but if he accompanied his male friends on those occasions, it seems more than likely that he avoided sexual encounters with the girls. Indeed, he has described

how, just a few weeks after his arrival in Paris, he visited the Chinese cabaret next to his hotel and began a conversation with one of the hostesses. She evidently expected that Buñuel would pay for sex with her, but he insists that he was much more interested in continuing the conversation, no doubt as a way of avoiding bedding her.[9] Similarly, he has revealed how shocked he was by the liberal habits and sexual behaviour of young Parisian men and women whom he observed 'kissing in public, or living together without the sanction of marriage'.[10] And when he and some friends attended a ball, Le Bal des Quat'zarts, which had the reputation of being the most original orgy of the year, he was completely dumbfounded when one of the students 'placed his testicles delicately on a plate' and when, outside the venue, he saw 'a naked woman . . . on the shoulders of a student dressed as an Arab sheik'.[11]

The nature of Buñuel's marriage to Jeanne Rucar was, similarly, quite extraordinary and will be discussed in more detail later on. Suffice it to say, though, that the early years of their courtship also revealed the narrow-mindedness, the jealousy, and the possessiveness that would characterise Buñuel's behaviour throughout his marriage. Jeanne's work as a gymnastics teacher required that she wore a blouse and a short, loose skirt over knickers with elasticated legs, but when Buñuel became aware of this, he objected to her 'displaying herself' and forced her to give up the activity. In much the same way, he discovered that she took piano lessons alone with a middle-aged man and obliged her to abandon them. And, in order to ensure that she was fully occupied during the day and therefore not exposed to the attentions of other men, he persuaded the owner of a bookshop to allow her to work there and agreed, without her knowledge, to pay her salary. Sexually reticent himself, he would not allow anyone else to act freely towards someone he regarded as his possession.[12]

At the same time as he was embarking on his courtship with Jeanne, Buñuel grew increasingly jealous and envious of Lorca's intimacy with Dalí. In a letter of 5 August 1927 to Pepín Bello, a friend of all three, he described Lorca and Dalí as 'disgusting', and in another letter of 5 September wrote as follows:

> Federico sticks in my throat a great deal . . . Dalí is much under his influence. He considers himself a genius, thanks to the love that Federico offers him . . . I'd really love to see him [Dalí] come

here and discover himself anew far away from the influence of the nefarious García. All this because Dalí is a real male and has great talent.[13]

Quite what Buñuel meant when he described Dalí as 'a real male' is not quite clear, but the description probably referred to his rebellious personality rather than to anything else. In fact, Dalí and Lorca continued to write to each other until 1929, though it has to be said that 1928 marked a decisive moment in the relationship of all three men. In May of that year, a piece called *The Anti-Art Manifesto*, in which Dalí, Sebastiá Gasch and Lluís Montoyà played leading roles, launched a withering attack on the stagnation of the Catalan intellectual and artistic establishment, praising instead the new age represented by the aeroplane, the gramophone, ships, trains, cinema, jazz, and the like, and naming writers and artists such as Picasso, De Chirico, Joan Miró, Tristan Tzara, Paul Eluard, Cocteau, Stravinsky, André Breton, Louis Aragon, and García Lorca as representatives of the new ideas. But the publication in July of Lorca's volume of poems, *Gypsy Ballads*, changed that perception of him as a symbol of the avant-garde.

As we have seen, Lorca had begun work in 1924 on the poems that would form the collection. The gypsy had for centuries in both Andalusia and elsewhere been pursued and marginalised by the authorities – a situation reflected in the poem, 'Ballad of the Spanish Civil Guard', in which a gypsy community is attacked by the Civil Guard:

> Forty Civil Guards
> Burst in through the doors
> ...........................
> A flight of long screams
> Rose from the weather vanes.

For Lorca, though, the gypsy, anguished and suffering, was to be seen not as simply picturesque, as was often the case in literature, but as symbolising the history and tragic spirit of Andalusia. The publication of the volume was greeted with acclamation by the reviewers and undoubtedly consolidated Lorca's growing fame as a poet, leading Ricardo Baeza, writing in the newspaper *El Sol*,

to describe the collection as 'the most personal and outstanding instrument of poetic expression in Spanish since the magnificent innovations of Rubén Darío'.[14] Dalí and Buñuel, despising everything that they saw as remotely traditional, fundamentally disagreed. At the beginning of September, Dalí wrote to Lorca, emphasising this very point and adding that the poems contained too much local colour, too much narrative, too many traditional verse forms, and too many hackneyed metaphors. His overall concern was that Lorca had not paid enough attention to the realm of the unconscious and that his writing was not sufficiently surrealist. He did not deny the poet's talent but urged him to write in a different way: 'The day you lose your fear, and shit on the Salinases [Pedro Salinas, a Spanish poet] of the world, give up Rhyme – in short, art as understood by the swine – you'll produce witty, horrifying, intense, poetic things as no other poet could.'[15]

Buñuel's assault was, if anything, even more damning, typifying his uncompromising and iconoclastic attitude. In 1926, as noted earlier, Dalí had enthused about Lorca's play, *The Love of Don Perlimplín*, and had persuaded him to read it to Buñuel. In his memoirs Buñuel recalls that, half-way through Lorca's reading, he had had enough, had banged his fist on the table, and had described the play as 'a piece of shit', causing Lorca to turn pale.[16] In 1928, Buñuel and Dalí had launched a similar attack on the acclaimed poet, Juan Ramón Jiméz, pouring scorn on his story about a donkey, *Platero and I*:

> Our Distinguished Friend: We consider it our duty to inform you – of course, disinterestedly – that we find your work deeply repugnant on account of its immoral, hysterical and arbitrary character.
>
> In particular: SHIT! on your *Platero and I*, on your facile and ill-intentioned *Platero and I*, less than a proper donkey, the most odious donkey we have ever come across.
> SHIT!
> Sincerely,
>                                          Luis Buñuel
>                                          Salvador Dalí[17]

The tone of the letter had the effect of forcing the ultra-sensitive Juan Ramón to take to his bed for three days. Predictably, then, the appearance of *Gypsy Ballads* provoked a similar response, for

in a letter to Pepín Bello, dated 14 September 1928, Buñuel wrote as follows:

> I saw Federico in Madrid . . . his book of poems seems to me
> . . . very bad . . . It has a dramatic quality for those who like
> that kind of flamenco drama; something of the classical ballad
> for those who want to continue the classical ballad tradition
> down the centuries; and it has too some magnificent and modern
> images, but they are few and always part of a narrative thread I
> cannot stand . . .[18]

In spite of or, perhaps, because of this attack, Lorca was trying desperately to maintain his relationship with Dalí, though he seems to have been aware that this was a losing battle. At the time of Dalí's comments on *Gypsy Ballads*, he was working on a prose poem initially entitled 'Technique of the Embrace', then 'Submerged Swimmer'. Together with another similar piece entitled 'Suicide in Alexandria', it was published at the end of September in *L'Amic de les Arts*, just three weeks or so after Lorca's receipt of the painter's criticisms. In 'Submerged Swimmer' the narrator declares that he knows what it is to say goodbye to his great love and describes his last embrace to the Countess X. The poem was, moreover, accompanied by an ink drawing in which the heads of two lovers fuse in a kiss. But if all this suggests on one level the last embrace of Lorca and Dalí, the poem and the drawing can also be interpreted on another level as Lorca's farewell to the traditional element in his work of which both Dalí and Buñuel were so critical. In this respect the narrator in 'Submerged Swimmer' states that he has 'given up the old literature' that had until now been so successful, while in a letter to the editor of *L'Amic de les Arts* Lorca suggested that the two poems corresponded to his 'new *spiritualist* manner, free from logical control', a clear indication of the surrealist mode which now obsessed both Dalí and Buñuel, though Lorca denied that his method was surrealist: 'But it is not surrealism – the sharpest consciousness illuminates them [the poems]. They are the first I have written. Of course, they are written in prose because verse is a restriction they couldn't permit.'[19]

In the following month, he also gave two lectures at the Athenaeum Club in Granada, both of which point in the same direction. In the first of these, 'Imagination, Inspiration and Escape in

Poetry', he argued that the poet should now seek to write without the control of logic and reason, seeking a new reality that could be discovered in the world of dreams and the unconscious. In the second, 'Sketch of the New Painting', he suggested that Cubism and Surrealism were the forces that freed the painter from traditional restraints, and he gave particular praise to the artist Joan Miró for his dream-like paintings. Although Lorca did not regard his work as truly surrealist, then, it was certainly a direction that his poetry and theatre would take over the next few years.

Despite his efforts to hold onto Dalí, and perhaps because he knew he could not, Lorca became involved in 1928 in a homosexual relationship with a sculptor eight years younger than him, Emilio Aladrén Perojo. Aladrén had been a student at the Academy of Fine Arts in Madrid, entering the institution at the same time as Dalí, and was in 1928 the boyfriend of another student there, the painter Maruja Mallo, who subsequently claimed that Lorca lured Aladrén away. Handsome and extremely passionate, Aladrén was also rebellious, excitable, lacking in discipline, and a considerable womaniser who would soon let Lorca down. Many disliked him and thoroughly disapproved of his friendship with Lorca. José María García Carrillo, Lorca's homosexual friend from Granada, faced up to him in a Madrid café, announcing that he was extremely glad not to have known such a shit, while Dalí, in a letter that may well suggest his disapproval of Lorca's relationship with the sculptor, suggested that Federico had 'indulged in something you should never have indulged in'.[20] But Lorca, infatuated by his new friend, paid no attention to such warnings. He delighted in showing off his Emilio, took him everywhere, praised his ability as a sculptor, though this was decidedly average, and went to some lengths – unsuccessfully – to persuade the newspaper *ABC* to publish a photograph of the head of himself made by Aladrén. But by early 1929 the sculptor was becoming involved with the young woman whom he would eventually marry towards the end of 1931. Eleanor Dove, from Gosforth, Northumberland, was the Madrid representative of the cosmetics firm Elizabeth Arden. The knowledge that, having virtually lost Dalí, he – the most famous poet and dramatist of his time – was now losing Aladrén to such a person, must have seemed a savage blow to Lorca.

This must have been, in part at least, the cause of the depression that Lorca began to suffer during the summer of 1928 and which

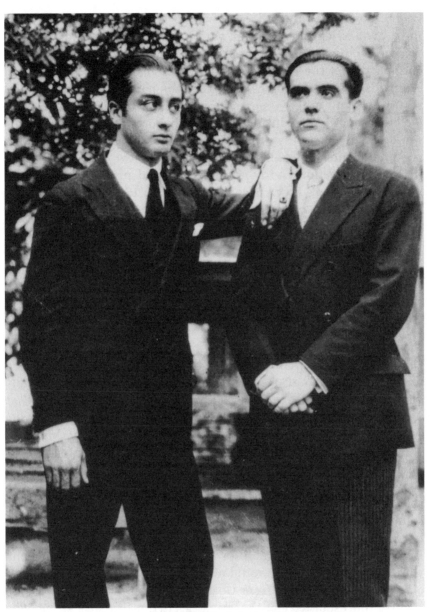

5. Lorca and Emilio Aladrén in Madrid, 1928

lasted for most of 1929. He had had periods of depression in the past, but this was clearly more serious and longer lasting. There may, though, have been other causes, not least the hostility of Buñuel and Dalí towards his work, and perhaps the feeling that, having decided to change direction, he would not achieve in the future the artistic success he had achieved to date. And then there was also the question of his growing fame and the invasion of his privacy that this entailed. On 5 May 1929, for example, a banquet was held at Granada's Alhambra Palace Hotel in honour of Lorca and Margarita Xirgu, the distinguished Spanish actress whose company had just performed *Mariana Pineda* in the city's Teatro Cervantes and who would in the years ahead be closely involved in several of his plays. In his speech to the assembled guests Lorca expressed his sincere thanks to Xirgu but, significantly, described himself as 'a poet from birth and unable to avoid it' and referred too to finding himself 'burdened with a sense of responsibility in the one place where I do not wish to feel responsible, where I desire only to live quietly in my house, at rest and preparing new work'.[21] Two weeks later, the municipal council of Fuente Vaqueros, Lorca's birthplace, also honoured him with a banquet, inviting him to launch their plans for a public library. Given such events, it is easy to understand how Lorca's growing celebrity, combined with the other tumultuous events in his life, must have overwhelmed him.

His parents, well aware of their son's fragile emotional state but either unaware of the source of his emotional problems or, perhaps, choosing to ignore them, had decided fairly early in 1929 that a change of scene would probably be beneficial. It seemed, therefore, fortuitous that Lorca's former Professor of Law at the University of Granada and long-standing friend of the family, Fernando de los Ríos, would be setting out in the summer for New York to lecture at Columbia University. It was agreed that Lorca, who had never previously set foot outside Spain and who was not the most practical of individuals, would accompany him, and that Fernando de los Ríos, an elegant and highly sophisticated individual, would keep an eye on him.

Because de los Ríos was first obliged to accompany one of his nieces to Lucton School in Herefordshire, where she would be employed as a teacher of Spanish, the journey to New York proved to be somewhat circuitous, taking the three travellers from

Granada to Madrid, Paris, London, and Hereford. Then, on 19 June, Lorca and de los Ríos set sail from Southampton to New York on the *SS Olympic*, sister-ship to *Titanic*. The sea voyage proved to be extremely calm and Lorca managed to forget his habitual fear of drowning, but his depressed state of mind may be gauged from a note to his friend Carlos Morla Lynch, the Chilean Ambassador in Madrid, in which he stated: 'I see myself in the mirror of my narrow cabin and I seem another Federico.'[22] On 25 June the *SS Olympic* sailed into New York Harbour.

The contrast between provincial Granada and cosmopolitan New York, with its teeming millions and its mixed races, was clearly enormous. Lorca must have known something about the city from reading novels and magazines, and he would certainly have seen it portrayed in films such as Fritz Lang's *Metropolis*, as well as in the comic films of Chaplin, Harold Lloyd, Buster Keaton, and others, all of which the surrealists greatly admired. The reality, however, must have been overwhelming, and more so for someone who had never before left his native shores and did not possess a word of

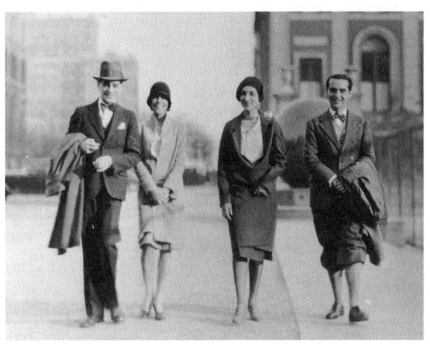

6. Lorca walking with friends in New York

English. But at least Lorca had Fernando de los Ríos for moral support, and various Spaniards awaiting his arrival: in particular Federico de Onís, Professor of Spanish at Columbia and Angel del Río, a colleague in the same department. It was de Onís who found Lorca suitable accommodation in Furnald Hall on the Columbia campus and helped him enrol as a student of English. Lorca was in one sense a wordsmith, but he was certainly no linguist. Although at first he regularly attended his English classes, he later claimed to have learned only a few phrases, including 'ham and eggs' and 'Times Square'. If such a claim were true, his diet would have been extremely monotonous, and every time he got lost and asked for directions, he would clearly have ended up in Times Square.

During his first six weeks in New York, Lorca was both amazed and depressed by what he saw. His sense of alienation and inner disorientation may be gauged from the poem 'Return from a Walk':

> Assassinated by the sky.
> Among the forms that move toward the serpent
> And those that go in search of crystal,
> I shall let my hair grow long.
>
> With the stump of a tree that grows no more
> And the child with a face white as an egg.
>
> With the little animals, their heads broken,
> And the ragged water with dry feet.
>
> With everything that is weary and mute
> And the butterfly drowned in the ink-well.
>
> Colliding with my face, so different every day.
> Assassinated by the sky.

In architectural terms, this was a city in which the skyscrapers, despite their soaring height, lacked any notion of mystery or transcendental quality. In the vast, cavernous avenues, the constant movement of cars and people merely drew attention to the emptiness of human lives. He vividly described the scene in a lecture, 'A Poet in New York', which he frequently gave between 1931 and 1935:

The two elements which first strike the traveller in the big city are extra-human architecture and furious rhythm. Geometry and anguish. At first sight, the rhythm may seem to be joyful, but when you look more closely at the mechanism of social life and the painful slavery of men and machines, you see it as a typical empty anguish in comparison with which crime and banditry are a forgivable means of evasion . . . There is nothing more poetic and terrible than the battle of the skyscrapers with the heavens that cover them. Snow, rain and mist set off and conceal the great towers, but those towers, hostile to mystery and blind to any kind of play, sever the rain's tresses and pierce the soft swan of the mist with their three thousand swords.

On Sundays Coney Island attracted an army of pleasure-seeking visitors who drank, ate, trampled on each other, left their litter behind, and vomited on their return to the city. And then there was Wall Street and the preoccupation with money:

The terrible, cold and cruel part is Wall Street. Rivers of gold flow there from every part of the world, accompanied by death. There, as in no other place, one finds a total absence of spirit: herds of men who cannot count past three; herds more who cannot count past six, who scorn pure science and madly worship only the present. And the terrible thing is that the people who fill the street are convinced that the world will always be the same, and that they are obliged to keep the machine running, day in, day out.[23]

True to his socialist beliefs, Lorca was appalled by the American pursuit of profit, and he was shocked too by the gulf between rich and poor and by the exploitation, in particular, of the poor black people of Harlem, whom he saw as the slaves of the white man, uprooted from their African origin, strangers in a foreign land. In this respect, his view that they would be better off in their land of origin may seem somewhat naive, but his love of Negro song and dance, which he partly encountered through the friendship of a black novelist, Nella Larsen, and in which he found a relationship with his beloved 'deep song', cannot be questioned.

In the middle of August, Lorca left New York for a while in response to an invitation from an American friend, Philip Cummings, whom he had previously met in Madrid and Granada. Cummings and his parents were spending August in a rented

cabin on the shores of Lake Eden, in Eden Mills, Vermont, a rural paradise seemingly a million miles from the noise and activity of New York. Lorca undoubtedly responded to a place that in certain respects reminded him of the tranquility of Granada, and he spent his days with Cummings exploring the woods around the lake and the evenings in the pleasant company of his mother, Addie. Even so, Lorca's depression had not disappeared, and the onset of autumn, with its increasing rain and darkening evenings, seems to have depressed him further. After a ten-day stay with the Cummings family, he moved on, staying first with Angel del Río and his wife in a rented cabin at Bushnellsville, New York State, and then with Federico de Onís at his country house in Newburgh.

7. Lorca with two children, Stanton and Mary Hogan in Bushnellsville, United States, 1929

Back in New York, Lorca moved on 21 September 1929 into John Jay Hall on the Columbia University campus. He was still suffering from depression, and this was hardly improved by the cataclysmic event that shook both New York and the rest of the world that autumn. If Lorca had already been shocked by the American pursuit of money, the Wall Street Crash revealed to the full the folly of placing one's faith in it. Driven to despair by the sudden and apparently unstoppable fall in the value of shares, crowds gathered around the Stock Exchange, panicking and desperately waiting for the latest news. Many, facing complete ruin, considered suicide the better option and threw themselves from the windows of high buildings, one individual hitting the pavement not far from where Lorca stood. It was a scene of complete pandemonium, the very opposite of the peace for which he longed, and hardly calculated to improve his state of mind.

There were, of course, lighter moments. This was, after all, the time of the first 'talkies' in the cinema and, although there is no record of the films that Lorca saw in New York, there can be no doubt that he saw many. In addition, his suggestion to his parents that the money they gave him was insufficient to allow him to go to the theatre points to his interest in contemporary American theatre and its importance for his own writing. In particular, the off-Broadway Theatre Guild, founded in 1925, staged contemporary American and English plays, as well as, in English translation, the great works of Ibsen, Strindberg, and other famous dramatists. The Civic Repertory Theatre, another off-Broadway venue, staged a number of plays by Chekhov while Lorca was in New York. And in the same year the Neighbourhood Playhouse, which in 1933 would stage an English-language version of *Blood Wedding*, put on several musicals. Lorca's lack of English would, of course, have been a considerable handicap, but this would not have prevented him from observing the production styles and the acting qualities of the companies in question.

Whether or not Lorca's depressed state of mind affected his involvement in the gay scene in New York is a matter of conjecture. Given his sexual nature and the fact that he was often alone, he probably had short-term relationships, and he certainly attended a party arranged by the writer Hart Crane, who was also homosexual and who, when Lorca arrived, was surrounded by a group of drunken sailors. An American student, John Crow, with whom

Lorca struck up a friendship in John Jay Hall, later wrote that Lorca 'drank, necked, and caroused like many another young masculine animal',[24] and made no reference of any kind to his homosexual inclinations. It could well be that, as he had done in Madrid, Lorca concealed this aspect of his nature when required, but gave free rein to it when the opportunity arose.

As far as his writing was concerned, the New York experience proved to be the inspiration for a number of Lorca's major works. He had commenced work on some of the poems that would form the collection *Poet in New York* not long after his arrival. 'The King of Harlem', which launches a fierce attack on the materialistic values of a capitalist society that in turn oppresses the minority black people, is dated 5 August 1929. Another poem, '1910 (Interlude)', in which he evokes the innocence of his childhood and a child's unawareness of the horrors that the future, adult world has in store, was also written in August. In Eden Mills Lorca wrote three more poems, of which 'Double Poem of Lake Eden' reveals the full extent of his anguish, and on his return to New York there followed a series of poems in which he expressed both his own despair and the horror and suffering of man in general, condemned to live in a harsh and materialistic world. In 'Childhood and Death' Lorca reveals to the full his tormented state of mind as he realises that 'Here, alone, I see that they've closed the door on me'. And in 'New York (Office and Denunciation)' he rages against a society in which consumerism is all:

> Each day in New York they kill
> Four million ducks,
> Five million pigs,
> Two thousand pigeons to satisfy the palate of the dying,
> A million cows,
> A million lambs,
> Two million cockerels,
> That leave the heavens in pieces.[25]

This was a point of view very different from that of Dalí, who, during his years in New York, would avail himself to the full of its commercial opportunities, as we shall see. Lorca's letters to his parents suggested that his stay was a happy one, but even if he enjoyed particular moments, his writings, the true reflection of his state of mind, point in the opposite direction.

Particularly revealing in this respect is Lorca's screenplay, *Trip to the Moon*, written in the course of an afternoon and possibly inspired by Buñuel and Dalí's first film, *Un chien andalou*, which had opened in Paris on 6 June 1929 and about which Lorca would have heard or read a good deal, given its effect on those who had seen it. At all events, *Trip to the Moon*, consisting of seventy-eight short sequences and characterised by episodes of considerable violence, vividly reflects its author's sexual anguish at the time of writing. While he was still in New York, Lorca may also have commenced work on *The Public*, the play he continued to write in Cuba in 1930 and then completed in Granada, and which is his only overtly homosexual drama. Once more it contains scenes of sexual violence and domination, but by its conclusion its protagonist, the Director – who initially denies and attempts to conceal his homosexuality – appears to have come to terms with it, reflecting, perhaps, Lorca's experience as a result of his time away from Spain and of the freedom he discovered in Cuba on his arrival there on 7 March 1930.

In many ways Cuba was for Lorca a kind of rebirth, and his joy on arrival there and finding himself once more in a Hispanic country is reflected at the end of his lecture, 'A Poet in New York':

> But the ship is moving further away, and we are beginning to come to palm and cinnamon, the scent of the America with roots, the America of God, Spanish America . . . But what is this? Spain once more? Universal Andalusia? It is the yellow of Cadiz, but even brighter; the rose colour of Seville, but more like carmine; the green of Granada, but with a soft translucence like a fish.[26]

In Cuba, Lorca encountered not only his own language but that relaxed way of life and lack of inhibition that are essentially Hispanic. Just as importantly, he found in Cuban society a sexual freedom that did not exist in puritanical North America. Happy among his many admirers, he gave five lectures in Havana, further talks in other towns, enjoyed the hospitality of numerous distinguished people, and indulged himself in a much more uninhibited manner. While some accounts of his homosexual adventures may have no basis in reality, he certainly had a relationship with a young and handsome Mulatto called Lamadrid and, in all probability, with another good-looking young man, Juan Ernesto Pérez de la Riva,

the son of wealthy parents. When they discovered that Lorca was homosexual, they put an end to Lorca's visits to the house, but he continued to meet the young man elsewhere.

In addition to completing *The Public*, it seems that Lorca had already written some of *Yerma*, which he would not finish until 1934, and was also working on *Doña Rosita the Spinster*, premiered in 1935. The other major piece of this time was, though, 'Ode to Walt Whitman', the first draft of which seems to have been written largely in Cuba. In this highly personal poem, Whitman is presented as a homosexual free of effeminate traits, someone who in his manly qualities does not bring the world of homosexuality into disrepute. In the process Lorca launches a bitter attack on the degenerate, effeminate and camp individuals who give homosexuals a bad name. The vitriolic nature of the diatribe explains in part, perhaps, the efforts that Lorca made to conceal his own sexual nature and his fear of being included among such people.

After three months in Cuba, Lorca felt newly invigorated and refreshed, his depression cast aside. On 12 June 1930, the *Manuel Arnús* set sail from Havana, arrived in New York six days later, and on 30 June reached Cadiz, where Lorca was happily reunited with his brother Francisco and his sister Isabel.

Meanwhile, Dalí was beset by family and sexual problems. In August 1929, shortly after Lorca's departure for the United States, Dalí had first set eyes on the woman he would marry five years later: Helena Diakanoff Devulina, more commonly known as Gala. He was immediately fascinated by her, but at the time of their meeting she was married to the French poet, Paul Éluard. When, in spite of this – Gala and Éluard enjoyed an extremely open marriage – she embarked on a relationship with Dalí, his father, Don Salvador, now more reactionary than he had been in the past, was enraged and changed his will in favour of his daughter, virtually disinheriting the errant son. The relationship of father and son was then made even worse by the display in an exhibition of Dalí's work in Paris in November of a picture entitled *The Sacred Heart*. In one part of the picture the phrase 'Sometimes I spit for PLEASURE on the portrait of my mother' accompanied the image of a young man doing precisely that. Dalí subsequently claimed that, in painting the picture, he had merely followed the promptings of his subconscious, for in dreams

individuals often abuse the people they love, but the argument did not wash with Don Salvador, who regarded the words in the painting as the most outrageous insult to his dead wife. A terrible row ensued, as the result of which the angry father threw his son out of the house. It would be five years before Dalí spoke to his father again.

Dalí's paintings in 1928 and 1929 continued to focus on his sexual problems and, after the break with his father, on family conflict. In *Dialogue on the Beach*, completed in 1928 and later renamed *Unsatisfied Desires*, the hand on the left, with its curled fingers, clearly suggests Dalí's masturbatory habit, as does the phallic-like extended finger, while the female form to the right, separated from the hand by an empty space, points to his failure to find sexual satisfaction with a woman. Similarly, *The Great Masturbator*, completed in 1929, is, as its title indicates, full of details that suggest masturbation, but towards the top left-hand corner of the painting a woman's face, close to male genitals, evokes fellatio, to which Gala had probably introduced Dalí, though it did not put paid to his deeply ingrained love of masturbation. The first reference to the rupture with his father appears in *Illumined Pleasures*, also completed in 1929. In the bottom half of the picture an older man has his arms around a woman whose breasts are exposed and whose hands are bloodstained, while a short distance away another hand holds a bloodstained knife. The latter undoubtedly suggests castration. Is Dalí suggesting, then, that his own failure with women – his castration – was partly due to his father's affair with his aunt's sister while Dalí's mother was still alive? In the top half of the picture, the head of an angry lion threatening the head of Dalí is undoubtedly Don Salvador. If precise meaning is not always clear in the paintings, the resultant ambiguity is always fascinating. Although these years witnessed the beginning of Dalí's most inspired period as an artist, they also saw the completion in 1929 of one of the most original and disturbing films in cinema history: Dalí and Buñuel's *Un chien andalou*.

## NOTES

1   In an interview with Alan Bosquet in 1966. See Gibson, *Federico García Lorca: A Life*, p. 164. The translation is my own.

2   In the same interview with Alan Bosquet. See too Gibson, *The Shameful Life of Salvador Dalí*, pp. 135–6.

3   For an English translation of the piece, see Gibson, *The Shameful Life of Salvador Dalí*, pp. 157–61.

4   On the theme of severed hands in relation to masturbation, see Robert Havard, *The Crucified Mind: Rafael Alberti and the Surrealist Ethos in Spain*, Woodbridge: Boydell and Brewer, 2001, pp. 42–50.

5   See Buñuel, *My Last Breath*, pp. 86–7.

6   For the Spanish text, see Sánchez Vidal, *Luis Buñuel: obra literaria*, p. 141.

7   See Jeanne Rucar de Buñuel, *Memorias de una mujer sin piano* (escritas por Marisol Martín del Campo), Madrid: Alianza Editorial, 1990, p. 51.

8   Max Aub, *Conversaciones con Buñuel*, Madrid: Aguilar, 1985, p. 160. In *My Last Breath* 'a victim of the most fierce sexual repression in history' is translated incorrectly as 'the powerful sexual repression of my youth reinforces this connection'. See the Spanish original, Luis Buñuel, *Mi último suspiro*, Barcelona: Plaza y Janes, 1982, p. 23.

9   Buñuel, *My Last Breath*, p. 79.

10  Ibid.

11  Ibid., pp. 82–3.

12  Rucar de Buñuel, *Memorias de una mujer sin piano*, pp. 38–9.

13  See Agustín Sánchez Vidal, *Buñuel, Lorca, Dalí. El enigma sin fin*, Barcelona: Planeta, 1988, p. 162.

14  For the critical reception of *Gypsy Ballads*, see Gibson, *Federico García Lorca: A Life*, pp. 212–13.

15  Ibid., pp. 216–17.

16  See Buñuel, *My Last Breath*, pp. 101–2.

17  For the Spanish original, see Sánchez Vidal, *Luis Buñuel: obra literaria*, pp. 28–9.

18  See Gibson, *Federico García Lorca: A Life*, p. 220.

19  See García Lorca, *Epistolario, II*, p. 114.

20  Ibid., p. 107.

21  See Gibson, *Federico García Lorca: A Life*, p. 236.

22  See García Lorca, *Epistolario, II*, p. 128.

23  See García Lorca, *Obras completas*, vol. 3, pp. 163–73. The translation is my own.

24  See John A. Crow, *Federico García Lorca*, Los Angeles: University of California, 1945, p. 47.

25  García Lorca, *Obras completas*, vol. 1, p. 555. The translation is again my own. For an English translation of the volume as a whole, see Federico García Lorca, *Poet in New York*, trans. Greg Simon and Steven F. White, ed., and introduced by Christopher Maurer, London: Penguin Books, 1990.
26  García Lorca, *Obras completas*, vol. 3, p. 173. The translation is my own.

# 5

# SURREALISM

*ে৩*

ALTHOUGH SURREALISM IS usually associated with Paris and, in particular, with its founder and high priest, André Breton, it was in fact a much broader-based movement, which contained creative artists of like mind from various countries, including 'foreigners' as influential as Max Ernst, Man Ray, Joan Miró, and, of course, Buñuel and Dalí. In one way or another, the artistic movements that burst on the European scene in the early part of the twentieth century were essentially anti-traditionalist, seeking either to reject past values or, in certain cases, to combine that rejection with an attempt to express more accurately the much greater complexity of the modern world. Cubism, as in the paintings of Picasso, Juan Gris and George Braque, sought to view the real world in a different way. Futurism reflected, by means of its dynamic style, the accelerated nature of modern life. Expressionism aimed at capturing, through its dramatic use of colour, light, and shade, the emotional state or personal vision of the artist. In general, though, these were movements that were largely concerned with painting, and in that respect they differed considerably from Dada and Surrealism, both of which had social, psychological, and political aims.[1]

Dada had made its appearance around 1916, based on the iconoclastic activities of the Cabaret Voltaire in Zurich, where, for example, Richard Huelsenbeck, a medical student and poet, read his poems to the beat of a big drum; Tristan Tzara, one of the founders of the Cabaret, accompanied his recitations with bells,

screams, sobs, and whistles; and Hugo Ball, a theatre director, appeared in cardboard costumes and intoned his 'sound-poems'. Ball and Tzara were also the co-editors of a new magazine that in 1917 acquired the name *Dada*, its purpose to attack and undermine all conventional art forms. In 1920, however, Tzara moved from Zurich to Paris and soon met up with two of his greatest admirers: André Breton and Louis Aragon.

Initially, Breton and Aragon participated in Dada events, but before very long the serious-minded Breton became weary of Dada's largely negative character. Influenced by the writings of Sigmund Freud and the researches of Pierre Janet, a leading French expert on the unconscious, he began to move in a different direction, which, of course, became known as Surrealism. In contrast to Dada, the aim of Surrealism was not to destroy but to change man's priorities. It therefore emphasised the importance of the inner life, unrestricted by logic and reason, as the true reality, in contrast to the rational and conventional values on which western society had long been based and which, in the view of many people, had led to catastrophe, including the horrors of the First World War. Unsurprisingly, then, Breton's *Manifesto of Surrealism*, which appeared in 1924, defined Surrealism in the following way:

> SURREALISM. *n. masc.* Pure psychic automatism through which it is intended to express, either orally, or in writing, or in any other way, the actual way thought works. The dictation of thought, free from all control exercised by reason, without regard to any aesthetic or moral concern.[2]

Within a relatively short time, however, Breton realised that this initial emphasis on the unconscious was insufficient and that the movement required a more solid intellectual base, in effect a commitment to change in the material world. In his *Second Surrealist Manifesto* of 1929, he therefore stated: 'Everything remains to be done, every means must be worth trying, in order to lay waste the ideas of family, country, religion.' In short, Surrealism now acquired a strong social and political character, and it is no surprise to discover that after 1926 the surrealists, some more than others, developed strong links with Communism, which likewise sought a revolution in society and the overthrow of

the bourgeoisie, whose loyalty to family, country, and religion was the source of its strength.

Buñuel claimed in his autobiography that, prior to the making of *Un chien andalou* in 1929, he knew little about Surrealism: 'During those first years in Paris, when practically all the people I knew were Spanish, I heard hardly any mention of the surrealists . . . To be quite frank, at that time, Surrealism had little interest for me.'[3] He was clearly referring here to Breton's Paris-based movement, but his claim seems rather dubious for a variety of reasons. First, Breton's ally, Louis Aragon, had lectured on Surrealism at the Residencia on 18 April 1925, outlining its character and object-ives. Although Buñuel had left for Paris some months earlier, he seems to have been present at the Madrid lecture, and in any case extracts from it were published in *La Révolution Surréaliste* in the following June. Furthermore, in the second half of the 1920s Dalí was, as we have seen, becoming more and more obsessed with Surrealism. Given Buñuel's correspondence with him, as well as their relatively frequent meetings and Buñuel's uncompromising advocacy of the avant-garde, it seems clear enough that they would have discussed surrealist ideas. Even Lorca's warning against see-ing the new tendency of his poems as strictly surrealist could not have been made without a sound knowledge of the tenets of the movement. And then, of course, there was Freud.

Just before Dalí's arrival in Madrid in 1922, the publishing house Biblioteca Nueva had started to produce the works of Freud in Spanish, the first translation into any language. The first two volumes, *The Psychopathology of Everyday Life* and *A Sexual Theory and Other Essays*, appeared in 1922. They were followed in 1923 by *Jokes and their Relation to the Unconscious* and *Introductory Lectures on Psycho-Analysis*, and in 1924 by *The Interpretation of Dreams*. Needless to say, they were the kind of revolutionary works that were food and drink to the intellectually curious students and teachers at the Residencia, and their content was eagerly absorbed. Buñuel was particularly impressed by *The Psychopathology of Everyday Life*, and Dalí bought a copy of the Biblioteca Nueva volumes as soon as they appeared in print, observing that, after reading *The Interpretation of Dreams*, 'I was seized with a real vice of self-interpretation, not only of my dreams but of everything that happened to me, however accidental it might seem at first glance.'[4] Although Lorca seems to have been less

obsessed by Freud than either Dalí or Buñuel, there is little doubt that, like so many others at the Residencia, he too was familiar with many of his ideas.

At the same time, some account has to be taken of the extent to which a growing familiarity with Breton's Surrealist movement was mixed with particular Spanish influences that pointed in the same direction. Buñuel, for example, was influenced to a considerable degree by the paintings of his fellow Aragonese, Francisco Goya. Recovering from a period of deep depression in 1818, Goya had painted on the walls of his house fourteen almost monochromatic compositions that have come to be known as the 'Black Paintings', depicting Spain as a kind of hell inhabited by madmen and filled with superstition. They are, in a sense, visions and nightmares that spring from the unconscious. As well as this, the frontispiece of Goya's twenty-two drawings known as the *Caprichos*, completed between 1795 and 1797, portrays a sleeping man tormented by flying, bat-like creatures, and, significantly, has a caption that would have appealed to any surrealist: 'The Sleep of Reason Begets Monsters.' Goya's paintings and drawings, located in the Prado Museum in Madrid, were easily accessible to Buñuel, Lorca, and Dalí, as were those of the fifteenth-century Flemish painter, Hieronymous Bosch, exemplified in the triptych, *The Garden of Earthly Delights*, the right-hand panel of which depicts a nightmare vision of eternal damnation in which a monstrous bird devours a man, bodies are pierced by knives, and anguished individuals cry out in terror. But if the past had an influence on Spanish creative artists, there is also much evidence to suggest that, in the early part of the twentieth century, avant-garde and anti-tradition movements were as much to the fore in Spain as they were in France. As we have seen, Dada was the forerunner of Surrealism, and in 1916 Francis Picabia's Dada magazine, *391*, was published in Barcelona, where a Dada group also became established by 1919. In Madrid, Gómez de la Serna, in the manner of a Spanish André Breton, encouraged his disciples to seek out new, forward-looking forms of expression, and set an example in his own work. And in 1925 Guillermo de Torre's *Literaturas europeas de vanguardia*, with its account of the origins and growth of Surrealism, was published in Madrid. In short, Buñuel's claim that he remained ignorant of and had no interest in Surrealism until well after his arrival in Paris seems rather far-fetched, given

the hotbed of new ideas in which he and others found themselves in the 1920s.

Although Buñuel intensely disliked the kind of films and the style of filming in which he had been involved with Epstein, the experience had sharpened his desire to direct a film of his own. At first, in the autumn of 1928, he was interested in making a film based on short stories by Gómez de la Serna, to be written by de la Serna himself, but the script never materialised, and Buñuel quickly turned his attention to collaborating on a film with Dalí. In early 1929 they met in Figueras, where they worked on a screenplay and, according to Buñuel, 'never had the slightest disagreement'.[5] The screenplay, initially to be called 'Dangerous to Lean In', a pun on the warning to passengers on the windows of French trains, was completed in a week. The film's title soon became *Un chien andalou*, which was originally the title for a collection of Buñuel's poems. It was to become one of the most famous and notorious films in the history of cinema, and was soon acclaimed by André Breton, its surrealist character confirmed by the publication of the screenplay in *La Révolution Surréaliste* at the end of 1929. Contrary to his claim to know little about Surrealism, Buñuel was able to say now: '*Un chien andalou* would not exist if Surrealism did not exist.'[6]

Buñuel's description of the methods which he and Dalí adopted in writing the screenplay could not be closer to the aims of the surrealists:

> Our only rule was very simple: no idea or image that might lend itself to a rational explanation of any kind would be accepted. We had to open all doors to the irrational and keep only those images that surprised us, without trying to explain why . . . 'A man fires a double bass', one of us would say. 'No', replied the other, and the one who'd proposed the idea accepted the veto and felt it was justified. On the other hand, when the image proposed by one was accepted by the other, it immediately seemed luminously right and absolutely necessary to the scenario.[7]

The two images that served as their initial inspiration were, according to Buñuel, the result of two dreams: his own, in which a long, thin cloud had sliced through a full moon, like a cut-throat razor slicing through an eye; and a dream of Dalí's in which a hand was seen crawling with ants.[8] To what extent these and other

images in the film were really suggested by the one or the other remains unclear, for no initial draft or background notes to the film exist, but the fact that Buñuel and Dalí had no disagreements in deciding on them suggests that they were meaningful to both.

In the opening sequence, announced by a title – 'Once upon a time' – a man appears on a balcony sharpening a cut-throat razor and looking up at the full moon. The moon gives way to a close-up of a young woman's face. This then becomes the moon approached by a single thin cloud – thin clouds also appear around Buñuel's head in Dalí's portrait of him, completed in 1924 – and the moon a close-up of the young woman's eye approached by the razor. The cloud cuts across the moon, the razor slices the eyeball. The image of the eye and the razor may owe something to a variety of sources, but the brutal aggression of the incident is typical of Buñuel. It still has the power to unsettle the viewer, as it certainly did in 1929. When, not long afterwards, Henry Miller saw the film in Madrid, he described the reaction of the audience:

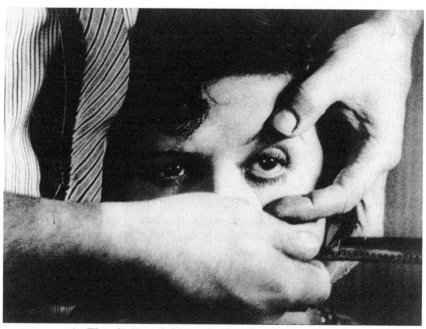

8. The slicing of the eyeball in Buñuel and Dalí's
*Un chien andalou*, 1929

Afterwards they showed *Un chien andalou*. The public shuddered, making their seats creak, when an enormous eye appeared on the screen and was cut coldly by a razor, the drops of liquid from the iris leaping onto the metal. Hysterical shouts were heard.[9]

The intention was, in true surrealist fashion, to shock out of its complacency what would probably have been a largely bourgeois audience.

The sequences and images that follow are markedly autobiographical, for they reveal all those characteristics we have seen to be part of both Buñuel and Dalí's psychological make-up. Their presence suggests that they had no disagreements when they worked on the screenplay precisely because they identified with them. After the razor incident, a young man is seen riding a bicycle along a Paris street. He does so mechanically, his expression is blank, and on his head and around his shoulders and waist are white baby frills. When he falls from the bicycle and lies in the gutter, a young woman rushes to help him, caresses and kisses him passionately, but finds no response. The young man, sexually inhibited, immature and even infantile, unable to respond to the attentions of a woman, is very clearly a projection of both Buñuel and Dalí, even if, at a conscious level, they intended him to be an image of Lorca.

When in New York Lorca heard about Buñuel and Dalí's film, he was convinced that he was its effeminate protagonist. Buñuel would later say:

> Later, thin-skinned Andalusian that he was, he thought (or pretended to think) that the film was actually a personal attack on him 'Buñuel's made a little film, just like that!' he used to say, snapping his fingers. 'It's called *Un chien andalou*, and I'm the dog!'[10]

Buñuel does not, though, refute the accusation, which Lorca evidently felt was well founded. After all, the students at the Residencia who came from the south of Spain were often referred to as 'Andalusian dogs', and the young man on the bicycle was strongly reminiscent of Lorca's earlier play, *Buster Keaton's Spin*. The young man's blank expression is precisely that associated with Keaton in the comic films and suggested by Lorca in his play; the fall from the bicycle echoes a similar moment in the

play. The young man's failure to respond to the embraces of the young woman parallels Buster's failure to respond to the advances of two women, which is, of course, an expression of Lorca's own inhibition. And, as well as this, there is a sequence in *Un chien andalou*, when the young man lies inert and lifeless on a bed, which could well be based on Lorca's celebrated performance of his own death. In short, there was much in Buñuel and Dalí's film to suggest that its protagonist was based on Lorca himself, and his conviction in this respect must have been further cemented by the hostility recently shown towards his work by both Buñuel and Dalí. But if, as seems quite likely, they had Lorca in mind as a model for their protagonist, this does not exclude the probability that he also embodies their own sexual inhibitions.

The passionate young woman who embraces the young man in the sequence mentioned earlier appears in various forms throughout the film. A little later, an androgynous female prods a severed hand with a stick, attempting to instil life into it, and later still the first young woman mocks the young man's passivity when she sticks out her tongue at him and provocatively applies lipstick to her mouth. Towards the end of the film, she walks off with an energetic young man who is more to her taste. She is, in short, the kind of sexually aggressive female whom Dalí feared and Buñuel tried to avoid.

The deep-seated anxiety associated with a woman of this kind was represented in an image that was common to both men: that of the female praying mantis, which, after mating, devours the male. In this context, Jean-François Millet's famous painting, *Angelus*, in which a young man and a young woman are standing in a field, praying at the end of their day's work, had for Dalí a markedly sexual significance. He suggested that in Millet's painting the young man's hat, which he holds in front of him, conceals an erection, while the young woman, who seems passive and demure, is about to pounce on and devour him. So obsessed was he by this notion that he produced a number of works on the theme: in 1933 *Atavism of Twilight*, in which the man is already a skeleton, and *Gala and the 'Angelus' of Millet Immediately Preceding the Arrival of the Conic Anamorphosis*; in 1934 *Homage to Millet*, in which a mantis-like female is about to attack a man's erect penis with a knife; and in 1935 *Angelus of Gala* and *Archaeological Reminiscence of the 'Angelus' by Millet*. As well as this, Dalí

argued in an essay written in 1933 but not published until 1963 that his obsession with Millet's painting could only be explained in Freudian terms; that the figures in the painting could equally be mother and son, and that he himself has a memory of his mother sucking and devouring his penis when he was a child, thereby causing his subsequent impotence and fear of sex with a woman.[11] In this context, only Gala had been able to allay such fear.

As for Buñuel, his interest in insects can be traced back to his childhood and later on to his studies in Madrid under the guidance of the celebrated entomologist, Ignacio Bolívar. One of his favourite books, which Dalí also came to know through him, was *Souvenirs entomologiques*, by the famous French entomologist, J.H. Fabre. Insects such as the black widow spider and the praying mantis were, therefore, a source of fascination to him, particularly so when we recall his often-stated belief that he had 'always felt a secret but constant link between the sexual act and death'.[12] It seems likely, then, that the ending of *Un chien andalou*, in which the young woman and the young man, half-buried in sand, face each other in a manner reminiscent of the Millet painting, is not so much attributable to Dalí, as is frequently claimed, as to both men. In addition, the dying couple, as has been suggested previously, bring to mind the notion of death and decomposition that was of such interest to them and of which Lorca's performance was such a graphic example.

The image of the severed or damaged hand appears on various occasions: the young man stares at his hand, which has a hole in the palm; the androgynous female pokes a severed hand with a stick; the young man's hand is painfully caught in a closing door. As we have seen, hands figure repeatedly in Dalí's paintings, associated with masturbation and the resultant guilt, but they can be seen too in Lorca's drawings of bleeding and severed hands, as well as in his poems, and in a page of twenty-seven drawings by Buñuel entitled *Short Lexicon of Eroticism*. In short, the hand was something with a special significance for many who were taught by the Catholic Church that sex was sinful, and who therefore found release in masturbation. Indeed, the memory of the damaging education experienced by both Dalí and Buñuel is evoked in *Un chien andalou* in two significant sequences. First, when the young man, suddenly overcome with desire to possess the young woman, attempts to pursue her, he is held back by a

great weight that includes priests and, associated with them, decomposing donkeys. Later on, when the young man is chastised for his lack of energy by a vigorous newcomer, there are echoes of a schoolroom, of punishment, and, when books turn into pistols, of the destructive effects of education. Quite clearly, the film is replete with associations rooted in the psychological make-up of both Buñuel and Dalí and corresponds very closely to Breton's description of the first phase of Surrealism.

*Un chien andalou* received its premiere at the Studio des Ursulines in Paris on 6 June 1929, sharing the bill with Man Ray's *The Mysteries of the Château du Dé*. Prior to this, however, Buñuel and Dalí made every effort to give their film maximum publicity in the press, and before the premiere arranged a private showing for Man Ray and Louis Aragon. They in turn communicated their astonished reaction to their fellow surrealists, most of whom were present at the premiere, together with the flower of Parisian society. Dalí, probably unwell, was back in Figueras, and Buñuel, fearing a hostile audience, prepared for trouble:

> Before the show, I'd put some stones in my pocket to throw at the audience in case of disaster, remembering that a short time before, the surrealists had hissed Germain Dulac's *La Coquille et le clergyman*, based on a script by Antonin Artaud, which I'd rather liked. I expected the worst . . .[13]

He need not have worried, for the reaction of the surrealists and much of the press was wholly enthusiastic. Writing in *Cahiers d'Art*, J. Bernard Brunius concluded that Buñuel had destroyed the pretensions of those who considered art to be a pleasant pursuit and had succeeded in conveying in the film 'the absurd but implacable logic of dream'.[14] His view was echoed by many others. *Un chien andalou* enjoyed a long run and Buñuel soon joined the official surrealist group.

After the quarrel with his father and his banishment from the family home in December 1929, Dalí set out for Paris, met up again with Gala, and was, like Buñuel, welcomed into the surrealist group. He remained in Paris for only three weeks, after which he and Gala set out for Carry-le-Rouet, a small town some twenty-five kilometres from Marseilles, where for the next three months they stayed at the Hôtel du Château. Dalí's subsequent claim that

there he experienced with her a period of sexual initiation should perhaps be treated with a pinch of salt, but what cannot be denied is that, in spite of his absence from Paris, he and Buñuel were constantly exchanging ideas for their second film, *L'Age d'or*. Lorca was still in New York and out of the picture.

As a result of the success of *Un chien andalou*, Buñuel had become friendly with the Vicomte Charles de Noailles and his wife Marie-Laure, sophisticated and wealthy patrons of the arts who had secured a licence for the public screening of the first film and now wished to commission a second. Buñuel and Dalí had already met in Cadaqués in the late summer of 1929 in order to exchange ideas, but Dalí's obsession with the recently arrived Gala had made it impossible. Buñuel soon concluded that Dalí was much changed and would talk only about Gala. It seems that she, jealous of Buñuel's friendship with Dalí, attempted to cause friction between them, while Buñuel, intensely annoyed that she was preventing them from working together, became so enraged that at one point he placed his hands so tightly around her throat that Dalí fell to his knees and begged him to stop. At the end of the year and during Dalí's stay in Carry-le-Rouet, they exchanged ideas once again, but to what extent Dalí's suggestions were incorporated into the final shooting script of what was initially called 'The Andalusian Beast' is difficult to determine in the absence of any detailed account of their collaboration. Buñuel later claimed the film for himself, but even though Dalí was not present at the shooting, it is clear that many of his ideas were accepted, even if the more scandalous ones were rejected.[15]

Early on in the film, a coastal landscape is undoubtedly based on the rocks around Cadaqués. Later, a man carrying a stone on his head anticipates Dalí's painting *Triangular Hour* (1933), in which there is a similar figure. Another incident in which the film's main female character is seen to have a damaged finger while elsewhere her father vigorously shakes a vial of liquid probably derives from Dalí's addiction to masturbation. Dalí's more outrageous suggestions included one that, in the love scene towards the end of the film, would depict the male protagonist kissing the tips of the young woman's fingers and ripping out one of her nails with his teeth. Another was that the camera should focus on the young woman's lips, which would in turn suggest her vagina, while a

feather boa framing the lips would be the equivalent of pubic hair. It was little wonder that Buñuel, well aware of a watchful censorship, chose not to proceed with Dalí's more sensational suggestions. But both men agreed that the central idea of the film was to be the confrontation between sexual instinct and the social and religious forces that seek to repress it.

This central theme suggests that *L'Age d'or* had a greater political emphasis than its predecessor, and in that sense accords perfectly with André Breton's statement in his *Second Surrealist Manifesto* that Surrealism should now be concerned with laying waste the ideas of family, country, and religion.[16] Indeed, Buñuel would later explain very clearly his and the surrealists' main objective from this moment on: 'The real purpose of surrealism was not to create a new literary, artistic, or even philosophical movement, but to explode the social order, to transform life itself.'[17] In this context it is important to remember that at this time great changes had and were taking place throughout Europe. The First World War of 1914–18 had left much of Europe in a state of shock and had led to a questioning of the traditional values of patriotism, of blind loyalty to one's country, and of the rights of those in authority – the government, the politicians, the military hierarchy, the religious leaders – to send ordinary men to their deaths. In Russia the Revolution of 1917, in which the aristocracy had been swept aside, had led to a much greater emphasis on social equality and, at least in theory, on a fairer distribution of wealth. As for the surrealists, the link with Communism was clear enough, for Surrealism was itself a revolutionary movement that sought to undermine traditional bourgeois values. Breton himself had emphasised the connection in the *Second Surrealist Manifesto*:

> Why must we accept that the dialectical method [of Karl Marx] can be applied properly only to solving social problems? It is the whole of us surrealists' ambition to supply it [Surrealism] with possibilities of application that do not conflict in any way with its immediate practical concerns.[18]

It is worth pointing out too that the surrealists were concerned not only with the domination of bourgeois and right-wing values in France; they were also preoccupied by the dictatorship of Primo de Rivera, who had seized power and established military rule

in Spain in 1923. As for Buñuel, he was already familiar in his teenage years with the works of Karl Marx. His left-wing leanings would have been reinforced by the political debates that took place during his years at the Residencia, and the process was evidently consolidated by his connection with the surrealists. Although it remains unclear whether or not he was a paid-up member of the Communist Party, he certainly attended some of its meetings. Communism, like Surrealism, appealed to his aggressive and rebellious personality, and he never forgot, of course, his father's wealth and idle way of life, and the poverty and degradation of the less fortunate in Calanda and the surrounding area.

From the very outset, *L'Age d'or*'s attack on the bourgeoisie could not be clearer. The film begins with a documentary sequence that highlights the aggressive behaviour of scorpions and the killing of a rat, while accompanying titles inform us that the scorpion is both unsociable and resentful of any intruder into its territory. Later on, the young man who, uninvited, attends the dinner party at the villa of the Marquis of X and behaves in a manner unacceptable to the host and his bourgeois guests, is ruthlessly expelled by them. The film's opening sequence is thus suggestive of what is to come, and leads into a second sequence whose relevance to what follows may at first seem unclear but which is actually quite precise. Here, on an island, a group of exhausted, delirious and dying bandits give way – as did the rat to the scorpion – to new arrivals who include priests, the military, and civic dignitaries. The bandits, their leader played by Max Ernst, are clearly the equivalent of the surrealists, unacceptable to bourgeois society, and the point is further underlined when the latter turn on and separate two lovers – the young man mentioned above and a young woman – whose amorous grappling it finds unacceptable. The lovers, oblivious to all but their feelings for each other, embody, of course, the surrealist emphasis on the importance of instinct free from the control of reason and all aesthetic or moral concerns that, countered by bourgeois intolerance, now becomes the film's central concern.

The longest section of *L'Age d'or* is set in the elegant villa of the Marquis of X where bourgeois manners and values are scrutinised as closely as Buñuel would have scrutinised insects under a microscope. The ritualistic nature of bourgeois life is seen as cars draw up at the villa one after the other, in the formal dress of the

guests, and in the way they greet each other. Their self-absorption becomes evident when they fail to notice a horse-drawn cart full of drunks rumble through the drawing room, a servant overcome by a fire in the kitchen collapse at their feet, and when they express only mild disapproval at the gardener's shooting of his young son. The arrival of the young man in pursuit of his girl is, though, soon to upset such bourgeois complacency.

Prior to his arrival, the single-minded nature of the young man's passion has been revealed in a series of striking incidents calculated both to scandalise bourgeois viewers of the film and to eulogise irrational feelings. The transcendental power of love allows the young man to impose his vision of his beloved on the world around him, including advertisements for hand cream and silk stockings; she, thinking of him, sees in her dressing-table mirror, not her own reflection, but a beautiful romantic sky. In his haste to find her, moreover, he knocks aside a blind man and, when chosen by the International Assembly of Good Works to carry out its mission, dismisses all notions of loyalty to one's country in favour of erotic passion. Such is his desire and annoyance at any delay to his quest that, when at the villa he is engaged in idle conversation by the Marquis's wife, he throws wine in her face and is ejected from the room. And then, in a rendezvous with the girl in the garden of the villa, the rapture of passion is set against – often comically – bourgeois restraint.

The guests, emerging from the drawing room, sit in rows in neatly arranged chairs as they listen to an orchestra playing the music of Wagner. Simultaneously, the lovers kiss and embrace in a corner of the garden, their uncontrolled rapture comically at odds with the elegant statues and trimmed hedges that form the background, and ironically underpinned by the surging music from *Tristan and Isolde*. Even so, true love never runs smoothly. The young man is suddenly called away to the telephone and harangued by the Minister of the Interior for not undertaking the good works to which he has been assigned. In his absence, the young woman eases her frustration by sucking the toe of a classical statue – a suggestion of fellatio probably attributable to Dalí, newly initiated into the practice by Gala. When the young man returns, the lovers ecstatically embrace once more, but suddenly, as though overcome by a pang of conscience, the girl breaks away and runs into the arms of the conductor of

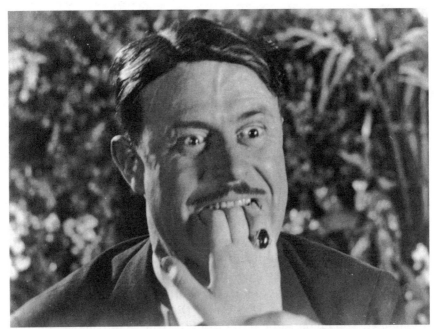

9. The force of passion in Buñuel and Dalí's *L'Age d'or*, 1930

the orchestra, in effect returning to the bourgeois fold and the respectable way of life from which passion has led her astray. In response, the enraged young man rushes into the villa and proceeds to vent his anger on one of the bedrooms, hurling its contents – including a bishop – through a window in an act of pure anarchy.

Throughout its course this far, *L'Age d'or* embodies both the surrealists' hatred of the bourgeoisie and their advocacy of uninhibited feeling, but just as the scorpion's sting is contained in its tail, so is the film's in its conclusion. Based on the Marquis de Sade's novel, *One Hundred and Twenty Days of Sodom*, the final sequence portrays the entrance to the Château de Selliny where the debauched Duke of Blangis and his associates have indulged in a prolonged orgy. As the Duke emerges from the castle, he is seen to be a Christ look-alike, who then goes back inside and murders a girl. The film then ends with a shot of a cross decked out with female scalps. Since Buñuel was a great admirer of the Marquis de Sade, it is quite probable that *L'Age d'or*'s final sequence is

mostly his. At all events, it scandalised many who attended the premiere.[19]

This first showing was a private screening on 30 June 1930, arranged by Charles and Marie-Laure de Noailles, followed by several more screenings for friends and critics, and on 22 October a private screening at the Cinéma du Panthéon for 300 guests, including the official surrealists and other luminaries such as Jean Cocteau, Picasso, Gertrude Stein, André Gide, Alberto Giacometti, George Bataille, and Marcel Duchamp. Buñuel had returned to Zaragoza and was therefore unable to attend but was delighted to hear that many of the aristocrats who saw the film were so shocked by it that they left in silence. It was a reaction that anticipated the outrage that attended the first public screening at Studio 28 on 28 November.

Buñuel was again absent, having been invited to Hollywood by Metro-Goldwyn-Mayer in order to learn American film techniques, but he would probably have expected the violent right-wing reaction that then exploded. On 3 December, the cinema was attacked by members of the League of Patriots and the Anti-Semitic League, ink was hurled at the screen, smoke and stink bombs were thrown into the audience, and surrealist paintings in the foyer were slashed. Over the following days, right-wing newspapers described the film as obscene, disgusting, and tasteless, while left-wing newspapers praised it for its attack on bourgeois values and its eulogy of sexual love.[20] Such was the furore that in the end the Paris Chief of Police, Jean Chiappe – clearly sympathising with the Right – had the film banned, copies confiscated, and the cinema owner prosecuted. The surrealists, delighted by the scandal, produced a four-page account of the events and questioned the right of the police to ban the film, limit free speech, allow property to be damaged, and encourage fascist activities. The upshot was, however, that *L'Age d'or* was not screened publicly for another fifty years, and the Vicomte de Noailles found himself forced to resign from the Jockey Club, snubbed by his social circle, and almost excommunicated by the Vatican.

Earlier in 1930, Dalí had succeeded in buying a broken-down fisherman's cottage on the shore of Port Lligat, a small village quite near Cadaqués. Inhabited only by a dozen or so fishermen, it was a place that, in spite of its relative inaccessibility, Dalí loved

and where, as his fortunes improved, he was able to develop the property. His father was, of course, infuriated by the knowledge that his banished son would be living nearby with a married woman, and did everything in his power to make life difficult for them, including harassment by the local Civil Guard. It is hardly surprising, then, given Dalí's habit of expressing his personal obsessions in his work, that his paintings at this time should be concerned not only with the sexual anxieties referred to earlier, but also with Gala and his father. The first direct reference to Gala appears in *Imperial Monument to the Child-Woman*, which was probably completed in Paris in early 1930. She is represented here by the bare-breasted figure to the left-hand side of the painting and the naked buttocks above. At the top of the picture, the angry lions' heads and the staring eyes of a father figure look down at Gala and, just above her, on hands hiding a face in shame. The rocky form that fills the left-hand side of the painting and against which the figures are placed is Cape Creus, where the Dalí–Gala relationship that had so enraged Don Salvador had begun.

In 1930 Dalí painted the first of a number of paintings on the theme of William Tell. In Swiss legend Tell was, of course, a father who, when instructed by the Austrian governor to shoot at an apple placed on his son's head, had done so successfully, thereby saving his life. In *William Tell*, in contrast, the Swiss hero is replaced by Dalí's angry and threatening father who, far from being the loving parent who saves his son, is presented as a scissor-wielding authoritarian who either has or is about to castrate him, his intent reflected not only in the scissors but in the numerous penis motifs throughout the picture.[21] Completed in 1931, *The Old Age of William Tell* depicts Dalí's and Gala's rejection by Don Salvador, for a couple representing them are seen walking away in anguish from the episode they have just witnessed in which, half hidden by a sheet, the William Tell figure is being masturbated by two women. For Dalí, his father was not only a dominating and vengeful individual but also someone whose rampant sexuality – recall his affair with his wife's sister – caused his son inescapable shame and anguish, as well as reminding him of his own inhibitions. Two years later, one of the last of the William Tell paintings, *The Enigma of William Tell*, depicts a man on one knee with a massive penis-like shape extending horizontally from his rear, its head supported by a forked crutch. In his arms he holds a small child

and near his left foot is a tiny nut. Dalí would later suggest that the painting represented his father, who wished to devour him, and that the small nut was a cradle containing Gala, whom Tell is about to crush.

To this period too belongs one of Dalí's most famous and memorable paintings, *The Persistence of Memory*, completed in 1931. It depicts a dead and deserted landscape near Port Lligat, in which the only things present are one solid watch covered by ants and three melting watches, one draped over the corner of a solid wooden object, a second over the branch of a bare tree, and a third over a shell-like form on the otherwise empty beach. According to Dalí, the idea for the soft watch came to him suddenly, after he had consumed a piece of Camembert cheese, but, whatever its origin, the notion of softness or limpness, as in many other paintings, was deeply psychological, related to his feeling of impotence and emptiness, which Gala was now helping him to overcome; the ants, here as elsewhere in Dalí's work, evoke death and putrefaction.[22] The shell-like form on the beach is, indeed, similar to the face in *The Great Masturbator*, the tightly closed mouth synonymous with Dalí's constant anxiety. Gala may have helped him overcome them to some extent, but it is doubtful that his sexual problems were ever put behind him.

By 1930 Dalí had invented his 'paranoiac-critical thought' process, which, by 1932, he was calling his 'paranoiac-critical method'. Its purpose, as he would later explain, was 'to achieve the most rigorous systemization possible of the most delirious phenomena and materials, with the intention of making tangibly creative my most obsessively dangerous ideas'.[23] For Dalí, paranoia had become a source of fascination from 1930 onwards, for he had discovered that his grandfather on his father's side had suffered from delusions that had eventually led to his suicide. Furthermore, he often wondered if his father's unpredictable rages did not also point to paranoia, and if he, his son, had inherited that tendency. Dalí's knowledge of the condition would, of course, have been enhanced by his familiarity with Freud's *The Interpretation of Dreams* and *Introductory Lectures on Psychoanalysis*, in which Freud had linked paranoia to a strong desire to keep homosexual impulses at bay. In expressing his own sexual inhibitions in his paintings, Dalí may therefore have thought that he was employing a kind of safety valve whereby his demons would be released and

not harm him. As for the method itself, it consisted of seizing upon an obsessional idea suggested by the unconscious and the subsequent elaboration of that idea by means of consciously related associations. As we have seen, many of Dalí's paintings of this period can be seen to be the result of this method. An obsessive image of his enraged father, for example, becomes the source of a number of associated images, from that of a knife to a beautiful woman, roaring lions, individuals overcome by shame – a kind of map, in short, of a traumatic experience. It is hardly surprising, then, that the paranoiac-critical method was seen by André Breton as a valuable contribution to Surrealism.

By this time Dalí's paintings were being shown in numerous exhibitions, either on their own or with the work of other artists. In late March 1930, Dalí's *The First Days of Spring* appeared at the Galerie Goemans in Paris alongside paintings by Arp, Braque, Duchamp, Ernst, Gris, Miró, Magritte, Man Ray, Picabia, Picasso, and Tanguy. In June 1931 an exhibition of Dalí's work at the Pierre Colle Gallery in Paris included, among other paintings, *Little Ashes, The Lugubrious Game, William Tell,* and *The Persistence of Memory.* It attracted the interest of Julian Levy, a New Yorker who was looking for paintings he could display in the gallery he was soon to open in Madison Avenue; he at once bought *The Persistence of Memory.* At the same time, Dalí's paintings caught the attention of Alfred Barr, the first director of the recently opened Museum of Modern Art in New York, who also met Dalí at a party hosted by Charles and Marie-Laure de Noailles. It would not be too long before New York became an important city in Dalí's life.

The year 1930 also saw the publication of the first issue of *Le Surréalisme au Service de la Révolution,* successor to *La Révolution Surréaliste.* In the spirit of the *Second Surrealist Manifesto,* it emphasised that the aim of Surrealism was to undermine bourgeois society and, in that context, expressed its hatred of French colonialism, the army, the Catholic Church, and Christianity in general. Both Buñuel and Dalí were well represented: Buñuel by stills from *L'Age d'or* and Dalí by his text, 'The Rotten Donkey', in which he emphasised the importance of paranoia for Surrealism.

Lorca's interest in Surrealism may have been genuine enough, but the change of direction in his work after 1928 was, as we have seen, partly a response to Buñuel and Dalí's biting criticisms

of its hitherto traditional nature. In his two lectures of 1928 at the Athenaeum Club in Granada, 'Imagination, Inspiration and Escape in Poetry' and 'Sketch of the New Painting', Lorca had argued that the poet should seek a new reality in the world of dreams and the unconscious and that Surrealism was one of the forces that freed the painter from traditional restraints. As well as this, he observed in a letter to a friend, Jorge Zalamea, that he was now concerned with writing a poetry of pure inspiration and intense feeling:

> Now I shall write poetry in which the *veins are opened*, a poetry which is an *escape* from reality and which has an emotion which reflects my love of things and my tenderness for things. Love of death and scorn for death. Love. My heart.[24]

On the other hand, in submitting to *L'Amic de les Arts* the two prose poems, 'Submerged Swimmer' and 'Suicide in Alexandria', he had pointed out, that, although they represented his new approach to writing, 'pure naked emotion', they also had 'a tremendous poetic logic' and were not surrealist, for 'the sharpest consciousness illumines them'.[25] Lorca's denial of the surrealist nature of this and of other later works of this period has much to do, though, with his refusal to be categorised as belonging to any particular movement. What is more, unlike Buñuel and Dalí, he had no links with Paris and Breton's surrealist group. Even so, many critics have described Lorca's work in the period 1929–31 – *Trip to the Moon, Poet in New York, The Public, When Five Years Pass* – as surrealist. And although Lorca was very much his own man, there are clearly surrealist elements in it.

*Poet in New York* is a work that is driven throughout both by Lorca's intense feeling of loneliness and his profound anger towards a society that dehumanises the individual. This second theme, which certainly parallels the more political aims of Surrealism, is most obvious, of course, in the poems about black people, such as 'The King of Harlem', or in the condemnation of the power of money, as in 'New York (Office and Denunciation)'. Otherwise, many of the other poems hark back to Lorca's childhood, or pour out his present feelings of isolation, or suggest the anguish created by the knowledge that he will never father a child. To this extent they are intensely personal, the expression of obsessive concerns

as deeply rooted as Dalí's. And if they have a strong element of artistic control, which provides shape and structure for individual poems and the overall structure of the collection, this is something that, as we have seen, is as true of Dalí's paintings as it is of the two films made in collaboration with Buñuel. On the other hand, there is a further dimension to Lorca's writing characteristic of all his major work. The first-person subject of *Poet in New York* is, of course, Lorca, but he is also the Poet in a more general, universal sense, expressing his anguish not merely in relation to a particular society but in relation to twentieth-century civilisation in general and the spiritual emptiness of twentieth-century man. As in his greatest plays, a local and particular location becomes an image that has a universal, not simply a personal, resonance.

In much the same way, Lorca's *Trip to the Moon*, which he saw as a screenplay for a silent film, vividly expresses his sexual agony through images of violence, castration – echoes of Dalí – and death. The Mexican artist, Emilio Amero, in whose apartment Lorca wrote the piece in the course of an afternoon, noted that it was the work of 'a dreamer, a visionary', which suggests the workings of the unconscious, but he observed too that Lorca returned the next day 'and added scenes he'd thought about overnight'.[26] In short, while *Trip to the Moon* expresses Lorca's personal obsessions, it has too, unlike the automatic writing described in Breton's *Manifesto of Surrealism*, that element of artistic control referred to above.

In 1930 and 1931 Lorca completed two of his most ambitious and innovative plays: *The Public* and *When Five Years Pass*. He may well have begun writing *The Public* – sometimes referred to as *The Audience* – during his stay in New York, worked on it further in Cuba, and finished it in Granada in 1930. *When Five Years Pass* quickly followed, for it was completed on 19 August 1931, its title ominously anticipating Lorca's murder by fascists five years later, on 18 or 19 August 1936. As was his habit, he read both plays in private to a group of friends, some of whom described them as surrealist, and they evidently contain strongly surrealist characteristics. Lorca, however, never used the word in relation to either play. Rather, in acknowledgement of their often shocking subject matter, he referred to them as 'unplayable', 'for the theatre years from now', and he also believed that 'these impossible plays contain my true intention'.[27]

Like *Poet in New York*, both *The Public* and *When Five Years Pass* are strongly self-revelatory, an outpouring of powerful personal feeling. Theatre, though, is a very different form from poetry, not least in the sense that a play requires a plot, a group of characters, and communication with an audience, all of which demand from the dramatist considerable organisational qualities in relation to his material. *The Public* is Lorca's only overtly homosexual play and its protagonist, the Director, is to a large extent Lorca himself. Indeed, when the Director first appears, dressed in a morning coat and therefore the embodiment of bourgeois respectability, he is strongly reminiscent of the dramatist who in almost every photograph wears a conventional suit and tie. But it is also possible that, believing himself to be the protagonist of Buñuel and Dalí's *Un chien andalou*, Lorca also had Dalí in mind in creating this character, thereby taking revenge for what had been done to himself. At all events, the Director attempts to conceal his homosexual leanings beneath a façade of respectability and is only revealed when he is pushed behind a screen which acts as a kind of X-ray and emerges as a boy dressed in white satin, played by an actress. The Director's theatre productions are strictly conventional, avoiding all possible offence to a bourgeois public, as in the case of Shakespeare's *Romeo and Juliet*, in which Juliet is played by a young girl. Even so, Lorca's play is concerned with the revelation of the truth, with seeing the blood and bones beneath the flesh. Just as the Director, in the course of the action, comes to acknowledge his homosexuality, so his safe production of *Romeo and Juliet*, characterised by Lorca as 'the theatre of the open air', becomes more authentic, 'the theatre beneath the sand', when Juliet is played by a boy, predictably shocking the bourgeois audience.

The Director also has his equivalent in some of the other characters. In the very first scene, it emerges that the three men who visit the Director, each of them respectable in appearance, are covert homosexuals. In Scene Two, the Director and the three men observe a game of sexual domination involving the Figure with Bells, the Figure with Vine Leaves, and the Roman Emperor, which is in effect a mirror to their own activities. And in Scene Five, the Red Nude, a suffering, Christ-like figure, who is then seen to transform into one of the three men of the earlier scenes, suggests that the homosexuals of the play are identical in the sense that they all suffer individually and separately.

Apart from suggesting Lorca's anguish in relation to his own homosexuality – in particular the relationships with Dalí and Emilio Aladrén – and his coming to terms with it in the way that the Director finally does, *The Public* is also concerned with the nature of love itself. In Scene Three, for example, Juliet is seen, after her death, in her tomb in Verona, where her rejection of an amorous approach by First White Horse expresses her disillusionment with love, which she sees as an illusion, a footprint in water, synonymous with despair and, ultimately, death. The scene ends, moreover, with the Director and the three men searching in vain for the men they love and discovering that nothing is what it seems to be – an episode that suggests, perhaps, Lorca's futile attempt to hold onto Dalí and Aladrén. It powerfully expresses Lorca's bitter experience of love, but, as in *Poet in New York*, suggests that in this play as a whole that bitter taste is, as well as personal, something that, as human beings, we all share from time to time in the course of our lives.

In certain respects, some of Lorca's images and techniques in *The Public* have a Dalinian resonance. The play's settings, for example, are not unlike Dalí's paintings of the late 1920s, evoking the painter's decapitated heads, dismembered limbs, torsos and the like, all placed against bare backgrounds. Such is Lorca's setting for Scene One: '*A blue background. A great hand imprinted on the wall. The windows are X-ray plates.*' The suggested setting for Scene Three is in the same vein: '*Wall of sand. To the left, painted on the wall, a moon with the transparency of gelatine. In the centre, an immense green leaf, pierced*'; and Scene Six is also similar: '*The same design as for Scene One. To the left, a great horse's head on the ground. To the right, an enormous eye and a cluster of trees with clouds pinned to the wall.*' In the last example, the eye may, of course, owe something to the opening of *Un chien andalou*.

In the first scene of Lorca's play, the Director is confronted by three homosexual men who demand that he reveal his true nature; in an attempt to prove that he is not homosexual, he calls upon a woman, Elena, to speak up for him. In this context, it is appropriate to remember that the real name of Dalí's lover and future wife, Gala, was in fact Helena. It seems possible, therefore, that in the play Lorca is suggesting that Dalí's association with Gala-Helena was, at least in part, a denial of the painter's homosexual leanings.

*The Public* is also characterised by a series of transformations, a technique that was also favoured by Buñuel and Dalí and that again underlines the links between them. In *Un chien andalou*, for example, there is a sequence in which the male protagonist squeezes the young woman's breasts, which then become her buttocks. Similarly, a close-up of the hair in a female armpit dissolves into a sea urchin, which in turn becomes a female head seen from above. For Dalí the coastline around Cadaqués suggested constant metamorphosis, the rocks resembling first one thing, then another, while his paintings frequently contain multiple images. In *Apparition of Face and Fruit Dish on a Beach*, painted in 1938, a fruit bowl, a dog, and Lorca's face merge into each other, as they do in another painting completed in the same year: *Invisible Afghan Hound with the Apparition on the Beach of the Face of García Lorca in the Form of a Bowl of Fruit with Three Figs.*

In the first scene of *The Public*, as mentioned earlier, the Director and the three homosexuals who visit him pass behind a screen and reappear in a totally different form. In the second scene of *The Public*, the Figure with Bells and the Figure with Vine Leaves play a game in which transformation is the essence:

FIGURE WITH BELLS:    If I were to change into a cloud?
FIGURE WITH LEAVES:    I would change into an eye.
FIGURE WITH BELLS:    If I were to change into shit?
FIGURE WITH LEAVES:    I would change into a fly.

In the third scene, characters remove their costumes and reveal a different one beneath in a process pointing to an ever-changing identity. The last scene of the play introduces the Magician, whose profession is, after all, to transform one thing into another.

Undoubtedly, Lorca, Buñuel, and Dalí saw transformations of the kind described above in their own particular way. For Buñuel and Dalí the technique was one that allowed them to suggest the shifting nature of dream and the workings of the unconscious mind. For Lorca it enabled him to convey his realisation that identity is not always what it seems to be, and that the outer, observable appearance of an individual may be stripped away to reveal what lies beneath and is often shameful. For all their differences of approach, the notion of transformation was something common to all three.

*When Five Years Pass* once more voices Lorca's obsessive concerns with love, passing time, and death. Although it is in general a more structured play than *The Public*, its dream-like and nightmarish episodes, its playing with time, and its emphasis on the inner lives of its characters give it a distinctly surreal quality.[28] The protagonist, the sexually inhibited Young Man who prefers to dream of women rather than engage with them, is, like the Director in *The Public*, a projection of Lorca himself, and the other characters and the events in which they are involved can fairly be said to be the projection of his desires, fantasies and fears: in short, to occur inside his head. The Old Man is thus a more faded, disillusioned form of the Young Man; the sexually charged and energetic Friend and, later, the Football Player, the person he would like to be; the Second Friend a reminder of the innocence of childhood; the Dead Child and the Dead Cat personifications of death; the Girlfriend the woman he is able to love only in his fantasies; the accusing Manikin the voice of his conscience; Harlequin and the Clown the forces that mock and frustrate him; the three Card Players the reality of death. The way in which some of these characters appear, disappear, and reappear again in a changed form parallels, moreover, the fluctuating, shifting character of dream. In Act One, for example, the Secretary, passionately in love with the Young Man, is rejected by him, but later, in Act Three, when he has changed, desires her and seeks her out, he is rejected by her. As well as this, the dream-like fluctuation of the action is shot through with nightmarish figures and episodes. In Act One, the on-stage characters of the Young Man, the Old Man, the Friend, and the Second Friend witness the appearance and the anguish of the Dead Child and the Dead Cat, the reality of death from which there is no escape. And in Act Three that reality presents itself in the sinister figures of the three Card Players in their long cloaks, coming to oblige the Young Man to play his final game, at the end of which they cut the thread of life.

As the above suggests, *When Five Years Pass* is less about homosexuality than about a failure to respond to women. It reveals too, as Lorca grew older, his deeply ingrained fears about passing time and death. It is, without doubt, one of his most accomplished plays. A planned production at the Anfistora Club in Madrid in the spring of 1936 did not materialise, but in 2006 an English production in my own translation at the Arcola Theatre in London

proved what an accomplished and theatrical work it is, described by John Peter in the *Sunday Times* as 'a revelation'.[29]

While *When Five Years Pass* contains a strong autobiographical element, it is also reminiscent in certain respects of Buñuel and Dalí's *Un chien andalou*. Convinced, as we have seen, that the film's protagonist was based on himself, Lorca may well have thought of turning the tables on them in his play, as he may have done in *The Public*. While the sexually inhibited Young Man of the first two acts is undoubtedly a projection of the dramatist, he also brings to mind the male protagonist of the film who lies in the gutter, unable to respond to the young woman's embraces, and could therefore be a form of Dalí or Buñuel. Again, the play's final scene, in which the Young Man's clothes are laid out on the bed, recalls a similar episode in an early sequence of the film. The energetic Friend who in Act One of the play seizes the Young Man's lapels in order to pull him to his feet parallels a similarly vigorous male in the film who does precisely the same thing. And if the all-action Friend – and in Act Two the Football Player – suggest the 'masculine' person that Lorca would have liked to be, they have their equivalent in the bold and dashing young man who, towards the end of the film, walks off with the young woman. The coincidences are many and probably not coincidental.

Largely disillusioned by his first experience with Metro-Goldwyn-Mayer, Hollywood, and American cinema in general, Buñuel returned to Paris in April 1931. He had hoped to be employed as a director, given the success of *Un chien andalou*, but – like Lorca – unable to speak English, found himself isolated, at a loose end, and bored by Los Angeles. He resigned and left for France after four months, but by the time he arrived, the Paris surrealist group was beginning to fall apart. Louis Aragon, Georges Sadoul, Pierre Unik, and Maxime Alexandre had left by 1932 in order to join the Communist Party, regarding the Surrealist movement as too elitist and intellectual. Buñuel, always a firebrand, abandoned the group in 1932 for similar reasons:

> In 1932 I separated from the surrealist group, although I remained on good terms with my ex-companions. I was beginning not to agree with that kind of intellectual aristocracy, with its artistic and moral extremes, which isolated us from the world at large

and limited us to our own company. Surrealists considered the majority of mankind contemptible or stupid, and thus withdrew from all social participation and responsibility and shunned the work of the others.[30]

Given his aggressive nature and his innate hatred of bourgeois values, it is not surprising that he should now have turned his attention to making a film that differed from both *Un chien andalou* and *L'Age d'or* in the sense that it was concerned neither with the revelation of the unconscious nor with portraying the clash between passion and traditional values, but entirely with the victims of bourgeois complacency and neglect. In short, *Las Hurdes*, also known as *Terre sans pain* (*Land Without Bread*) – completed in 1933 – represented the political dimension of Surrealism described by Breton in the *Second Surrealist Manifesto* of 1929. In addition, it was a film made without the collaboration of Dalí, now too involved with Gala and his own ambitions.

The political inclinations of Buñuel's backers and collaborators on *Las Hurdes* make for interesting reading. Financial backing came from Ramón Acín, a committed anarchist. The assistant director, Rafael Sánchez Ventura, was also an anarchist. The cameraman, Eli Lotar, was a committed Trotskyist, and Pierre Unik, Buñuel's collaborator on the script, had, as mentioned above, left the surrealist group in order to join the Communist Party. As for the subject of the film, Las Hurdes, a mountainous region in the province of Extremadura in south-west Spain, had been for years a symbol of the country's isolation and backwardness, characterised by extreme poverty, hunger, deplorable housing conditions, and disease. In this respect it had been the subject of numerous articles and studies, including a detailed account, *Las Hurdes, etude de géographie humaine*, by the French scientist Maurice Legendre, published in 1927. Prior to this, a debate on the region had taken place in the Spanish Parliament, and King Alfonso XIII made two visits there, the first in 1922, the second in 1930. But nothing had been done to improve conditions in Las Hurdes, despite the election in 1931 of a left-wing government committed to social change.

Buñuel's strategy in *Las Hurdes* was to create an initial sense of complacency in the audience, which was likely to be highly bourgeois, and then to deliver step by step the kind of shock that

had distinguished his earlier films. The opening of *Las Hurdes* therefore gives the impression that the film is to be a documentary, a 'cinematic essay in human geography' about people who struggle to survive. The Fourth Symphony of Brahms on the soundtrack provides a suitably heroic note, and early shots of the town of La Alberca, with its whitewashed houses and preparations for a traditional ceremony, create a pleasant and favourable impression. The first of a series of stomach-churning shocks arrives when part of this ceremony is shown to consist of recently married men ripping the heads off cockerels. On the soundtrack, the commentator's observation that 'In spite of the cruelty of this scene, our duty to be objective obliges us to show it to you,' is all the more unsettling for its coolness.

A transition to the valley of Las Batuecas, with its lush vegetation and flowing streams, reintroduces a note of pastoral reassurance, but it is short-lived, for Buñuel then takes us into the heart of Las Hurdes, delivering one shock after another. In the village of Aceitunilla the houses are primitive, the people are shabbily dressed, and children drink from the same stream as pigs. In the local school, many of the children have no shoes and their heads are shaved to free them from lice. Moving on to the village of Martilandrán, the camera reveals pigs in the streets, individuals dressed in rags, and the prevalence of goitre. Finally in Fragosa, where the diet is poor, the land unfertile, and incest frequent, dwarfs and cretins are much in evidence, their grinning faces staring mindlessly into space. Vipers and mosquitoes are also a constant cause of death, and when death comes, the body has to be transported many miles, as in the case of a small child, to the cemetery where a rough wooden cross marks the graves, reminding us that in this region life is cheap and expendable.

The first screening of *Las Hurdes*, in December 1933, was a private one at the Palacio de la Prensa in Madrid, attended by many of the capital's intellectuals. Their reaction was decidedly cool. In order to obtain a licence for public screening, Buñuel also arranged a private showing for Dr Gregorio Marañón, then an influential figure in Spanish cultural and political life. But Marañón simply complained that Buñuel had neglected to portray in his film not only the beautiful dances of Las Hurdes, but also the carts loaded with wheat that frequently passed along the roads of the region. Consequently, the film was banned and did not obtain a licence for

public screening until early 1936, only for the outbreak of the Civil War in July of that year to prevent its release. Not until 1965 did a final version, with sound and cuts restored, appear. But if such setbacks disappointed Buñuel, he must have been pleased, in true surrealist fashion, that his documentary had offended the powers that be to the point where they felt obliged to ban it.

As far as surrealist ideals and objectives are concerned, Buñuel remained true to them throughout his life. His first film opens with the shocking assault on an eyeball. His last, *That Obscure Object of Desire*, ends with the explosion of a terrorist bomb. Even if, in some of the later films, Buñuel seems to have mellowed somewhat, he never ceased to emphasise the importance of the unconscious or to place bourgeois values in the direct line of fire. Dalí, in contrast, produced his best surrealist work between 1926 and 1938, surrendering for the rest of his long life to the temptations of money and fame and embracing Fascism in a way that the surrealists could never stomach. As for Lorca, his surrealist experiments were bold, striking, and relatively short-lived in terms of form and technique, but his left-wing views and his hostility towards the bourgeoisie and the Catholic Church – both surrealist targets – continued until his death at the age of thirty-eight.

## NOTES

1   On Surrealism, see David Hopkins, *Dada and Surrealism: A Very Short Introduction*, Oxford: Oxford University Press, 2004.

2   See André Breton, *Manifestoes of Surrealism*, trans. Richard Seaver and Helen R. Lane, Ann Arbor: University of Michigan Press, 1972, p. 3.

3   Buñuel, *Mi último suspiro*, p. 86. This observation does not appear in *My Last Breath*. The autobiography was first published in France under the title *Mon dernier soupir*, Paris: Robert Laffont, 1982.

4   See Dalí, *The Secret Life of Salvador Dalí*, p. 167.

5   Buñuel, *My Last Breath*, p. 104.

6   *La Révolution Surréaliste*, no. 12, 15 December 1929, p. 34.

7   Buñuel, *My Last Breath*, p. 104.

8   Ibid., pp. 103–4.

9   Henry Miller, *The Cosmological Eye*, London: New Directions, 1945, p. 57.

10  Buñuel, *My Last Breath*, p. 157.

11    See Salvador Dalí, *Le Mythe tragique de l'*Angélus *de Millet. Interprétation 'paranoïaque-critique'*, Paris: Jean-Jaques Pauvert, 1963, p.57.
12    Buñuel, *My Last Breath*, p. 15.
13    Ibid., p. 106.
14    See '"Un chien andalou", Film par Louis Buñuel', *Cahiers d'Art*, no. 5, 1929, pp. 230–1.
15    Buñuel refers to a collaboration on the film with Dalí in a letter to Pepín Bello, dated 11 May 1930. See Sánchez Vidal, *Buñuel, Lorca, Dalí. El enigma sin fin*, p. 246.
16    See the reference to the *Second Surrealist Manifesto* earlier in this chapter.
17    Buñuel, *My Last Breath*, p. 107.
18    See André Breton, *Oeuvres complètes*, Paris: Gallimard, 1988–92, vol. 1, p. 793; Buñuel, *My Last Breath*, p. 107.
19    For a more detailed study of the film, see Gwynne Edwards, *The Discreet Art of Luis Buñuel*, London: Marion Boyars, 1982, pp. 63–86, and *A Companion to Luis Buñuel*, pp. 29–37.
20    Edwards, *A Companion to Luis Buñuel*, p. 36.
21    See Alan Moorhouse, *Dalí*, Leicester: Magna Books, 1990, p. 20.
22    See Secrest, *Salvador Dalí: The Surrealist Jester*, pp. 128–9.
23    Salvador Dalí, *Diary of a Genius*, trans. Richard Howard, London: Hutchinson, 1990, p. 195.
24    García Lorca, *Epistolario, II,* p. 108.
25    Ibid., p. 114.
26    See Richard Diers, 'Introductory Note to FGL "Trip to the Moon". A Filmscript', *New Directions*, vol. 18, 1964, pp. 33–5.
27    In an interview with Felipe Morales. See García Lorca, *Obras completas*, vol 3, p. 631.
28    For a more detailed study of *The Public* and *When Five Years Pass*, see Edwards, *Lorca: Living in the Theatre*, pp. 29–60.
29    'When Five Years Pass', *Sunday Times*, 10 September 2006.
30    See Aranda, *Luis Buñuel: A Critical Biography*, p. 88.

# 6

# POLITICS AND SEX

ల్లు

WHEN LORCA RETURNED to Spain in the summer
of 1930, the political situation had changed completely.
Seven years earlier a military coup had seen Miguel Primo
de Rivera seize power, allegedly in response to years of political
inefficiency and ever-changing governments. In this respect the
dictatorship, which promised stability and an end to the political
corruption and uncertainty of the past, was initially welcomed.
Primo de Rivera, despite the fact that he was a powerful landowner,
had great sympathy for the poverty-stricken workers of his native
Andalusia and, within the limits open to him, had every intention
of improving their lot. Even so, his seven years in power slowly
went from bad to worse. Censorship of the press, the banning of
left-wing trade unions, the abolition of parliament, the suppres-
sion of public liberties, and the replacement of town councils with
groups chosen by the military, all proved to be highly damaging.
And it was, of course, a disastrous period for Spain's intellectual
and artistic life. Among other organisations, the Madrid Ath-
enaeum, where Lorca was a frequent visitor, was closed on the
grounds that it was a hotbed of left-wing politics. Individuals who
were regarded as spreading anti-government propaganda, as in
the case of Fernando de los Ríos, friend of the Lorca family and
Lorca's companion on his voyage to America, were prosecuted. In
February 1929, moreover, Lorca had himself suffered at the hands
of the regime, when rehearsals for a production of *The Love of Don
Perlimplín* were suddenly stopped. The ostensible reason was the

failure of the company to observe the period of mourning decreed by the government for the recently deceased Queen Mother, María Cristina, but the real motive probably lay in the fact that the main character in the play, the cuckolded Perlimplín, was not to the taste of a regime that proclaimed manliness as an ideal; in addition, the actor playing the role was a retired army officer.

Just under a year later, the dictatorship came to an end. The Wall Street Crash of 1929 had its repercussions in Spain as much as anywhere else. While Lorca was still in New York, opposition to Primo de Rivera grew steadily, and in January 1930, unable to cling to power any longer, the dictator stepped down and left Spain for Paris. He was replaced by the more moderate General Dámaso Berenguer, who promised general elections and a return to democracy. Somewhat strangely, municipal elections, which finally took place on 12 April 1931, preceded general elections, and the victory of the Left, who bitterly opposed the monarchy, guaranteed a similar victory in the subsequent general elections. Under these circumstances, King Alfonso XIII, who had supported Primo de Rivera in his seizure of power eight years earlier, left the country, paving the way for the inauguration of the Second Republic on 14 April 1931. By this time, Primo de Rivera was dead and the old order swept away.[1]

The new republican government, fired by its socialist ideals, immediately set about righting the wrongs that had undermined Spanish society for so many years. Among other things, it set about legalising divorce, providing women with more rights, introducing agrarian reform and undermining the power of the rich landowners, curbing the influence of the religious orders, such as the Jesuits – not least in relation to their control of education – and raising educational standards in general by building more schools and implementing more enlightened policies. Even so, the euphoria associated with the introduction of long-repressed freedoms had its negative side. On the one hand, the reaction of the Church to the new policies was bitter and hostile; on the other, those who opposed and had suffered at the hands of religious authorities vented their anger by attacking and burning churches. There were bitter clashes too between republicans and those who supported the monarchy. It was a polarity that would constantly reveal itself during the five years of the Second Republic and would become more exaggerated with the passing of each year.

ꝏ

Lorca's political views were, perhaps, rather naive, motivated less by an interest in politics and the complexities of political life than by that compassion for the underprivileged that he had felt as a child in Fuente Vaqueros and Asquerosa, and which, as an adult, caused him to rage at the exploitation of the black people of Harlem – a reaction that paralleled Buñuel's sympathy for the deprived and forgotten poor of Las Hurdes. In this respect his feelings certainly ran deep; he was instinctively opposed to regimes that deprived individuals of their rights, and he was therefore delighted by the downfall of Primo de Rivera and the installation of a democratically elected government. Furthermore, he fully approved of the new government's cultural and educational initiatives, which included the creation of 'Teaching Missions' designed to improve the lot of those who lived in remote and isolated villages by providing concerts, play performances, art exhibitions, talks, films, library facilities, and additional educational opportunities. Within this framework, a group of students at the University of Madrid proposed the creation of a touring theatre company that would perform the great plays of Spain's Golden Age in towns and villages throughout the country, with Lorca as their artistic director. Government support for the company was soon granted by Fernando de los Ríos, now Minister of Justice, and it soon came to be known as La Barraca, a word meaning 'barn' or 'shed' and describing the permanent structure the company intended to build in Madrid but which never materialised. Lorca, as artistic director, was also provided with a right-hand man, Eduardo Ugarte, who took responsibility for the more practical and organisational requirements of the group. They proved to be a successful team, and over the next four years La Barraca would stage many highly successful productions.[2]

For La Barraca's first tour, Lorca chose to present three *entremeses* – short plays or interludes – by Miguel de Cervantes, and Calderón's religious play, *Life is a Dream*. On 10 July 1932, the company set out from Madrid, their means of transport consisting of a lorry carrying the portable stage, scenery and props, two police vans transporting the student actors and stage-hands, and several private cars. The first stop was the town of El Burgo de Osma, in the province of Soria, a hundred or so miles to the north of Madrid. Over the next two days they performed in San Leonardo

10. Lorca's production with La Barraca of Calderón's *Life is a Dream*, 1932

and Vinuesa, on 13 July in the town of Soria itself, and then in Almazán before returning to Madrid, where they presented two of the Cervantes plays and the first half of *Life is a Dream* at the Residencia de Estudiantes.

Lorca was delighted by the success of the enterprise, in spite of the fact that the tour had had its problems. In San Leonardo and Soria, for example, bad weather forced the company to perform indoors rather than in the open air, and in both Vinuesa and Soria it encountered considerable hostility. In Vinuesa, where the inhabitants were in many cases people who, like Buñuel's father, had made their fortune in South America, the arrival of a group of young people dressed in overalls – worn to create a sense of equality within the company – created initial suspicion and the belief that they were communists. In Soria the right-wing enemies of La Barraca, in all probability monarchist students from Madrid, succeeded in stopping the performance, first by heckling, and then by sabotaging the electricity and plunging the stage into darkness. It was the kind of right-wing opposition to the company – and to Lorca himself – that would persist throughout the coming years.

One month after the end of their first tour, La Barraca went on the road once again, on this occasion to the north-western provinces of Galicia and Asturias, where they performed the same programme, without any problems, in Avilés, Cangas de Onís, Grado, La Coruña, Oviedo, Pontevedra, Ribadeo, Santiago de Compostela, Vigo, and Villagarcía de Arosa. In October, the company travelled to Granada, where, as part of the University of Granada's fourth-centenary celebrations, they presented *Life is a Dream* at the Teatro Isabel la Católica, and, the next day, the three short Cervantes plays to an audience of workers and children in the square of a former artillery barracks. At the end of the month they were in Madrid, performing at the Central University, and on 19 December they presented *Life is a Dream* and the three Cervantes plays at Madrid's famous Teatro Español to a distinguished audience whose enthusiasm was echoed in glowing theatre reviews. A week later they travelled to Murcia and Elche in the south-east, and then ended a triumphant year by staging *Life is a Dream* in Alicante. If the government's educational policy were to be measured by the activities of La Barraca, it would certainly be regarded as a great success.

Lorca's experience with his touring company also had a signifi-
cant effect on his own writing, for during his time as its director
he also wrote four of his major plays. He was probably at work on
*Blood Wedding* at the end of 1931 and seems to have completed
it in a feverish burst of creative activity in the summer of 1932.
Based on a newspaper account of 1928 in which a twenty-year-old
bride-to-be ran off with a previous lover, only to see him killed
on the road by the bridegroom's enraged cousin, *Blood Wedding*
is a highly accomplished theatre work revealing a great variety
of influences, as well as the personal preoccupations of Lorca's
earlier work, and, to a certain extent, the political colouring of the
plays he would write over the next four years.

The theme of sexual frustration that had been expressed so
powerfully a year earlier in *When Five Years Pass* is embodied here
in the characters of the Bride, soon to be married to the Bridegroom,
and her former lover Leonardo, who now has a wife and child and
a second child on the way. Unable to withstand their feelings for
each other, the Bride and Leonardo make their escape during the
wedding reception, but are then hunted down by the Bridegroom
and his relatives until, finally, the Bridegroom and Leonardo kill
each other in a fight with knives, leaving behind them a grieving
mother on the one side, and a widow and fatherless children on
the other. In the two lovers, Lorca clearly expressed his belief that
passion cannot be denied, but in his portrayal of the society in
which they live, he also depicted a Spain rooted in the past and
ruled by values of the kind that the new government clearly hoped
to change. In this respect, the imminent marriage of the Bride
and the Bridegroom is one arranged by their respective parents
and motivated, as in so many cases, by financial considerations
and concerns with land, not by the young people's love for each
other. Furthermore, both families believe implicitly in a code of
honour which had existed for centuries in Spain and which, when
the lovers escape and bring dishonour to their families, demands
revenge and the cleansing process of bloodshed. In many respects
*Blood Wedding* reveals the influence of Greek tragedy, not least in
its use of a chorus and in the way the characters are manipulated
by forces over which they seem to have no control, but the play
is also Lorca's portrayal of old Spain, a portrayal that he would
develop in *Yerma* and in *The House of Bernarda Alba* and which,
although it does not contain any direct political comment, is highly

relevant to the social and political aspirations of the government with which, as director of La Barraca, Lorca was now associated. In the sense that it is a play in which fate is seen to have a crucial role – especially in the final act – *Blood Wedding* also seems to express, however, Lorca's belief that, as far as his own sexual inclinations were concerned, he could not change. Like the lovers of his play, his course was now set.

The premiere of *Blood Wedding*, directed by Lorca himself and staged by the company of the Argentinian actress, Josefina Díaz de Artigas, took place on 8 March 1933 at the Teatro Beatriz in Madrid. Prior to this, three of his plays had been staged: *The Butterfly's Evil Spell* in 1920, *Mariana Pineda* in 1927, and *The Shoemaker's Wonderful Wife* in 1930, the last two successfully produced by the company of the famous actress Margarita Xirgu. But none of these could compare with either the achievement or the impact of *Blood Wedding*, Lorca's first unqualified success in the theatre and the play that truly established him as Spain's leading dramatist. Writing in the newspaper *El Sol*, M. Fernández Almagro reflected the views of many theatre critics:

> What impressed me most in *Blood Wedding* was just this: the spirit which drives it all, a breath which comes from very far and very deep, the soul of a primitive people. The same soul of *Gypsy Ballads*, which doesn't allude to the Andalusians of the East or the West, of inland or coast, but to the Andalusians in their deepest historical and psychological perspective . . . From scene to scene the effects are executed with magisterial skill . . .[3]

Such was the audience's reaction to the play that Lorca was obliged to appear on stage at the end of each act and on several occasions during the course of the action.

Just under a month later, on 5 April, *The Shoemaker's Wonderful Wife* and *The Love of Don Perlimplín* were staged for one night only at the Teatro Español by the amateur company of Pura Maórtua de Ucelay, once more to great acclaim. At the end of May, the Madrid production of *Blood Wedding* transferred to Barcelona. In July the company of another famous actress, Lola Membrives, opened their production of the same play in Buenos Aires, and in October Lorca himself arrived there aboard the liner *Conte Grande*. Once more *Blood Wedding* proved to be a huge success, as was *The Shoemaker's Wonderful Wife*, but *Mariana*

*Pineda*, the third Lorca play in Lola Membrives's autumn season, proved to be less appealing to an audience who apparently disliked historical drama. Lorca did not return to Spain until April 1934. During his six months in South America he had not only witnessed the triumph of two of his plays but had given a number of highly successful and profitable public lectures and been acclaimed by an adoring public wherever he went. He was at the height of his fame, but in Spain the political situation had fundamentally changed.

The tensions that had followed the electoral triumph of the Left in 1931 had grown steadily over the next years. In August 1932, for example, the monarchist General José Sanjurjo had staged a military coup against the Madrid government; although a failure, the coup was sufficient indication of the intentions of the Right. At the beginning of 1933 a dissatisfied group of anarchist labourers descended on the barracks of the Civil Guard in the village of Casas Viejas in south-west Spain, where they killed two of the occupants and were themselves, as the result of a series of misunderstandings, massacred on the orders of the Madrid government, which, in theory, was their political ally. It was an incident that severely damaged the authority of the government and which, of course, the Right used to its advantage. Furthermore, in 1933, José Antonio Primo de Rivera, the son of the former dictator, was in the process of forming the Falange Española, the Spanish Fascist Party, an event that coincided with the growth of Fascism in Germany and Italy under Hitler and Mussolini. The party held its first official meeting in October. By this time, increasing tensions between the various groups that made up the Left had made effective government impossible and finally obliged the government to set a date of 19 November for general elections. The predictable outcome was, of course, that the Right came into power and proceeded at once to overturn many of the progressive policies introduced by the Left. When Lorca returned to Spain in early 1934, the euphoria that had accompanied his homecoming from Cuba four years earlier had completely disappeared.

The changing political situation can also be seen in relation to the increasing hostility that the activities of La Barraca encountered. Before his departure for Argentina, Lorca had created for the company an updated version of Lope de Vega's seventeenth-century play, *Fuente Ovejuna*, in which he gave particular emphasis to its social message. In the original play, set in the fifteenth century,

Fernán Gómez, feudal overlord of the village of Fuente Ovejuna, takes advantage of his position to abuse the local inhabitants, in particular abducting Laurencia, who is promised in marriage to Frondoso. Unable to tolerate further the nobleman's behaviour, the villagers finally rebel and murder him and, when called to account by the king, refuse to name any individual as the perpetrator of the crime, claiming instead that the village as a whole bears the blame. Lorca, in updating the story, saw an opportunity to focus on an issue that the left-wing government of 1931–3 had attempted to resolve: the exploitation of twentieth-century peasant workers by wealthy landowners, especially in the south of Spain. He therefore transformed the overlord of the original play into a contemporary landowner dressed in a black business suit, while the workers and women on his estate wore corduroy and typical dresses. The modern character of the production was further emphasised by the introduction of songs and dances with which a modern audience would be familiar.[4]

The premiere took place on 31 May 1933 in Valencia and greatly impressed the largely working-class audience in a way that was subsequently echoed in the other towns and villages where the play was performed. The Right, of course, hated the production. From the outset, they had objected to government backing for a company they regarded as spreading left-wing propaganda, an accusation that the production of *Fuente Ovejuna* merely reinforced. Furthermore, considering actresses to be little different from prostitutes, what could be said about a company in which there were twenty or so men and only five or six women? The sleeping arrangements and associated nighttime activities could only be imagined. And then there was Lorca himself, the director of La Barraca and a known homosexual. All this amounted to an opposition that merely increased as time passed.

During the autumn and winter of 1930–1, Buñuel was, as we have seen, in the United States at the invitation of Metro-Goldwyn-Mayer. His return to Europe on 1 April 1931 occurred, therefore, when the new republican government was about to come into office in Madrid, and, as a committed supporter of the Left, he was clearly delighted by it. Indeed, such was his enthusiasm for the overthrow of the dictatorship that he now urged his fellow Paris surrealists to set out for Madrid at once in order to burn the

Prado, archetypal symbol of bourgeois good taste and wealth. He even suggested burning the negative of *L'Age d'or* in front of the Sacré Coeur, but Breton had an intense dislike of violence and resisted Buñuel's proposal, as did most of the other surrealists. An enraged Buñuel therefore set out for Spain alone and was overwhelmed by the spectacle in Zaragoza of so many people in the streets celebrating the arrival of democracy. In mid-April he was in Madrid for the declaration of the Republic, but there is no evidence that he encountered Lorca there. He remained in Spain for only two weeks, somewhat disappointed that the level of violence had not met his expectations.

For most of 1932 and 1933 Buñuel worked in Paris, dubbing films for Paramount, but he returned to Spain fairly regularly and was present when, on 22 November 1932, *L'Age d'or* was shown for the first time at a private screening at the Palacio de la Prensa in Madrid, and was followed by a screening of *Un chien andalou*. It was an occasion attended by many important left-wing artists and intellectuals, but Lorca was at this time in Galicia and would not therefore have seen the film. As for the general political situation, riots and strikes frequently paralysed the country, and peasant workers grew more and more dissatisfied with promises of land reform that never materialised. In such circumstances Buñuel's strongly left-wing views remained intact, unlike Dalí's, but he seems not to have committed himself officially either to the communists or the anarchists with whom he made *Las Hurdes* in late 1932.

During his teenage years, Dalí had been strongly influenced by his father's radical views. He kept abreast, through the newspapers, of the social and political problems that were affecting Spain, as well as other countries such as Russia after the Revolution, and professed both an affinity with Communism and a hatred of capitalism. Indeed, at the age of fifteen he was a powerful advocate of a Russian-type revolution in Spain itself, suggesting in his diaries that he would welcome it 'with open arms, crying out "Long live the Soviet Republic!" And if tyranny is needed to bring about a true democracy and a genuine social republic, then long live tyranny!'[5] Two years later he was involved with three Catalan friends in setting up a group called Social Renovation, which advocated class struggle and the triumph of the workers. At

the Residencia de Estudiantes, his political views were reinforced by his friendships with other left-wing individuals, not least with Buñuel, and his rebellious nature was clearly demonstrated both by an apparent plan to blow up the King during a visit to the Academy of Fine Arts in March 1923,[6] by his dismissal for one year from the institution in the same year, and by his final expulsion in 1926.

Dalí's embracing of the ideals and objectives of Surrealism also possessed, as we have seen, a political dimension inasmuch as the movement sought to revolutionise man's thinking and to undermine those traditional values represented in particular by the bourgeoisie. In this respect he strongly supported André Breton's view in the *Second Surrealist Manifesto* that Surrealism and Marxist thought were compatible and complimentary, and in 1930 signed a statement to that effect along with fourteen other surrealists. Later in the year, Dalí and Buñuel were also signatories to a document in support of Breton that appeared in the first issue of *Le Surréalisme au Service de la Révolution*, and in 1931, just after the inauguration of the Republic, they joined other surrealists in signing a tract in which they advocated the burning of churches and the need for a full-blooded Marxist revolution in Spain. In November 1931, in an address to the Workers' and Peasants' Front in Barcelona, Dalí gave a lecture, 'Surrealism in the Service of the Revolution', in which he attacked the Catalan cultural establishment in general and explained that one of the main aims of Surrealism was to demoralise bourgeois society.

Even so, Dalí was by now beginning to get himself into trouble. In December 1931 he published in *Le Surréalisme au Service de la Révolution* a piece called 'Reverie', in which he described in detail his plan to sodomise an attractive eleven-year-old girl called Dulita. The fantasy, which apparently lasted several days and involved innumerable erections, ended with his penetration of her, at which point she was transformed into Gala. By the time the piece appeared, those Paris surrealists who were also ardent communists, in particular Aragon, were increasingly concerned about Dalí's obsession with his inner life, which they now began to see as excessively self-indulgent. By 1933 Breton, despite his continued support of Dalí – whom he had so far regarded as essential to the Surrealist movement – also began to be troubled by the painter's increasing fascination with Hitler, who was now

eliminating all opposition in Germany. In 1934 Breton had further issues to consider, for, as well as publicly praising Nazi Germany, Dalí was expressing his delight in the mishaps endured by working-class people, defending academic painting and criticising modern art, and strongly advocating paternal authority, all matters he had previously opposed. It was an extraordinary transformation. Dalí's defence that he would never allow such personal issues to override his championing of surrealist group activities saved him for the moment, but when in February 1934 he exhibited *The Enigma of William Tell* at an exhibition in Paris in defiance of the surrealists' decision not to include their work, he was soon threatened with expulsion from the group. It was a sign of things to come and of the fact that Dalí was now moving in a very different direction.

Given the fact that the surrealists championed freedom from the restrictions of conventional social and moral values, we should not be surprised to discover that sexual freedom figured prominently in their list of priorities. While the surrealist group that Buñuel and Dalí joined in 1929 included individuals whose temperament and personality were often different, most of them seem to have practised what they preached in terms of their sexual activities. André Breton was in general a highly disciplined and extremely intellectual individual, but his marriage to Simone Kahn was an open one in which both partners indulged their sexual inclinations to the full. In 1927, for example, Breton was on holiday in Normandy at the same time as Louis Aragon and his mistress, Nancy Cunard, the rich and beautiful daughter of the shipping magnate, and took advantage of the situation by sleeping with her. A year later, he became obsessed with Susanne Muzard, a former Paris prostitute living with Emmanuel Berl, whom she abandoned for Breton but to whom she returned at the end of the year. It was, to say the least, a game of sexual musical chairs.

Aragon was a much more emotional and uninhibited character. He had numerous mistresses, one of whom was the bisexual American, Elisabeth (Eyre) de Lanux, a married woman who was also the mistress of Aragon's good friend, Drieu La Rochelle. When the relationship broke down, he began another with Nancy Cunard. Rich and beautiful, she was something of an exhibitionist, given to drink, and had a string of male admirers. When she dropped Aragon for the black American jazz pianist, Henry Crowder, Aragon turned to Lena Amsel, a Viennese dancer, but she subsequently agreed to

hand him on to Elsa Kagan, the Russian daughter of a rich Jewish merchant. She and Aragon were married for forty years, but, after her death, Aragon revealed that he was homosexual.

The Franco-Cuban painter, Francis Picabia, another notable member of the surrealist group, was married to Gabrielle, an extremely rich French woman, but in 1918 became obsessed with Germaine Everling, then in the process of divorce. Both women became pregnant at around the same time, Gabrielle giving birth in the autumn, Germaine a few months later. The same astonished midwife attended both women. It was not long, though, before Picabia moved on to the singer, Marthe Chenal.

Equally liberated was the poet, Paul Éluard, since 1917 the husband of Gala, the woman with whom Dalí became fascinated in 1929 and whom he would subsequently marry. Although he was deeply in love with Gala, Éluard was also attracted to group sex and had no objection to the affair on which she embarked with the painter Max Ernst in 1922. Indeed, Ernst subsequently moved into the Éluard apartment to set up a cosy *ménage à trois*. When that came to an end, both husband and wife had many other partners, something that was to characterise Gala's life well into her seventies.

Born in Kazan on the Volga in 1894, Helena Diakanoff Devulina had already acquired the pet name of Gala at home. Her father was a civil servant whose work took him to Moscow, her mother a cultured woman who ensured that her daughter learned French from the age of seven. When she was about ten, Gala's father disappeared from the scene, though the circumstances of his disappearance are unclear – he either went off with another woman or died in Siberia while prospecting for gold on behalf of the tsar. At all events, Gala's mother, left to bring up four children, moved in with a wealthy lawyer.

Throughout her childhood and adolescence, Gala's health was never good, and at the age of eighteen she was sent by her doctors, who feared tuberculosis, to a sanatorium in Switzerland, where she remained for two years. There she met and fell in love with Éluard, eighteen months younger than herself. In 1914 she returned to Russia and Éluard to Paris. When the First World War began in the same year, he was drafted into the army, but he and Gala continued to write to each other, and in 1916 she left home in order to marry him.

Although she could not be described as truly beautiful, Gala had physical attributes that appealed to many men. Her face was oval in shape, her eyes and hair dark, her breasts relatively small, her body in general slim and athletic, and her legs shapely. In terms of character, she was a young woman of resolution, always determined to get her own way, and the precariousness of her family's situation after her father's disappearance meant that a concern with financial security was subsequently a powerful motive in her life. Prior to her marriage to Éluard, she claimed to have been a virgin, but thereafter her appetite for sex, possibly as the result of her husband's influence, became insatiable. Within marriage they had no inhibitions of any kind, free love became the guiding rule of their lives, and they eagerly exchanged accounts of their many extra-marital relationships. While Gala's extreme sexual activities cannot be over-emphasised, it is also important to remember that she was a highly cultured woman who delighted in the literary world of Paris, and that she also craved a life of luxury.

As some of the earlier discussion has suggested, Buñuel and Dalí were surrealists in many ways, but in sexual matters fell far short of the excesses of their colleagues. As for Lorca, he clearly believed in sexual freedom, for in the Prologue to his very first play, *The Butterfly's Evil Spell*, he states that 'Love is born with the same intensity at all levels of existence,' for in nature 'All things are equal.'[7] This, however, represented an aspiration rather than a reality, for, as we have also seen, Lorca on the whole attempted to conceal his homosexuality, highly conscious of the narrow-minded society in which he lived, of the teachings of the Catholic Church, and of the embarrassment that his family would have to endure were they to learn of his affairs. To a greater or lesser extent, then, and in contrast to the surrealists described earlier, all three individuals carried with them the inhibitions imposed upon them by their background.

Although more sexually driven than either Buñuel or Dalí, Lorca's relationships with Dalí and Aladrén were, significantly, conducted well away from Granada and his immediate family, in the more liberal atmosphere of Madrid and in distant Cadaqués, as indeed were the short-lived affairs in which he became involved in Cuba and later still during his six-month stay in South America in 1933–4. In Buenos Aires he became obsessed with Maximino

Espasande – an amateur actor who may have been an extra in the production of *Blood Wedding* – but the young man, ardently pursued by Lorca, had no interest in a physical relationship and rejected his advances. It seems likely that there were other relationships too, although there is no concrete evidence to support that suggestion.

In 1933 Lorca also met Rafael Rodríguez Rapún, who would become the great love of the last few years of his life. Appointed secretary to La Barraca, Rapún was only twenty-one in 1933, good looking, passionate, athletic, and highly efficient in keeping the company's accounts. Although he was not homosexual and was, according to a close friend 'mad about women',[8] Lorca became strongly attracted to him and pursued him relentlessly until Rapún found it impossible to resist his attentions. During his stay in South America, Lorca wrote to him constantly, despite his various sexual exploits, and on his return to Spain clearly threw himself once more into a relationship, facilitated by their involvement with La Barraca. There were occasions when Lorca was extremely upset by what he saw, rightly or wrongly, as his companion's betrayal of him, as on the occasion when, in 1935, they were in Barcelona for Margarita Xirgu's production of *Blood Wedding*. When Rapún failed one night to return to the hotel where they were staying, Lorca suspected him of having spent it with a gypsy girl he had met the previous evening and became extremely depressed. It was probably because he did not wish to leave Rapún behind that he decided not to join Xirgu and her company when they departed for Mexico in early 1936, a decision that led indirectly to his death later in the year. Lorca's relationship with Rapún was also, in all probability, the inspiration for the collection of eleven poems entitled *Sonnets of Dark Love*, of which Lorca gave a private reading in 1936 but which was not published for another forty-five years. According to the poet Vicente Aleixandre, who was present at the reading and who later claimed that the poems were inspired by a male friend – he did not name him – the phrase 'dark love' described a passion that was difficult rather than homosexual.[9] Lorca himself, though, undoubtedly used the word 'dark' in relation to feelings that were forbidden and secret. To that extent, the word describes perfectly both his homosexual relationship with Rapún and the relative secrecy that their activities with La Barraca and their stays in hotels allowed them.

∞

Far less passionate than Lorca in sexual matters, Buñuel's inhibitions were evident, as we have seen, both prior to and during his eight-year courtship of Jeanne Rucar; during that courtship there were also numerous incidents involving other women. In 1930–1, while he was in America, he became attracted to a friend of Lya Lys, the leading lady in *L'Age d'or*, but, by his own admission, he 'fell in love (platonically, as usual)'.[10] Not long afterwards, during the return sea voyage to France, he met an eighteen-year-old American girl who was strongly attracted to him, but even though he went to her cabin on two occasions, he failed to take advantage of the situation and later described his relationship with her as 'once again perfectly chaste'.[11] Again, in 1933, following a performance by the Ballets Russes in Monte Carlo, Buñuel found himself alone with an attractive ballerina but 'I was seized by that awkwardness which seemed an inevitable part of my relationships with women.'[12] Incapable of any amorous advance, he preferred to become involved in a discussion about Russia, Communism and the Revolution, finally lost his temper, and gave the young woman money for a taxi. Two years later, by which time he had been married for about a year, Buñuel was in Madrid, where he met a young actress called Pepita, in whose company he spent the whole summer and with whom he says he fell in love. The relationship, he claims, was chaste, but when he was told that the girl was sleeping with someone else, he insisted that she became his mistress and that she should make love only with him. He has described what happened then:

> She seemed surprised, but accepted readily enough. I helped her off with her clothes and held her naked in my arms only to find myself paralysed with nervousness. I suggested we go dancing; she got dressed again, and we got into my car, but instead of going to Bombilla, I drove out of Madrid. Two kilometres from Puerta de Hierro, I stopped and made her get out.[13]

Buñuel's insistence on his sexual reticence and on the chaste nature of these relationships could, of course, be taken with a pinch of salt and seen as a desire to present himself as a moral and virtuous individual, and later as a faithful husband, but such a view is undermined both by his frequent references to his

overwhelming unease in such situations and, in particular, by his wife's account of their marriage, which was written after his death and can be seen in many ways as a kind of revenge for the manner in which he treated her.

After their long courtship, Buñuel and Jeanne Rucar were finally married in Paris in January 1934, but there was no consummation of the marriage, for, after a civil ceremony, from which Buñuel had excluded all relatives, they and two friends ate in a restaurant, and Buñuel, without more ado, took the train to Madrid. Jeanne arrived in Madrid a month later and Buñuel evidently practised his matrimonial rights before she returned to Paris, for in November she produced her first child. But when in March 1935 she brought the child to Madrid and moved into their apartment, her husband's insistence that they occupy separate bedrooms was both a shock and a prelude to sleeping arrangements that would continue throughout their married life. Furthermore, when sexual intercourse did occur, which must have been infrequently, Buñuel was in the habit of carefully placing a sweater over the keyhole of the bedroom door. Nothing could have been further removed from the sexual habits of the majority of his fellow surrealists.

At the same time, Buñuel's sexual inhibitions were accompanied by an extreme jealousy and possessiveness in relation to Jeanne that can fairly be described as paranoid. We have already seen that, in the early years of their courtship, he objected to the revealing clothes she wore as a teacher of gymnastics and movement, as well as to her piano lessons in the company of a middle-aged man. When she asked one of Buñuel's friends, Pepe Moreno Villa, why he wouldn't ask her out, he replied that, if he did, Buñuel would kill him. There were others, including Jean Epstein, who advised her not to marry Buñuel. During his absences from Paris, Buñuel would also instruct Jeanne's mother to keep a close eye on her and would allow her to go out only with two Spanish friends he trusted, one of whom was Dalí. It is no surprise that she subsequently observed: 'I'm glad I wasn't born in the Middle Ages. Luis would certainly have made me wear a chastity belt.'[14]

One of the worst examples of Buñuel's sexual paranoia occurred when he and Jeanne had settled in Mexico and she decided to call, unannounced, on Ana María Custodio, the wife of Gustavo Pittaluga, who had written the music for Buñuel's *Stairway to Heaven*. Because Ana María was not at home, Jeanne chatted

for a while with her husband, but when she returned home and informed Buñuel of this, such was his rage that he accused her of going to bed with Pittaluga, marched upstairs, reappeared with a gun, and phoned the innocent husband with the news that he intended to kill him. Only with great difficulty did Pittaluga succeed in calming him down.

It is not, perhaps, surprising to discover that the relative absence of physical passion in Buñuel's life was largely replaced by dreams and fantasies, for both are, after all, free from the constraints of reason and conscience. His awkwardness in the presence of the ballerina from the Ballets Russes may be compared, therefore, with the fantasy that he experienced on his way to the performance:

> During the two-hour trip, I lapsed into my habitual fantasies –
> this time of a bevy of dancers in black stockings sitting side by
> side on a row of chairs, facing me, like a harem, awaiting my
> commands. When I pointed to one, she stood up and approached
> meekly, until I suddenly changed my mind. I wanted another
> one, just as submissive. Rocked by the movement of the train, I
> found no obstacle to my erotic daydreams.[15]

Similarly, at the age of fourteen he had fantasised about having sex with the Queen of Spain after putting her to sleep with a narcotic. But if certain dreams and fantasies liberated Buñuel from his inhibitions in a way that reality did not, he also had dreams in which the obstacles to sexual freedom – the ever-watchful Jesuit teachers of his schooldays and the sense of guilt inculcated by them – were also very apparent:

> One of the strange things about dreams is that in them I've never
> been able to make love in a truly satisfying way, usually because
> people are watching. They're standing at a window opposite
> our room; we change rooms, and sometimes even houses, but
> the same mocking, curious looks follow us wherever we go. Or
> sometimes, when the climactic moment arrives, I find the woman
> sewn up tight. Sometimes I can't find the opening at all; she has
> the seamless body of a statue.[16]

The kind of fantasies described above are clear evidence of an arrested sexual development that characterised Buñuel's entire adult life, but this, as we shall see, had its positive side in the

sense that it fed into some of Buñuel's best films, including *He, Viridiana, Tristana,* and *That Obscure Object of Desire.*

When Dalí first met Gala in August 1929 he had already heard a good deal about her from her husband, Paul Éluard, as well as from others, and became even more fascinated by her when, in the company of Éluard, René Magritte and his wife, and Camille Goemans and his girlfriend, he first set eyes on her in Cadaqués. He was attracted in particular by her relatively small but well-proportioned breasts and by her well-shaped buttocks, an aspect of the female form that had often figured in his paintings long before he met her. For him she would soon become the Gradiva of Wilhelm Jensen's short story of the same name, the girl who restores the sanity of the archaeologist, Norbert Hanold. Dalí believed that Gala would do the same for him. But the question remains: what attraction could the timid, sexually inhibited Dalí possibly have for a woman whose sexual appetite was so extraordinary? And what exactly was the nature of their relationship? There can be no doubt that Gala saw in Dalí an artist who would become famous and therefore rich, providing her with the lifestyle she craved and the financial security that, from childhood, was always a source of concern. It is no coincidence in this context that, when Gala first encountered Dalí, Éluard's considerable wealth was in rapid decline. As for Dalí, the physical attractions that Gala offered him, together with the hope that she would help him to overcome his sexual problems, were no doubt accompanied by the expectation that she would manage the affairs of someone whose practical incompetence extended to an inability to tie his shoelaces. While the sexual aspect of their relationship would loom large in the years ahead, there were clearly other factors that have to be borne in mind.

If Dalí wanted to attract Gala, his initial efforts to do so were of the kind that would alienate most women. In *The Secret Life,* he describes how he daubed himself with perfume smelling of goat manure, wore a garish outfit and a pearl necklace, bloodied his armpits, and placed a red geranium behind his ear, while failing to control outbursts of nervous laughter.[17] Whether or not we believe his account is another matter, but such behaviour clearly matches the eccentricities of which Dalí was capable and to which, under pressure, he may well have surrendered. As for Gala, her positive

reaction to such extraordinary behaviour may owe more to what she had already heard about Dalí than to what she witnessed in Cadaqués. Éluard had informed her of Dalí's good looks and, as suggested above, she was evidently convinced that here was a painter with a future. At all events, she was soon flirting with him and he was overjoyed.

Given his timidity and, in particular, his fear of impotence in a sexual relationship with a woman, it is no surprise that Dalí should at first have experienced considerable anxiety about making love with Gala. Asked in 1979 about the nature of his early days with her, he replied that it took three months before he could make love successfully,[18] but we may well ask ourselves what precise form that activity took. In *The Secret Life* he claims that the six months spent with Gala at Carry-le-Rouet in 1930 was a time of wonderful sexual initiation, but the question remains: initiation into what? His suggestion that he and Gala did not leave the hotel for two months seems fanciful. Furthermore, she was now beginning to experience painful gynaecological problems that a year later were shown to be caused by a cyst, the removal of which left her sterile. Even if Dalí had at last been attracted to vaginal penetration, such problems could well have been a deterrent, and they may well have further encouraged his attraction to alternative forms of sexual activity. In this context, it is perhaps useful to remember that in the 1931 fantasy 'Reverie', he described how the eleven-year-old is transformed into Gala and is anally penetrated. Furthermore, only in his dreams – a clear parallel here with Buñuel – could he imagine himself as a rampant lover in the Casanova mould:

> I took revenge in my dreams on what haunted and frightened me. I possessed my beloved like a brute, I tore her dress, laid bare her breasts, tattered her underclothes, and impaled her on the ferocious stake of my upstretched cock.[19]

It is not without significance that Edward James, a close friend and collector of Dalí's work, once described the painter's relationship with Gala as nothing to do with sex. She was, rather, his housekeeper, his mother, his accountant, and his muse. James also wrote: 'His real interests were instinctively far more homosexual than heterosexual; Gala tried to believe that she had cured him of his homosexuality, but she knew in her heart that

she had not really at all.'[20] Their long marriage was certainly to prove very strange indeed, for with the passage of time Dalí's sexual tastes grew steadily more perverse and Gala's liking for other men more voracious.

## NOTES

1   For the historical background, see Raymond Carr, *Spain, 1808–1939*, Oxford: Oxford University Press, 1966; and Hugh Thomas, *The Spanish Civil War*, 10th edn, Harmondsworth: Penguin, 1986.

2   In this respect, see Suzanne Byrd, *'La Barraca' and the Spanish National Theatre*, New York: Ediciones Abra, 1975; and Luis Sáenz de la Calzada, *'La Barraca': Teatro Universitario*, Madrid: Biblioteca de la Revista de Occidente, 1976.

3   M. Fernández Almagro, 'Blood Wedding', *El Sol*, 9 March 1933.

4   Byrd, *'La Barraca' and the Spanish National Theatre*, pp. 54–5.

5   See Dalí, *Un diari*, pp. 27, 38, 50.

6   The bomb incident is described by a fellow-student, Josep Rigol, in Antonina Rodrigo, *Lorca–Dalí. Una amistad traicionada*, Barcelona: Planeta, 1981, p. 21.

7   See the translation of the play by Edwards in *Lorca Plays: Two*, and in particular p. 84.

8   See the statement by Rapún's close friend, Modesto Higueras, in Gibson, *Federico García Lorca: A Life*, p. 354.

9   Ibid., p. 420.

10   Buñuel, *My Last Breath*, p. 135.

11   Ibid., p. 136.

12   Ibid., p. 120.

13   Ibid., p. 149.

14   See Rucar de Buñuel, *Memorias de una mujer sin piano*, p. 41.

15   Buñuel, *My Last Breath*, p. 119.

16   Ibid., p. 97.

17   Dalí, *The Secret Life of Salvador Dalí*, pp. 227–34.

18   See 'El pincel erótico de Dalí. Reportaje por Luís Permanyer', *Playboy*, Barcelona, no. 3, January 1979.

19   Quoted in André Parinaud, *The Unspeakable Confessions of Salvador Dalí*, New York: Quill, 1981, p. 93.

20   See Meredith Etherington-Smith, *Dalí*, London: Sinclair-Stevenson, 1992, p. 260.

# 7

# DESCENT INTO CHAOS

∽

T HE VICTORY OF the Right in the Spanish general elections of November 1933 saw the beginning of the descent into chaos that led to the Civil War less than three years later and the death of Lorca in the first month of the conflict. Although the Left was soundly defeated in the elections, the Right was itself composed of groups that had their differences. The new Prime Minister, Alejandro Lerroux, was the leader of the Radical Republican Party that, despite the implications of its name, operated on an anti-socialist platform, while Gil Robles led the confederation of Catholic parties known as CEDA, the Spanish Confederation of Autonomous Right-Wing Groups. Without an overall majority and unable to form an alliance with the defeated socialists, Lerroux was forced into a coalition government with CEDA. He hoped that, by doing so and by introducing CEDA ministers into the cabinet, he would be able to commit them to furthering the interests of a republic for all Spaniards rather than their own right-wing interests. For his part, however, Gil Robles believed that, when the Radicals had failed in their ambitions, CEDA, which had now been seen by the nation to be involved in the affairs of the Republic, would be in a position to take power. At all events, the result of such an alliance was that the next two years were largely characterised by unproductive coalition government and frequent cabinet reshuffles. Indeed, Lerroux was forced to step down in April 1934, but Alcalá Zamora, the President of the Republic and a strong supporter of the republican ideal of a

fair and just society for all, refused to call on Gil Robles to form a government. By the following autumn, however, the government was once more in disarray, and on this occasion the President had no alternative but to give CEDA members important positions in the cabinet. But their appointment to the Ministries of Agriculture, Labour, and Justice had the immediate effect of inflaming the opposition of the Left.[1]

In this context, it is important to remember that, as indicated earlier, Fascism was on the rise in Europe. In January 1933 Hitler had become Chancellor of Germany. The following month the Reichstag had been burned, in March all political parties had been dissolved, Hitler's National Socialist Party was in full control, and there was strong evidence of the increasing persecution of intellectuals and Jews. These were matters that were being widely reported in the Spanish newspapers and anxiously discussed by the Spanish Left. By 1934, the Spanish Fascist Party, the Falange Española, had immeasurably increased its membership and was engaging in the kind of bullying that was a feature of the Hitler Youth. And, in addition, Gil Robles's CEDA was itself becoming more aggressive and had a strong youth following as extreme as that of the Falange. It is hardly surprising that, in such circumstances, the supporters of the Left should have begun to fear a fascist takeover of the kind that had already catapulted Hitler to power.

It was this increasing swing to the Right that in October 1934 led the trade unions to call for a general strike in opposition to the government. In Cataluña feelings ran extremely high and were further inflamed by Madrid's negative attitude to any kind of Catalan autonomy. The revolution that occurred in Barcelona was, however, a complete failure and its leader, Luis Companys, was quickly arrested. But in the north-western province of Asturias, working-class organisations presented a united front and initiated an all-out attack on their bourgeois oppressors. The rising, which included an attempt to take over the capital, Oviedo, lasted for two weeks, during which the fighting was ferocious, there were more than four thousand casualties, and an enormous amount of damage was done to buildings large and small. Finally defeated by units of the Spanish Army in Africa, including Moorish troops – significantly, Francisco Franco, the future dictator, was in charge of the military operation – the revolutionaries who survived were

subjected to brutal repression. Many were executed and many more imprisoned. Manuel Azaña, the left-wing Prime Minister during the first years of the Republic, was unjustifiably suspected of being involved in the Barcelona revolution and was arrested. The events in Asturias and the charges of atrocities on both sides were widely reported in the European as well as the Spanish press. In Spain itself, the Right was able to claim, of course, that it had saved the country from a communist rising encouraged by Russia. It was a claim that would be made repeatedly in the months preceding the beginning of the Civil War.

Lorca's position in relation to the political situation was, as we might expect, one of opposition to the Right, and therefore one that inevitably drew attention to him, marking him out for future attention from his enemies. In the summer of 1931, shortly after the inauguration of the Republic, the new town council of Lorca's hometown of Fuente Vaqueros had invited him to open their public library. In his address, Lorca spoke of his belief in a classless society, of the importance of education and culture, and of his opposition to capitalism, all of which pointed to his fervent support of the new republican government and its objectives. Later, during his stay in Buenos Aires, he was questioned by journalists about his political views, and stated that he objected strongly to the monarchy and had been delighted by King Alfonso XIII's decision to abdicate.[2] And when, following the failed Barcelona revolution of 1934, Manuel Azaña was arrested and imprisoned, Lorca joined other intellectuals in signing an open letter in which they protested about the way in which the former Prime Minister had been treated. During the next two years, his political views and actions would become even more prominent.

As far as La Barraca was concerned, right-wing hostility towards the company had increased during Lorca's absence in Argentina. In February 1934, the right-wing Madrid periodical, *El Duende*, voiced the opinion that state funds were being wasted on a group of university students who were little more than homosexuals.[3] The following July, after Lorca's return and prior to the company's summer tour, the newspaper of the increasingly influential Falange accused the group of corrupting rural audiences with their allegedly open display of promiscuity and their undisguised Marxist beliefs.[4]

La Barraca's tour began with performances at the International Summer School in Santander, which now included a production of Tirso de Molina's seventeenth-century Don Juan play, *The Trickster of Seville*. In late August the company performed in the town of Palencia, south-west of Burgos, where, while eating at a restaurant, they were suddenly confronted by the arrival of the founder of the Falange, José Antonio Primo de Rivera. It appears that, during the course of the meal, a note was passed to Lorca from Primo de Rivera to the effect that, if the blue overalls of La Barraca were to join up with the blue shirts of the Falange, the result would be a better Spain. Whether or not the message was deliberately ironic is unclear, but it seems quite likely that Primo de Rivera was intent on mocking someone who was already the object of right-wing scorn.

As for his own writing, Lorca had probably started work on *Yerma* as early as 1930, for while he was in Cuba he read some scenes from the play to members of the well-to-do Loynaz family. By the autumn of 1933, six months after the premiere of *Blood Wedding*, it seems likely that he had completed the second act, and by the summer of 1934 the third act had also been written. Rehearsals by the company of Margarita Xirgu, with the great actress herself taking the role of Yerma, began in earnest towards the end of the year.

Margarita Xirgu, a statuesque woman with a strong face, dark eyes, and an impressive voice, was born in Barcelona in 1888, the daughter of a working-class family. By her early thirties and running a theatre company with a fellow actor, Enrique Borrás, she was arguably the most famous and influential Spanish actress of her day, celebrated throughout the country, and indeed in South America too, for her outstanding ability as an actress in works ranging from classical drama – Seneca's *Medea* – to modern foreign theatre – Giraudoux's *La folle de Chaillot* (*The Madwoman of Chaillot*) – and to seventeenth-century and modern Spanish drama. Prior to the production of *Yerma*, she had already produced and appeared in two of Lorca's plays – *Mariana Pineda* in 1927 and *The Shoemaker's Wonderful Wife* in 1930 – and the dramatist had, from the outset, established with her a warm rapport that would continue throughout the remainder of his life and ensure her collaboration in some of the plays he was still to write. Following her production of *Mariana Pineda* in Granada at the end of April

1929, both she and Lorca attended a banquet in their honour at the Alhambra Palace Hotel, where he paid her this tribute:

> Here in Granada, where my distinguished heroine [Mariana Pineda] sleeps her dream of love, I wish to express publicly and in a totally rational manner my gratitude and admiration for her [Margarita's] work in the theatre of our country. She is the actress who brings a breath of fresh air to the stuffiness of our stages and who throws fistfuls of fire and jugs of cold water on audiences lulled into sleep by moth-eaten practices.[5]

Like *Blood Wedding*, *Yerma* is both an exploration of the theme of frustration and an exposure of the narrow-minded attitudes of a Spain deeply rooted in traditional values. On this occasion, however, the frustration is not the thwarted passion of a young man and a young woman, but the frustration of a young woman's inability to produce a child after several years of marriage. Increasingly desperate, Yerma succeeds only in alienating a husband who does not really love her and who – as a result of his lack of interest in raising a family and his harsh treatment of her in that respect – finally drives her to murder him, thereby ensuring that she will remain a childless widow for the rest of her life. The theme of childlessness, which is the source of Yerma's frustration, had been expressed previously in both *The Shoemaker's Wonderful Wife* and, even more powerfully, in *When Five Years Pass*, but nowhere does it acquire greater prominence or emphasis than in *Yerma*, where every situation and every character is an integral part of it. Lorca's love of children is evident in photographs of him with children he met in the United States, as well as with the children of his sister, Concha. When in 1929 he stayed in Bushnellsville in the Catskill Mountains with Angel del Río and his wife, he befriended two local children, Stanton and Mary Hogan, and delighted in their company, as he did with children throughout his life. They were in part a reminder of the childhood innocence for which he longed, but they also made him aware of the fact that, as a homosexual, he was unlikely to father a child. In this respect Lorca was very different from Buñuel and Dalí. Buñuel had children of his own. Dalí, for the reasons stated previously, may well have been incapable of producing them, and in all probability would not have wanted them. In the sense that longing for a child

runs through *Yerma*, the play is a poignant projection of Lorca's deep-seated frustration and sense of loss.

As well as this, though, *Yerma* is also a strong criticism of a society steeped in traditional values that encourage intolerance and hostility. Because producing a child is regarded as the natural function of a married woman, Yerma has been singled out by the inhabitants of her village, given the nickname of 'Yerma', 'the barren one', and systematically mocked. This, moreover, reflects on her husband, Juan, who also becomes the subject of local gossip and on that account considers his good name and reputation to be tarnished. He is progressively concerned, therefore, with his 'honour' and consequently more and more harsh towards his wife, virtually confining her to the house and leaving her in the care of his two spinster sisters while he is at work on his land. In his portrayal of a village in which compassionate attitudes are notable by their absence and people are always ready to cast the first stone, Lorca presents a microcosm of a country rooted in the past and of a narrow-mindedness of which he, as a homosexual, was a victim. It is a picture that would be painted in even harsher colours in at least two of the plays he was still to write.

The play's dress rehearsal took place on 28 December at the Teatro Español in Madrid, the premiere on the following night was to a packed and expectant house. It did not pass without incident, however, for right-wing elements in the audience were bent on disrupting the performance. They objected in the first place to Lorca himself, as well as to a play whose sexual content must have seemed at that time rather daring. And they were also enraged by the fact that Margarita Xirgu was a close friend of Manuel Azaña, who, having been jailed for his alleged part in the failed Barcelona revolution, had now been released. Trouble began, therefore, as soon as the curtain went up; insults were immediately directed at Lorca and Xirgu, who were described as a queer and a lesbian. After a scuffle, during which the performance came to a halt, the troublemakers were thrown out, but the incident revealed very clearly the growing hostility between the supporters of both the Right and the Left, and, in particular, the extent to which Lorca was quickly becoming a marked man. When calm had been restored, the performance proceeded without further interruption and ended in complete triumph.

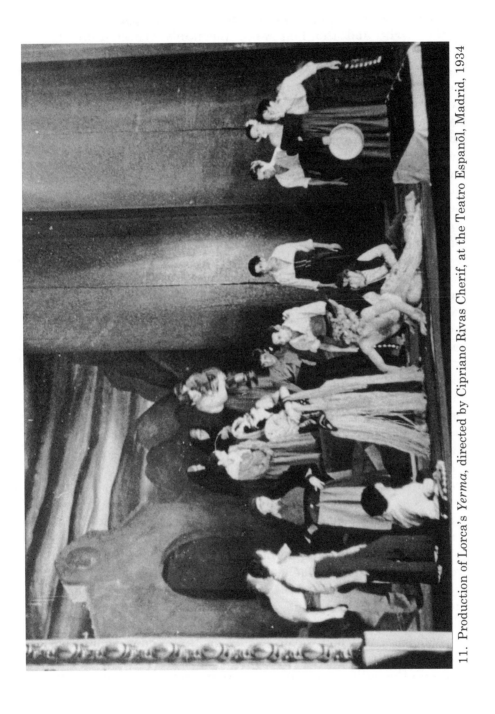

11. Production of Lorca's *Yerma*, directed by Cipriano Rivas Cherif, at the Teatro Español, Madrid, 1934

During the following days the diametrically opposing views of the Right and the Left were inevitably reflected in the newspaper reviews of the play. The old woman's remark in Act One, Scene Two that she does not believe in God, together with the sexual nature of the pagan fertility rite in Act Three, were quickly seized upon by the right-wing press as evidence of the play's attack on the Catholic Church. The influential right-wing *ABC* complained about the play's vulgarities, while *El Debate* and *Gracia y Justicia* drew attention to its many blasphemies. And in early 1935, the conservative Catholic newspaper *El Siglo Futuro* listed *Yerma* among the plays its readers should avoid seeing. In contrast, the left-wing press were wholly enthusiastic, arguing, as in the case of *El Pueblo*, that Lorca had now joined the mainstream of contemporary European theatre, while *Diario de Madrid* suggested that he had vividly exposed the plight of many women in Spanish society.[6] One interested spectator at the premiere was Buñuel, who was now back in Madrid and who later claimed that by this time he and Lorca 'were the best of friends once again' and 'spent a great deal of time together'.[7] But Buñuel considered *Yerma* to be very ordinary, a view clearly influenced by his intransigent surrealist ideas and by his conviction that Lorca's work was, as we have seen previously, too traditional. Rather surprisingly, Dalí, who saw the Barcelona production of the play in 1935, wrote in a letter to Lorca that he had found it to be 'full of extremely obscure and surrealist things' and suggested that they work together once again.[8]

In the summer of 1934, Lorca had been greatly shocked by the death in the bullring of his close friend, Ignacio Sánchez Mejías, at the age of forty-two. A relatively accomplished playwright and flamenco enthusiast as well as a bullfighter, Sánchez Mejías had returned to the bullring after a period of retirement but was somewhat overweight and by no means as agile as he had been previously. On the 11 August he agreed to replace an injured bullfighter in the ring at Manzanares, a town south of Madrid, and, late in the afternoon, faced his first bull, a fierce beast called 'Granadino'. When he attempted to execute a difficult and unusual pass, which involved sitting on the wooden ledge that circles the bullring at the foot of the barrier, the bull first drove a horn into the bullfighter's thigh and then proceeded to gore him. Consequently, and according to his wishes, Sánchez Mejías was

taken by ambulance to Madrid, but unforeseen delays meant that gangrene soon set in and he died two days later. In the following year Lorca's great elegy, *Lament for Ignacio Sánchez Mejías*, marked his tribute to the bullfighter.

After working for Paramount in Paris in 1932 and 1933, Buñuel had, as noted above, returned to Madrid in 1934. There he was employed by Warner Brothers as supervisor of their dubbing operations. He remained with the company for ten months, but was then invited by Ricardo Urgoiti, a producer of commercial films, to join his organisation, Filmófono, as a producer. In this capacity Buñuel initially supervised the making of *Don Quintín the Embittered One* and *The Daughter of Juan Simón*, both released in 1935, and, because the directors were often not up to scratch, was sometimes called upon to take a more than supervisory role. *Don Quintín the Embittered One* is the story of a middle-aged salesman who, when informed by his unfaithful wife that their baby, María, is not his, abducts the baby and abandons her at the front door of a fisherman's cottage. Brought up with the fisherman's daughter, Jovita, a talented singer and dancer, María is finally reunited with her father when both girls find their way to the cabaret he now runs. While *Don Quintín* is essentially a melodrama, *The Daughter of Juan Simón* is a musical comedy in which Juan's daughter, Carmela, is enticed to Madrid by a suave seducer, becomes pregnant, but is ultimately saved from an even worse fate by Juan and Carmela's boyhood admirer, Angel, who has now become a flamenco dancer.

Given the strongly political character of Buñuel's *Las Hurdes* in 1932–3, it is quite surprising to see his involvement in films of a commercial character with so little artistic quality. In this respect and at this stage in his life he was quite unlike Lorca, who wrote the plays he wanted to write, regardless of commercial considerations. But because he had a family to support, Buñuel was in need of the money, despite the fact that he was well aware of the deficiencies of his films. At all events, they were extremely successful with the public and Spanish audiences went in their droves to see them. From *Don Quintín* alone he made enough money to buy a substantial amount of land outside Madrid and a seven-room apartment in the city. Furthermore, the experience of recruiting film crews, dealing with contracts, and overseeing all

the different aspects of film production would stand him in good stead in the future. But the committed communist certainly seems at this point to have been far less involved in the volatile political situation than one might expect, though he would become so again a little later.

As for Dalí, the one-time revolutionary who had earlier planned to blow up the King of Spain was now more concerned with fame and personal profit, and while Lorca worked with the republican government and voiced his left-wing views, Dalí gradually turned his attention to the USA. In 1931, as we have mentioned, his work had been seen in Paris by Julian Levy, who, having bought *The Persistence of Memory*, exhibited it in December 1931, along with Dalí's *Solitude* and *By the Seaside*, and a number of works by Jean Cocteau, Marcel Duchamp, Max Ernst, Picasso, Man Ray, and several others. The event was a considerable success and prepared the way for the exhibition which took place at Levy's gallery in November and December 1933 and included twenty-six of Dalí's works. Prior to this, in May 1932, twenty-seven works of different kinds had been shown in a second exhibition at the Pierre Colle Gallery in Paris, and in 1933 another show at the same gallery contained twenty-two paintings, ten drawings, and two surrealist objects. There were further exhibitions too, in Brussels in May and June 1934, in London at precisely the same time, and in Paris in June and July of the same year. Dalí was becoming increasingly famous, his daily affairs and social activities controlled by Gala, for whom her keenly desired future of wealth and success seemed imminent. In this context, they had become friendly in the summer of 1933 with Edward James, a wealthy English aristocrat three years younger than Dalí, a patron of the arts, and someone who was to become an important figure in the life of the Dalís.

Dalí had not attended Levy's New York exhibition in 1933, but in early November 1934 he and Gala set sail for the USA in order to attend Levy's second exhibition, which ran from 21 November until 10 December. On board the ship, as well as when in New York he met the press for the first time, Dalí's paintings were tied by lengths of string to his fingers and his clothes. His arrival had the desired effect, fascinating reporters and public alike, and the exhibition itself was an enormous success, acclaimed by the critics for its originality and painterly skill. To celebrate the event, there

followed a number of dazzling parties, one at the Casa de las Españas, the New York focal point of Spanish culture, another a so-called Dream Ball arranged by Joella Levy and Caresse Crosby, at which the guests were invited to appear in the costumes associated with their recurrent dreams. Dalí wore bandages around his head, while his shirt took the form of a glass case that revealed a pink brassiere. Gala seemed to be giving birth to a doll on the top of her head, her tight sweater emphasised her breasts, and a transparent red skirt over a miniskirt revealed her shapely legs. By the time they set sail for Europe on 19 January 1935, they had had a taste of the good life and the money that New York could offer them. Both were there for the taking.

As for the events that had occurred in Spain in 1934, in particular the failed revolution in Barcelona and the crushed rising of the workers in Asturias, Dalí seems to have ignored them entirely, even though he had been in Barcelona to attend an exhibition of his paintings and to give a lecture on 5 October, the day before the Barcelona revolution. While many of the inhabitants took to the streets in order to express their opposition to the Madrid government, Dalí describes how he and Gala made their escape to the French frontier on 6 October.[9] New York beckoned and Dalí was no longer prepared to sacrifice self-interest, fame and fortune in favour of revolutionary beliefs. Realising, no doubt, that Gala would help him achieve such a goal, he had married her in the previous January.

The paintings shown in the various exhibitions between 1931 and 1934 included many of those finished earlier, such as *The Persistence of Memory* and *The Spectre of Sex Appeal*. In the latter, completed in 1932, Dalí had presented himself as a child dressed in a sailor suit, staring at a monstrous and headless female torso, which is supported by crutches, whose breasts take the form of two distended potato sacks, and whose limp left arm resembles a flaccid penis. He later stated that in this painting, 'The child Dalí is terrified by the giant spectre of the eternal feminine.'[10] The same sexual obsessions continued to dominate his work in the following years. *Meditation on the Harp*, completed between 1932 and 1934, presents, for example, a fully dressed man and a naked woman standing close to each other, the woman's left arm encircling the man's neck, while he, as in the Angelus painting, covers with his hat a presumably erect penis. In front of them is

a smaller masked figure who observes them and whose enlarged penis is supported by a crutch. The painting again expresses Dalí's fear of the consequences of sexual involvement with a female, evidently exacerbated now by his relationship with Gala. Indeed, the Angelus theme, which, as we have seen, represented for Dalí the predatory female about to pounce on her male victim, figured in 1934 in a number of the illustrations he provided for the Swiss publisher Albert Skira's edition of the Comte de Lautréamont's *The Songs of Maldoror*, a work much admired by the surrealists for its author's scepticism and his advocacy of personal liberation and rebellion against the Old Testament God.

If Dalí believed that Gala would help him overcome his sexual preoccupations, his work at this time suggests that, far from disappearing, they would become a life-long problem. At the same time, the painter was attempting to heal the disastrous rupture with his father. They met once more in Figueras in March 1935 and, although the still fiery Don Salvador hurled recriminations at his son, they ended up in each other's arms. Subsequently, Don Salvador changed his will, still leaving the bulk of the estate to his daughter, but now reinstating the son he had earlier disinherited. Family harmony had, to some extent at least, been restored.

The political picture in Spain as a whole was, however, one of growing discord. First, this was a period of weak government in which the aspirations of the early years of the Republic were completely lost. Instead of seeking to bring about social and educational progress, the right-wing government was concerned only with the need to balance the books and therefore embarked on a process of strict economies by cutting wages, which were already low – not least those of agricultural workers in the south of the country. As well as the discontent that such measures created, the Left was increasingly fearful of a right-wing coup, a fear exacerbated when in May 1935 Gil Robles, leader of the conservative coalition, became Minister of War. Furthermore, his appointment led to General Francisco Franco becoming Chief of the General Staff.

As far as the Left was concerned, Franco was someone who, for personal reasons, would do them no favours. In the early days of the Republic he had bitterly resented Prime Minister Azaña's cutting of the army's officer corps and his closure of the Zaragoza Military

Academy. Because Azaña also changed the rules for promotion in the army, favouring seniority rather than merit, Franco, still under forty, had also been demoted, and in 1933 his appointment to the position of General Officer Commanding, Balearic Islands, had really been intended to undermine his influence by moving him out of Spain. The right-wing victory in the general elections of 1933 marked, of course, a turning point in Franco's fortunes. In March 1934 he was promoted to Major General, and in the autumn of that year, having been given the task of crushing the workers' uprising in Asturias, had no hesitation in using notoriously merciless Moroccan troops in order to complete that task. By early 1935 he had become Commander-in-Chief of the Spanish Armed Forces in Morocco, a promotion followed shortly afterwards by his recall to Spain. Noted for his energy, his discipline, his coolness, and his belief that a communist assault on Spain was imminent, Franco soon became the favourite of the Right and a man to be feared by the Left. A purge of liberal and left-wing elements in the army did nothing to allay those fears.[11]

By the end of the year, however, the government was in disarray, the Radical Republican Party and Gil Robles's CEDA implicated in a financial scandal that finally led to the resignation of Prime Minister Alejandro Lerroux, the suspension of Parliament, and the announcement of general elections for 16 February 1936. Against this background, the Left saw its best opportunity as residing in a grouping of the various left-wing groups whose disunity had led to the electoral defeat of 1933, and so, under the leadership of Manuel Azaña, the Popular Front came into being, its existence confirmed by an agreement of January 1936 setting out its agenda. This consisted, if victory was achieved, of restoring the educational and religious policies of 1931–3; of bringing about the much-delayed agrarian reforms; and of introducing an amnesty for the thirty-thousand or so individuals who had been imprisoned by the Right after the uprising in Asturias and who were still in gaol. It was a programme that contradicted in almost every way the policies of the Right and highlighted the polarities that were now more marked than ever in the country as a whole.

Lorca's political views were clear enough well before 1935. In April 1933 he had already expressed his opposition to the rise of Fascism in Europe by joining the Association of Friends of the Soviet Union,

while a month later his name appeared at the head of a protest against the fascist activities of Hitler's Germany. During his visit to Argentina in the same year, he had spoken, as we have seen, of his dislike of the Spanish monarchy and revealed his pleasure at the abdication of King Alfonso XIII two years earlier. In the autumn of 1935, in an interview for the weekly newspaper *L'Hora*, the organ of the Partido Obrero de Unificación Marxista, he again emphasised his hatred of Fascism and his admiration for Russia's attempt to achieve a humane and classless society.[12] And, in November of the same year, he joined other creative writers and important politicians and lawyers in signing a manifesto objecting to Mussolini's invasion of Abyssinia. More politically outspoken than Buñuel, and at the opposite extreme from a Hitler-oriented Dalí, Lorca's views were unequivocal.

His political stance was also reflected in his views on what theatre should be attempting to do. In February 1935, in an interview with Angel Lázaro, a reporter working for the Madrid newspaper *La Voz*, he had stated that his current intention was to write revolutionary plays that would make people think, and that in this context he was proposing to write 'A Drama against War', a project that did not in fact materialise. In the later interview with the reporter from *L'Hora* mentioned above, he argued that the theatre had a social mission and praised the revolutionary plays of the German dramatist Erwin Piscator. To a certain extent, *Blood Wedding* and *Yerma* had embodied his criticisms of a narrow-minded and highly traditional society. But in 1935, *Play Without a Title*, the play on which Lorca was then working, which is alternatively known as *The Dream of Life*, and of which only one act remains, embodied his political views much more overtly.

The action begins with the appearance on stage of the Author, who informs the audience that they are not to see *A Midsummer Night's Dream*, the play they are expecting, but 'a tiny corner of reality', 'the things you do not wish to see', 'the simplest truths you do not wish to hear'.[13] The audience to which the Author makes these observations is, of course, the predominantly middle-class, comfortably off and conservative audience that attended the theatres in Madrid and elsewhere and which paid their money not to be confronted with uncomfortable social and moral truths but to be entertained by the largely escapist plays that characterised theatre life in Spain, much as it characterises London's West End

even today. This kind of audience, the Author suggests, closes its eyes to reality and goes to the theatre 'to see what is happening, but not what is happening to us', while the real purpose of theatre should be to make people feel that people are 'in the middle of the street', which is to say that they are involved in the pressing realities of daily life. As an example of these realities, the Author refers to an event he dramatised on this very stage a few days earlier and which reflected the poverty and hunger then so common in both rural and urban communities: the death of a woman from hunger and the desperation of her starving children who were obliged to eat from a tin of shoe polish. But although the members of the audience should be aware of and should respond to the miseries of the world around them, they should recognise too the truth of their own lives, which they might seek to ignore or conceal. In short, the theatre should strip away the masks, a process that had distinguished the personal and sexual nature of the characters in Lorca's *The Public*, but which in *Play Without a Title* is directed more towards social attitudes.

The process of stripping away masks is embodied on stage in the Actress, who initially appears as Titania and whose excessive declarations of love for the Author are rejected by him as nothing more than a piece of acting. In response, she removes her Titania costume and transforms herself into a voluptuous Lady Macbeth, thereby highlighting Lorca's emphasis on the way in which individuals hide behind their costumes. But the Actress who expresses her feelings for the Author is, as well as an actress, a woman, but a woman who, off stage, removes one mask only to assume another, someone who, even as a human being, clothes herself in layers of artifice. In this context her unmasking leads to the further point that there is no real difference between the actress on stage and the audience in the auditorium, the majority of whom conceal their real natures.

Gunshots outside the theatre announce a revolution in the streets – a clear echo of the 1934 uprising in Asturias, as well as an anticipation of the imminent Civil War – and draws from a worker in the gallery the statement that the workers will never kill defenceless people. In response, the apparently respectable Second Male Spectator, seated in the stalls, quickly reveals himself to be a supporter of the Church and the army and an enemy of the workers and the Jews. He unexpectedly produces a gun, boasts of

having been trained in the use of weapons by a German soldier, and proceeds to shoot the worker. His initial image of respectability is therefore stripped away and he is revealed to be a fascist, as indeed is the theatre owner, who pays his staff the lowest possible wage and demands that those who threaten the established order be killed: 'Let's make a great big rose from rebel heads! Let us adorn the façades, the lampposts, the porticoes of our millennial architecture with garlands made from the tongues of those who wish to destroy the established order.'

In such characters Lorca clearly depicted the conflict between Right and Left that typified Spanish life in 1935. Furthermore, in involving members of the audience – admittedly actors placed in the audience – in the action of the play, he sought to bridge the gap between the stage and the auditorium in a way that made the stage action relevant to the audience as a whole, rejecting therefore the notion of theatre as illusion and escapism. We can well imagine our own reaction if the person sitting next to us in the theatre stalls were suddenly to produce a gun and shoot another member of the audience, while in the streets outside gunfire comes closer, an air-raid warning sounds, the theatre lights go out, and bombs explode. In short, Lorca created in *Play Without a Title* a sense of theatre as real life, and in that respect anticipated with remarkable vision the terrible reality that would soon engulf the Spanish people. In 1937, 1949, and 1956, Margarita Xirgu recalled that in July 1935 Lorca had read to her and her husband the first act of an untitled play containing the events described above, and also that a second act, which existed mostly in outline, was set in a mortuary, and a third, none of which had been written, would be located in Heaven.[14] Had it been performed in Lorca's lifetime, *Play Without a Title* would undoubtedly have created bitterness and anger on the part of the Right. It did not receive its premiere until 1989 at the Teatro María Guerrero in Madrid, fourteen years after Franco's death.

In its political implications and its attack on the bourgeoisie, *Play Without a Title* brings to mind both *L'Age d'or* and *Las Hurdes*, and it looks forward too to some of Buñuel's later films. Lorca's desire to make his audience 'see what is happening' and make it aware of the poverty and suffering of the underprivileged runs parallel to Buñuel's resolve to confront the Madrid authorities with the terrible living conditions of the people of Las Hurdes. Again, the

complacency of the bourgeois audience in *Play Without a Title* is precisely that of the guests at the Marquis of X's mansion in *L'Age d'or*, and of similar individuals in the later *The Exterminating Angel* and *The Discreet Charm of the Bourgeoisie*. As well as this, the way in which Lorca strips away the bourgeois mask of elegance and sophistication is also a favourite Buñuelian device. In *The Exterminating Angel*, the apparently civilised guests, trapped in the drawing room and deprived of food and water, are gradually reduced to the level of savages, discarding clothes and good manners alike. In *The Discreet Charm of the Bourgeoisie*, a bishop, seemingly the personification of Christian values, gives confession to a dying man before calmly shooting him. And in the last sequences of *L'Age d'or*, the gentle Christ-like figure who emerges from the castle and then turns back, apparently to help a suffering young woman, does so only to murder her. If Buñuel had previously mocked Lorca's work for its traditional elements, he would surely have approved of the withering attack on the bourgeoisie in *Play Without a Title*.

Despite his allegiance to La Barraca, Lorca's association with the company came to an end after the summer of 1935. As in the past, the group carried out its summer tour, beginning in August at the International Summer School in Santander, but financial resources were now a problem. The Right's hostility to the company had already led to its annual grant being halved after the electoral victory of 1933, and by 1935 it had been removed completely. Lorca insisted that the company would survive and perform regardless of these circumstances, but his involvement in his own theatre work was now exceedingly demanding.

In January, February and March 1935, *Yerma* continued its success in Madrid, running up a total of more than 130 performances. At the end of February, the company of Lola Membrives, which had performed *Blood Wedding* in Buenos Aires in 1933, revived their production at the Madrid Coliseum, together with *The Shoemaker's Wonderful Wife*. In short, Lorca had three productions running in the Spanish capital in the first few months of 1935, all of which were highly praised and provided further proof of his standing in contemporary Spanish theatre. In addition, *The Puppet Play of Don Cristóbal* was performed as part of the Madrid Book Fair, and, as far as Lorca's non-theatrical work was concerned, *Gypsy Ballads* went into its sixth printing,

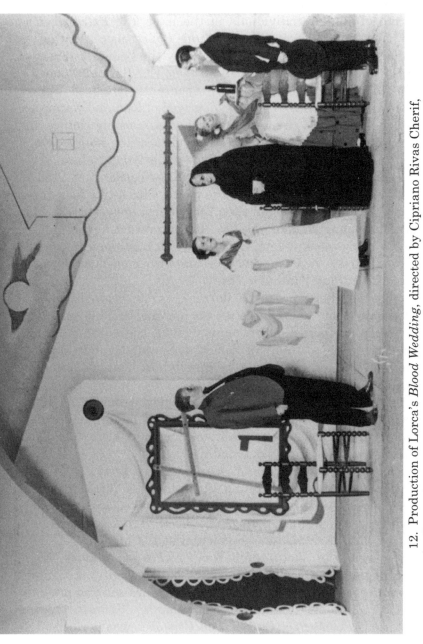

12. Production of Lorca's *Blood Wedding*, directed by Cipriano Rivas Cherif, at the Teatro Principal Palace, Barcelona, 1935, with Margarita Xirgu as the Mother

and *Lament for Ignacio Sánchez Mejías* was also published. By the beginning of the summer, he had also finished a new play, *Doña Rosita the Spinster*, on which he had been working for some time, possibly since 1930.

Unlike *Play Without a Title, Doña Rosita the Spinster* is set in the past, its three acts corresponding respectively to 1890, 1900, and 1910. Even though it does not suggest the pressing political problems that affected Spain in 1935, it has as its central theme the concern with the position of women in Spanish society that Lorca had previously explored in both his poetry and his plays. Initially, the young Rosita is engaged to be married to her cousin, but he is then summoned by his father to return to South America in order to take over the running of their estate. Subsequently, Rosita awaits his return for many years, only to discover finally that he has married someone else, leaving her to the empty life of an ageing spinster. Although Rosita differs from Yerma in the sense that she is not desperate for a child, both women are in the end the victims of a male-dominated society, of male exploitation, and of the gossip and the ridicule to which the childless wife and the spinster are subjected. Lorca's compassion for both women, as well as his desire for a fundamental change in social attitudes, is very clear. But the play also contains other important social themes, in particular middle-class pretentiousness, demonstrated in the Mother and her daughters and in the Ayola sisters, and the lack of consideration shown by the well-to-do towards the less fortunate, as in the case of the callous treatment of their teachers by the children of wealthy parents. Admittedly, *Doña Rosita the Spinster* contains a strong element of comedy, but it is also Lorca's biting comment on middle-class Granada, many of whose social values and prejudices had changed little between the beginning of the twentieth century and 1935.[15] In many ways, it is a play that reveals his love–hate relationship with the city in which he had grown up and which he revisited throughout his life.

*Doña Rosita the Spinster*, performed by the company of Margarita Xirgu, received its premiere at the Teatro Principal Palace in Barcelona on 12 December 1935, a little less than a year after the Madrid premiere of *Yerma*. Indeed, in October and November, the company had performed *Yerma* and *Blood Wedding*, the first at the Teatro Barcelona, the second at the Teatro Principal Palace. Both productions were enthusiastically acclaimed by the critics,

as was that of *Doña Rosita the Spinster*, which subsequently played to packed houses for forty-seven performances. At the end of the run, Margarita Xirgu and her company would set out on an overseas tour, first stop Cuba. The initial plan was that Lorca would accompany them. His decision not to do so, influenced by his desire to remain in Spain with Rodríguez Rapún, was the first of two that would prove fatal.

In late September 1935, while Lorca was in Barcelona, he and Dalí met for the first time in seven years. In spite of his conviction that Dalí and Buñuel had based *Un chien andalou* on himself, Lorca was delighted to encounter his old friend once more, observing of their relationship: 'We are twin spirits. Consider: seven years without seeing each other, but in spite of that we agree on everything, just as if we've been talking to each other every day. A genius, a genius, that's Salvador Dalí.'[16] Lorca was also amazed that someone who hated female breasts and genitals, feared that he was impotent, and had an anal fixation, could possibly be sufficiently obsessed with a woman to marry her. At all events, Dalí was just as pleased to see Lorca, and so, it seems, was Gala. But, given the chaotic events that would soon engulf the country, it was the last time that Lorca and Dalí saw each other.

As far as his creative work was concerned, the summer of 1935 saw the publication of Dalí's nineteen-page essay, *The Conquest of the Irrational*, which contained thirty-five black-and-white illustrations of his paintings and a text arguing in favour of the supremacy of his 'paranoiac-critical method'. As we have already seen, Dalí's growing sympathy with Hitler's Germany had already got him into trouble with the surrealists, not least with Breton, and the leader of the Paris group must once again have been disturbed by Dalí's essay equating Surrealism and National Socialism, and voicing a desire to conquer at any cost the territory of the irrational, an ambition that, as in Hitler's case, pointed to increasing megalomania.

A particularly interesting painting completed at this time, wholly revealing of Dalí's 'paranoiac-critical method' is *Outskirts of the Paranoiac-Critical Town*. The town of the painting is, first, an amalgam of architectural features from the town of Palamós, some eighty kilometres to the south of Cadaqués, and of Cadaqués itself. On the left-hand side of the painting, the portico and its

cupola combine distinctive features from two separate buildings in Palamós, while, on the right-hand side, is a suggestion of the street in Cadaqués known as the Carrer del Call, evocative perhaps of Dalí's unstable grandfather, who had lived nearby. Through the entrance to the building in the centre of the painting is a belfry, with the bell in the shape of a girl, which is based on the belfry of the convent once attended by Dalí's sister; in the open space in front of it is a skipping girl in a white dress, who brings to mind his aunt Carolinita, who had died when he was ten, but who seems to have been one of the first women to have aroused his sexual curiosity. As we have already seen, Dalí had, as a teenager, masturbated as he observed the tower of the church of San Pere in Figueras, which suggests that in *Outskirts of the Paranoiac-Critical Town* the belfry points to his continuing masturbatory habit, and that in earlier years Carolinita had inspired such activities. As for the present, Gala stands in the forefront of the picture, holding aloft, as though it were a trophy, a bunch of black grapes that doubtless represents her fondling of Dalí's testicles. In short, the painting contains elements from Dalí's life that are deeply rooted in his psyche but which, true to his 'paranoiac-critical method', he has controlled in a highly organised manner. In some ways there is a similarity between the creative work of Lorca and Dalí in the sense that both are extremely autobiographical, but there the similarity ends, for Lorca's channelling of his personal problems into his writing was often accompanied by a social and political element, while Dalí remained stubbornly self-obsessed, a Catalan Narcissus.

In 1935 Buñuel continued his work with Filmófono. With Eduardo Ugarte, he scripted *¿Quién me quiere a mí?* (*Who Loves Me?*), a film concerned with the highly relevant topic of divorce. The cinema-going public, given the charged political tensions existing in Spain at that time, were, however, much more interested in escapist entertainment, and the film proved to be a commercial flop. Even so, Enrique Herreros, the studio publicist for Filmófono, announced sixteen films for the following two years. They included Buñuel's *Wuthering Heights*, which he finally shot in 1953, an adaptation of Benito Pérez Galdós's great nineteenth-century novel, *Fortunata y Jacinta* (*Fortunata and Jacinta*), a version of Pío Baroja's trilogy *Fight for Life*, set in the Madrid slums,

and Ramón del Valle-Inclán's *Tirano Banderas* (*Banderas, the Tyrant*). Unfortunately, none of these projects, to which Buñuel would undoubtedly have brought a powerful social and political dimension, came to fruition in a country that was now on the verge of civil war. When Buñuel was involved in the filming of the military satire *Sentinel Alert!* in the early months of 1936, he later described how, 'when we were preparing to shoot a scene in a church, it burned to the ground; and as we edited, guns were exploding all around us.'[17]

This was a time, then, in which Lorca was very clearly much more political than either Dalí or Buñuel, both in his work and in his public actions and statements. He would, to his cost, continue to be so in 1936. Dalí, in complete contrast, had reverted from being a revolutionary with Marxist ideas to someone who, dazzled by fame, money and self-advancement, now sympathised with Fascism. As for Buñuel, a man of life-long communist sympathies, he seemed to be caught in terms of his principles between the demands of the commercial film company for which he worked and the lack of opportunity created by a country slipping into chaos. If the latter polarised his political views, these were now expressed only in heated discussions with friends.

## NOTES

1   For the political situation, see Carr, *Spain 1808-1975*.

2   See José González Carbalho, *Vida, obra y muerte de Federico García Lorca*, Santiago de Chile: Ediciones Ercilla, 1941, p.79.

3   *El Duende*, Madrid, 10 February 1934, p.15.

4   See *FE* (Falange Española), Madrid, 5 July 1934, p. 11.

5   See Antonina Rodrigo, *Margarita Xirgu y su teatro*, Barcelona: Editorial Planeta, p. 161.

6   For these contrasting views, see the reviews of *Yerma* in *ABC*, 30 December 1934, p. 53; *El Debate*, 30 December 1934, p. 4; *Gracia y Justicia*, 5 January 1935, p. 8; *El Pueblo*, 1 January 1935, p. 3; *Diario de Madrid*, 6 January 1935, p. 1.

7   Buñuel, *My Last Breath*, p. 157.

8   See Rafael Santos Torroella (ed.), *Salvador Dalí escribe a Federico García Lorca (1925–36)*, Poesía. *Revista ilustrada de información poética*, Madrid: Ministerio de Cultura, nos 27–8, 1987, p. 97.

9   Dalí, *The Secret Life of Salvador Dalí*, pp. 355–6.

10 See Robert Descharnes, *The World of Salvador Dalí*, London: Macmillan, 1972, p. 51.

11 See Gibson, *Federico García Lorca: A Life*, p. 402.

12 'Federico García Lorca parla per als obrers catalans', *L'Hora*, 27 September 1935, p. 1.

13 See my translation of the play in *Lorca Plays: Three*, pp. 105–24.

14 See Federico García Lorca, *El público y Comedia sin título, dos obras teatrales póstumas*, ed. Marie Laffranque, Barcelona: Seix Barral, 1978, p. 283.

15 See my translation of the play in *Lorca Plays: One*, pp. 97–156, and an analysis of it in *Lorca: Living in the Theatre*, pp. 157–79.

16 García Lorca, *Obras completas*, vol. 3, p. 604.

17 Buñuel, *My Last Breath*, p. 145.

# 8

# THE OUTBREAK OF WAR

❦

THE GENERAL ELECTIONS of 16 February 1936 saw the Popular Front returned to government with a total of 267 seats in the new parliament, as opposed to the Right's 132. Although the various groupings of the Left that made up the Popular Front were overjoyed by such an outcome, their victory soon became the prelude to five months of increasing and extreme political unrest. During the election campaign, the well-to-do had pinned their hopes on the success of Gil Robles, whom they saw as the equivalent of Mussolini: someone who would save the country from a Marxist take-over. His defeat meant that many of his supporters now shifted their allegiance to the Falange Party of José Antonio Primo de Rivera, whose extreme views have been mentioned earlier. The polarisation of Right and Left, which had been steadily growing over the past few years, therefore became even more intense, and between February and July led to bitter confrontations in which, on both sides, physical attacks, kidnappings, and assassinations became the order of the day.

Angered by the activities of the Falange Party, whose sole aim was now to undermine the authority of the Left, the government of the Popular Front took decisive action, arresting Primo de Rivera and several of his colleagues on 14 March and banning the Party a few days later. Needless to say, this, as well as the introduction of a State of Emergency, allowed the Right to question the existence of democracy under the new government and led to a considerable increase in support for the former. On the other hand,

the communist and socialist youth organisations joined forces on 1 April, and on May Day were out in force, sufficient proof of what the Right were up against.

The next three months witnessed a wave of increasing violence. On 7 May, a Republican officer, Captain Faraudo, was murdered by members of the extreme Right, while on 8 May an assassination attempt was made against the ex-Minister Alvarez Mendizábal, who had dared to criticise the army. On 12 July, Lieutenant José Castillo, an outspoken, anti-fascist member of the Assault Guard, founded to defend the Republic, was shot and killed; in retaliation, the following day José Calvo Sotelo, an extreme right-wing politician, was kidnapped and murdered. Prior to this, on 2 June, the anarchist Nationalist Confederation of Workers, the CNT, and the socialist General Union of Workers, the UGT, had called a countrywide strike that continued into the middle of July. Furthermore, if the Right was doing its best to disrupt daily life, the Left was now fatally divided. The Socialist Party, an important part of the Popular Front, had split down the middle over the support of rival groups for the policies of the moderate Indalecio Prieto and the much more revolutionary Francisco Largo Caballero, refused to take part in the government, and spent its time in constant feuding. By this time, people were afraid to leave their homes after dark, skirmishing in the streets between political opponents was a common sight, and the sound of gunshots became ever more frequent. On one occasion a stray bullet penetrated a window of the apartment in Madrid that Lorca now shared with his parents.

In this situation of increasing chaos, those members of the armed forces who envisaged a Marxist coup were carefully positioning themselves. Although General Francisco Franco disliked the Left for personal reasons, he respected democratic government and, in a letter of June 1936 to the Prime Minister, Casares Quiroga, insisted that the army remained loyal to the Republic and was not in the business of planning a coup against the government.[1] The murder of Calvo Sotelo less than a month later appears, however, to have changed his mind, and on 18 July, following the uprising of the military garrison in Morocco the previous evening, Franco made a radio broadcast from the Canary Islands in which he made it clear that the armed forces were now determined to restore order to a nation that was rapidly falling into anarchy, exploited by Soviet agents. Having then flown to Morocco, he made a number of

similar broadcasts over the next few days, emphasising that Spain would be saved by the Nationalists and that those who attempted to resist would receive exemplary punishment. This was the beginning of the Civil War.[2]

The military rising against the Madrid government was, of course, a closely co-ordinated affair in which at first Franco was only one of several generals. In Seville, for example, General Queipo de Llano, whom the republican government had initially trusted, quickly turned traitor, and on the afternoon of 18 July seized command of the city's garrison. By the evening, the military controlled the city centre and the radio station, from which Queipo proceeded to make the first of many notorious broadcasts in which, like Franco, he spoke of the danger to Spain and of the need to eradicate it:

> The generals who are responsible for this movement have no political motive. We simply defend our country against the criminal activities which a foreign power is undertaking in the heart of the nation ... Our aim is to restore the order undermined by foreign powers, by the Marxist threat ...[3]

In the reign of terror that was then directed at all supporters of the Left, Queipo was completely ruthless, accusing his opponents of the most horrendous atrocities, of which they were not always guilty, and allowing his men to arrest, torture, rape, pillage, and kill at will.

In the south of Spain, the fall of Seville to the rebels was soon followed by that of other cities, including Granada. During the months preceding the military uprising, the Falange had co-operated closely with the members of the Granada garrison who were known to oppose the government, in particular Commandant José Valdés Guzmán. The Military Governor in the city was, however, General Miguel Campíns Aura, a loyal supporter of the government who, when the military rebellion began, followed the government's advice in refusing to distribute arms to left-wing organisations in the belief that it would merely exacerbate the situation and that, in any case, the Granada garrison would not rebel. In the event it did, on the afternoon of 20 July. Campíns was arrested at gunpoint, the military seized the principal official buildings in the city, government representatives were arrested

and imprisoned, and within four days the whole of Granada was in rebel hands, including the steep, labyrinthine, working-class area known as the Albaicín, which held out until the last and which the military only overcame by employing machine guns, hand grenades, mortars, cannons, and aeroplanes. In the suppression that followed over a period of months, hundreds of men and women were rounded up and ruthlessly shot. Herded into lorries that climbed the hill to the cemetery behind the Alhambra, they were executed against the cemetery walls, while squads of assassins roamed the countryside in search of victims. Among those murdered in the cemetery on 16 August was Manuel Fernández-Montesinos, the socialist Mayor of the city and the husband of Lorca's sister, Concha.[4]

Lorca himself, as we have seen, had long been a target of the Right, and in 1936 both his actions and his statements drew further attention to him as an enthusiastic supporter of the Popular Front. Not long after the February general elections, he read his poems at a mass meeting of the Left in the Casa del Pueblo de Madrid and also joined two political organisations: the recently formed Friends of Latin America, dedicated to opposing Latin American dictatorships, and the Committee of the Friends of Portugal, which opposed the dictatorship of Oliveira Salazar. On May Day Lorca's message to the workers of Spain appeared in the communist journal, *¡Ayuda!*: 'I salute with great affection and enthusiasm all the workers of Spain, joined together on May Day by a desire for a more just and more united society.'[5] And, as if to underline his solidarity with them, he watched the parade through the streets of Madrid from a window in the Ministry of Communications, waving a red tie as it passed by. Later, in an interview for the newspaper *El Sol*, he repeated his belief that the fall of Moorish Granada to the Catholic monarchs, Ferdinand and Isabella, in 1492 had signalled the end of a magnificent civilisation, which he then compared unfavourably with the city's current inhabitants:

> It was a disastrous moment, even if in our schools they state the opposite. We lost a wonderful civilisation, poetry, astronomy, architecture, delicacy, all unique in the world, to be replaced by a poor, cowardly city: a 'miser's paradise' in which the worst bourgeoisie in Spain is at work.[6]

It was hardly a statement designed to endear Lorca to those who already disliked him, both for his allegiance to the Left and for his homosexuality, the latter incurring as much hostility as the former. Ian Gibson, as the result of conversations with individuals who were familiar with the situation in Granada in 1935–6, or with the relatives of those individuals, has drawn attention to the scorn with which many regarded Lorca, and to the fact that, among the local bourgeoisie, he was known, deprecatingly, as 'the queer with the bow tie'.[7]

As far as his theatre work was concerned, Lorca completed his great final play, *The House of Bernarda Alba*, on 19 June 1936, exactly two months before his murder. Less overtly political than *Play Without a Title*, *The House of Bernarda Alba* is, nevertheless, an extremely powerful portrayal of those narrow-minded, traditional, and often fanatically held values embodied by the Right. Indeed, Lorca clearly indicated the contemporary relevance of the play both in its subtitle, *A Drama of Women in the Villages of Spain*, and in his observation that 'The poet points out that these three acts are intended to be a photographic documentary.'[8] In this respect, it is no exaggeration to suggest that the play's protagonist is herself a kind of fascist, an intolerant mother who seeks to crush her five daughters' desire for physical and sexual freedom by confining them to the four walls of the house and by punishing any indiscretion on their part. The house itself is, in effect, a prison, its walls thick, its windows barred in the traditional Spanish way but suggesting too the notion of confinement. In the play's second act, Bernarda, railing against her daughters, reminds them that she has five chains, one for each of them. As well as this, their domestic chores, in particular sewing and embroidery, evoke prisoners sewing sacks in a prison workshop, while their occasional strolls in the large patio behind the house bring to mind the activities permitted to prisoners in the prison exercise yard. As for Bernarda herself, her black dress, the traditional dress of mourning – in this case for her dead husband – is also, significantly, suggestive of a black-shirted fascist, while the stick with which she is not averse to striking her daughters and which she bangs on the floor to reinforce her words, is clearly indicative of military discipline.

Bernarda Alba embodies in every sense that traditional Spain associated with the Right: the subordination and suppression of women; the importance of honour and reputation; the heartless

and cruel exploitation of the working class by those in power (Bernarda is a small landowner and treats her workers with scorn); and the teachings of the Catholic Church. In contrast, her daughters seek precisely those things advocated by the Left, by the first republican government between 1931 and 1933, and later by the Popular Front: the freedom to express one's individuality, to avoid the imposition of an arranged marriage, to seek to achieve one's ambitions, to be free, in short, from the narrow-minded shackles of the past. The inevitable and increasingly bitter clash between Bernarda and her daughters is, therefore, a microcosm of the broader political conflict that engulfed Spain as a whole in 1936, while the suicide of the youngest daughter, Adela, is both a reflection of the violence occurring in the country prior to the military rebellion and an indication of the carnage still to come. In *The House of Bernarda Alba*, therefore, Lorca portrayed a family that was an image of a nation, a pressure cooker that was soon to explode, with terrible consequences.[9]

Ten years later, as noted previously, Buñuel planned to make a film of Lorca's play but was prevented from doing so because the Lorca family had already sold the rights. While we can only guess at the kind of film Buñuel would have made, it is not too fanciful to imagine that he would have emphasised the contrast between the monotonous daily routine of the inhabitants of the Alba household and the inner lives of the frustrated young women in particular, a rich source of erotic dreams and fantasies. In addition, the traditional and conservative values Bernarda seeks to impose on her daughters, which may well have reminded Buñuel of his schooling by the Jesuits, are not unlike those that he mocked in many of his films, while the prison-house of the play has its equivalent in the imprisonment in the drawing room of the characters – albeit of a higher social class – in *The Exterminating Angel*.

As for Lorca's other work, *Blood Wedding* was performed in Bilbao in January 1936 by the company of Margarita Xirgu. Following their arrival in Cuba shortly afterwards, they presented *Yerma* in Havana, and a few months later, in Mexico, *Blood Wedding*, *Yerma*, *Doña Rosita the Spinster*, and *The Shoemaker's Wonderful Wife*. In Madrid, meanwhile, there were plans for a production of *When Five Years Pass*, to be staged after an autumn production of *Doña Rosita the Spinster*. In addition, Lorca announced in May

that he was working on a new play, *The Dreams of My Cousin Aurelia*, of which only one act remains.[10] In June and July he gave several private readings of *The House of Bernarda Alba* in which he played all the characters, while earlier in the year he had spoken of having a number of volumes of poetry ready to go to press, including *Poet in New York*, *Diwan of the Tamarit*, *Odes*, *Prose Poems*, and *Suites*.[11] Lorca's productivity remained unabated, his imagination as fresh as ever. But it was now about to come to a tragic conclusion.

The assassination of Lieutenant José Castillo in Madrid on 12 July, followed the next day by that of José Calvo Sotelo, alarmed Lorca to such an extent about the safety of his ageing parents, then back at their house in Granada, that he decided to join them almost immediately. His friends attempted to dissuade him. Buñuel would later recall:

> Lorca, who never got excited about politics, suddenly decided to leave for Granada, his native city.
>
> 'Federico', I pleaded, trying to talk him out of it. 'Horrendous things are happening. You can't go down there now; it's safer to stay right here.'
>
> He paid no attention to any of us, and left, tense and frightened, the following day.[12]

On the night of 13 July he took the overnight train and arrived at his parents' house, the Huerta de San Vicente, on the edge of the city, the following day. His return did not, however, go unnoticed, for it was announced in three newspapers: *El Defensor de Granada*, edited by his friend Constantino Ruiz Carnero, the Catholic *Ideal*, and the conservative *Noticiero Granadino*. His enemies, including those who were plotting the military insurrection in Granada, were well aware, then, that he was in the city once again.

The pity is, of course, that he had ample opportunity to escape from a situation in which he was increasingly in danger, but chose not to take it. Margarita Xirgu and her company had left Spain at the end of the previous January in order to undertake their South American tour. During the following months, aware of all that was happening in Spain and doubtless concerned for Lorca's safety, she vainly tried to persuade him to join her. There were various reasons why he did not do so. On the one hand, he was, as we have seen, involved in projects ranging from

the publication of his poems to the writing of new plays and the performance of those he had already written. On the other, there was his reluctance to leave behind Rodríguez Rapún, to whom he was now so attached. And finally, of course, when political events reached such an extreme in the summer of 1936, his concern for his parents, to whom he had always been very close, outweighed that for his own safety, even though he was extremely agitated. As he prepared for his departure to Granada, he revealed his fears to his friend, Rafael Martínez Nadal: 'Rafael, these fields will be full of corpses . . . But my mind is made up. I'm going to Granada, come what may.'[13]

By 23 July, as we have seen, Granada was in the hands of the rebels and a reign of terror was soon to begin. As far as the Lorca family was concerned, a Falangist squad arrived at the Huerta on 6 August and searched the house, possibly looking for a radio through which, it was suspected rather absurdly, Lorca communicated with the 'Reds'. The very next day, Alfredo Rodríguez Orgaz, a friend of Lorca, arrived at the Huerta and announced that he intended to escape to the Republican zone, a relatively short distance away. Lorca could, of course, have accompanied him, but again chose to remain with his family. The appearance at the Huerta of a group of fascists in pursuit of Rodríguez should have been sufficient warning of the danger that threatened all supporters of the Left.

Two days later a much more violent incident occurred. A group of men, all right-wing supporters who disliked Lorca's father on account of his liberal beliefs, arrived at the Huerta in search of the brothers of the Lorca family's caretaker, Gabriel Perea, whom they accused of having murdered two people in the village of Asquerosa on the day of the Granada insurrection. Failing to find the brothers after searching Perea's house, they threw his mother down the stairs, brutally questioned her, then dragged her and other members of the family outside. Perea himself was tied to a tree and beaten with a whip, and when Lorca attempted to intervene and protested the caretaker's ignorance of the events concerning his brothers, he was himself thrown to the ground, kicked, and derided by the group as 'the queer friend of Fernando de los Ríos'.[14] When the men were leaving, taking Perea with them for questioning, they informed Lorca that he was under house arrest. He was left in no doubt at all about the precariousness of his current situation.

Fearing for his safety, Lorca telephoned the young poet Luis Rosales, with whom he had become friendly in Madrid, and later that night was taken by car to the Rosales house at 1 Calle de Angulo. Although the location of the house, some three hundred yards from the civil government building, now occupied by the fascists, was potentially dangerous, and several of Luis Rosales's brothers were members of the Granada Falange, the head of the family, Miguel Rosales Vallecillos, was a man much respected for his integrity and was a liberal conservative who disliked extreme views. Without doubt, Lorca considered the house to be much safer than the Huerta de San Vicente. On the second floor and in the company of Señora Rosales's sister, Aunt Luisa Camacho, Lorca felt relatively secure.

Lorca spent a week in the Rosales house, a good deal of it in conversation with Señora Rosales, her daughter Esperanza, Aunt Luisa Camacho, and a female servant. For most of the time, the men were away: Don Miguel in his shop, José had his own flat, Antonio spent little time at home, and Luis, who was also a member of the Falange, only returned to the house in the evenings. Nevertheless, this was an extremely dangerous time and Lorca must have learned through the newspapers and the radio of the repressive measures being taken by the fascists, including the executions in and around Granada. Indeed, on Sunday 16 August, news reached him, probably by telephone, of the execution of his brother-in-law, Manuel, in the local cemetery. Lorca, somewhat timid by nature and obsessed by death, was at once terrified. He may also have known that on the previous day a fascist group had again visited the Huerta de San Vicente, armed with a warrant for his arrest. Unable to locate him, they had searched the house and questioned the family, threatening to arrest his father if his son's whereabouts were not revealed. Fearing for her father's safety and in a moment of panic, Lorca's sister Concha had revealed that he was staying with a friend, a fellow-poet and a member of the Falange. Whether or not she mentioned Rosales by name is unclear, but her words were sufficient to tell the fascists where Lorca was hiding.

At one o'clock on the afternoon of 16 August, Calle de Angulo was blocked off by the police and members of the military, who also took up positions on the surrounding rooftops. Three men approached the front door of the Rosales house: Juan Luis Trecastro, a local

landowner; Luis García Alix, secretary of the Conservative Party in Granada; and Ramón Ruiz Alonso, a right-wing ex-Member of Parliament for Granada who had lost his seat to the Left in the February elections, and who had a particular hatred for Fernando de los Ríos and for Lorca. When Ruiz Alonso demanded that Lorca be handed over for questioning, Señora Rosales refused to allow him into the house and attempted to contact her sons by telephone. She succeeded in speaking to Miguel, who arranged that Ruiz Alonso should drive to the Falange headquarters in order to discuss the matter. Later, both men returned to the Rosales house and Miguel informed his mother that, since Ruiz Alonso claimed to be following orders, he was compelled to take Lorca to the civil government building. Nevertheless, he, Miguel, would ensure that no harm would come to him.

Lorca, overcome by fear of what might lie ahead, left the Rosales house, accompanied the others round the corner into the Plaza de la Trinidad, and was driven to the civil government building, a short distance away, where he was confined in a room on the first floor. Subsequently, the Rosales brothers did all they could to secure Lorca's release. But when José Rosales confronted Valdés Guzmán, the Military Governor, he was informed that a formal document now in his possession accused Lorca of having a secret radio with which he was able to contact Russia; of being a homosexual; of working as a secretary to Fernando de los Ríos; and of being a subversive writer. They were charges that would have to be answered satisfactorily, but he assured José Rosales that no harm would befall the poet.

On 17 August, José Rosales obtained an order for Lorca's release, hurried to the civil government building, but was informed by Valdés that Lorca was no longer there. The evidence suggests that this was not true, for Angelina Cordobilla, nanny to Concha García Lorca's children, recalled that she delivered food to him on that day and the next. Only on the 19 August, when she made another visit, was she told that he was no longer in the building, though it seems quite possible that, attempting to recall these events twenty years later, she may have seen Lorca only on one occasion rather than two, and that she was informed of his absence not on 19 but on 18 August. As for Valdés, he had clearly wanted to stall while he made up his mind about what to do with Lorca. It seems quite likely that, before giving the order for his

execution, Valdés telephoned General Queipo de Llano in Seville and that the general suggested that Lorca be given 'plenty of coffee', a euphemism for execution. Given both Queipo de Llano's and Valdés's harsh and vindictive natures, particularly in relation to the 'Reds', Lorca stood little chance of being spared. In the case of Valdés, who could have saved Lorca but chose not to, it was only poetic justice that he should have died painfully less than three years later from a combination of cancer and a wound received in action.

Lorca, together with a primary schoolteacher and staunch Republican, Dióscoro Galindo González, was taken from the civil government building, pushed into a car, and driven away, probably on the night of 18 August as suggested above. The car made its way to the village of Viznar, a typical Andalusian village of whitewashed houses and steep streets, to the north-east of Granada, which, at the beginning of the Civil War, was both a Nationalist military position and a place of execution where hundreds of Republican supporters were murdered at dawn. Before execution, prisoners were held overnight in a ground-floor room of a building above the village that was known locally as the 'Colony', and it was here that Lorca found himself with Galindo González and two anarchist bullfighters, Joaquín Arcollas Cabezas and Francisco Galadí Melgar. Guarding the prisoners was the twenty-two-year-old José Jover Tripaldi, who usually informed them that they would be taken out to work on military defences or on the roads the following morning, and only told them the truth shortly before their execution. Lorca was apparently so terrified that, when he attempted to pray, he could not remember the prayer and felt that he would be damned. Jover Tripaldi attempted to reassure him that he would not.

Before dawn, Lorca and his three companions were bundled into a lorry and driven from the 'Colony' along the road that leads towards the village of Alfacar, separated from Viznar by a valley of olive groves. In the valley is a spring called the Fuente Grande, the 'Big Fountain', referred to by the Arabs in earlier centuries as the 'Fountain of Tears', and near there it was – given Lorca's love of Muslim culture, the irony could not be greater – that Lorca's life was cruelly extinguished. Many of the men who carried out the executions simply enjoyed killing for its own sake and boasted nicknames such as the 'Knife Man' and the 'Hangman'. It seems

possible that Lorca did not die immediately but had to be finished off by a single bullet at close quarters. Juan Luis Trecastro, the landowner who had accompanied Ruiz Alonso to the Rosales house in order to arrest Lorca, bragged later that he had been one of the executioners and that he had put 'two bullets into his arse for being a queer'.[15]

Shortly after they were shot, the bodies of the four men were buried in a shallow grave by a young man, Manuel Castilla Blanco, who remembered that one of them wore the kind of tie that artists wear. When Gerald Brenan visited the area thirteen years later, he attempted to count the small stones that marked the graves of the prisoners who had been held at the 'Colony', but abandoned the attempt because they ran into hundreds.[16]

Back in Granada, Manuel de Falla, learning of Lorca's arrest, made every effort to intervene but his efforts were in vain. Don Federico, having received a note from his son in which he was asked to give the army a donation of 1,000 pesetas, paid the money in the belief that he could save him. The news of Lorca's death did not reach the Republican press for another three weeks, but thereafter was widely reported both in the Spanish and the European newspapers. When H.G. Wells, president of the Pen Club of London, asked the Granada authorities for information about Lorca, they replied that his whereabouts were unknown. At the end of the Civil War and the beginning of the Franco dictatorship, Granada's Civil Register contained the statement that Lorca had died in August 1936 from war wounds.

When the military uprising began, Buñuel was, as we have seen, in Madrid, a witness to the chaos that was now descending on the country. But in comparison with Lorca's outspoken support of the Left and his considerable courage in returning to Granada, Buñuel cuts a relatively poor figure. Despite his much-publicised hatred of the Right, his communist beliefs, and his pugnacious character, he was strangely appalled and often frightened by real violence:

> I, who had been such an ardent subversive, who had so desired the overthrow of the established order, now found myself in the middle of a volcano, and I was afraid . . . I . . . couldn't stomach the summary executions, the looting, the criminal acts.[17]

In this he has drawn attention to the gulf between his intel-
lectual and emotional attraction to anarchy and to his deep-seated
desire for order and peace.[18] He detested the executions and the
criminal acts of the extreme Left as much as he abhorred the
atrocities committed by the fascists and their supporters. Further-
more, he has admitted that, as someone who lived in a comfortable
apartment, who was the son of a wealthy family, who was the
owner of land outside Madrid, and who worked for a commercial
film company, he was extremely fearful that he might himself be
seized by anarchists and shot. It came, therefore, as something of
a relief when, having already sent his wife and child back to Paris,
he was, at the end of September 1936, asked by Julio Alvarez
del Vayo, the Republican Minister of Foreign Affairs, to attend a
political convention in Geneva and to take instructions from the
Spanish Embassy there. As a result, Buñuel was sent to Paris,
where he remained for the duration of the Civil War, avoiding
the fate that had befallen Lorca. There he worked for the Spanish
Ambassador, Luis Araquistaín, a socialist and an old friend.

Buñuel's activities were, by his own account, rather varied.[19] He
was officially responsible for cataloguing Republican propaganda
films made in Spain and for helping individuals to shoot their films
there, but he also worked in many other capacities: as a kind of
cultural attaché, as a social secretary, as a courier, as a bodyguard,
and as a secret agent. As far as film was concerned, Buñuel helped
to finance André Malraux's *L'Espoir* (*Man's Hope*) (1938), a film
about pilots in Spain, and issued permits to Joris Ivens and Ernest
Hemingway to make *The Spanish Earth* (1937), a documentary
about the Republican Army. He also put together − and may
indeed have had a larger role than that of editor − a full-length
documentary called *España 1936*, also known as *Loyal Spain, To
Arms!*, a co-production with the French Communist Party. The film,
with commentary, depicts battle scenes from the Civil War derived
from both the Republican and Nationalist archives; episodes
behind the lines; the siege of Madrid and queues for food; shots
of the destruction caused by bombardment and bombing; images
of women with dead and wounded children; and political scenes
from abroad suggesting the relationship of the Great Powers to the
Spanish conflict. Reminiscent of *Las Hurdes*, *España 1936* has a
similar documentary quality and is edited, like that earlier film, in
a way that makes its political statement very clear.

One of the more interesting aspects of his work for the Paris Embassy was, of course, that of secret agent. In this capacity, Buñuel eavesdropped in the Montparnasse cafés on the groups, mainly consisting of South Americans, in which there were assassins in the pay of Franco and Stalin. He often came into possession of information about terrorists who conducted bombing campaigns on behalf of the Nationalists, as in the case of one individual who, at the end of the war, was decorated by Franco for his contribution to the cause. Even so, Buñuel soon discovered that the information he supplied to the French police was usually ignored, and he eventually became disillusioned with the whole process. As a courier, he sometimes took special documents across the border to Spain, and on one occasion at Bayonne released balloons carrying propaganda leaflets. But although he later admitted that he enjoyed much of his work as a so-called secret agent, the reality was that it was largely unproductive. His desire to obtain more important work was one reason why, in 1938, he decided to take his family to the United States.

There were undoubtedly other reasons too. As the Civil War unfolded and the supporters of the Republic began to lose ground, Spanish émigrés in Paris, especially those who were regarded as 'Reds', found that they were increasingly unwelcome and subject to frequent harassment. Buñuel may also have feared for his life once the war was over. There was also, of course, the possibility that in America he would be able to further a film career that, after the success of his earlier surrealist films, had found itself largely in limbo. Arriving in Hollywood, he was placed by Frank Davis at MGM on the payroll of *Cargo of Innocence*, a film about Spanish refugee mothers and children heading from Bilbao to the USSR. But Buñuel's early optimism was soon dashed when Washington instructed the Motion Picture Producers Association that no films about the Spanish Civil War were to be made. Unable to find the kind of work he really wanted, Buñuel did some dubbing, while Jeanne turned her hand to translating from English into French. It was a hand-to-mouth existence and Buñuel soon realised the utter futility of continuing to look for work in the Hollywood film industry. At the end of 1939 he therefore headed for New York and by early 1941, through the influence of Iris Barry, the wife of the vice-president of the Museum of Modern Art, he succeeded in obtaining a job there as editor-in-chief and head of the writers'

department, with the responsibility of choosing anti-Nazi propaganda films and arranging for their distribution in North and South America in English, Spanish, and Portuguese.

While Lorca was involved in the terrible events that led to his execution and Buñuel worked for the Republic in Paris, Dalí continued, self-obsessed as he was, to feather his own already comfortable nest. As Spain moved inexorably towards the beginning of the Civil War, 11 June 1936 saw the opening at the New Burlington Galleries in London of the International Surrealist Exhibition at which Dalí gave a lecture entitled 'Authentic Paranoiac Fantasies' from inside a diving suit, one of a series of outrageous stunts that would characterise his behaviour in the years ahead. On this occasion, however, it backfired. Unable to be heard by his audience and growing ever hotter and more panic stricken inside the suit, he finally had to be rescued by someone, who was instructed to go in search of a spanner. As for the show itself, Dalí exhibited three paintings – *The Dream, Daybreak*, and *Paranoiac Head* – together with various other items, but this was soon overshadowed by his one-man exhibition at Alex, Reid and Lefevre's in London where twenty-nine paintings and eighteen drawings were shown, seven of the paintings already sold prior to the opening. The paintings included *Soft Construction with Boiled Beans*, whose title Dalí subsequently changed to *Premonition of Civil War*, claiming its prophetic significance. In reality, he had produced preliminary drawings for the painting two years earlier, and the new title provides evidence more of his opportunism than of anything else. It was, incidentally, at the International Surrealist Exhibition that Dylan Thomas, who loved to mock all pretentiousness, wandered among the viewers with a cup of boiled string, asking them if they preferred it hot or cold.

By this time, the Dalís were an extremely rich and famous couple. In the late summer of 1936, for example, they had moved into an expensive house in the suburbs of Paris. Dalí's paintings were selling remarkably quickly for substantial amounts of money, and he was always eager to earn more by broadening his artistic activities. He now began to design clothes for the highly important and influential Paris dress designer, Elsa Schiaparelli, who also collaborated with artistic figures as significant as Picasso and Jean Cocteau. Among Dalí's playful designs were

a handbag that resembled a telephone, a hat made from a shoe turned upside down, and, other than clothes, a sofa in the shape of Mae West's lips. Gala herself was dressed in the smartest outfits by both Schiaparelli and Chanel, a far cry from the inexpensive clothes she had once worn. The couple were photographed by celebrated photographers, including Cecil Beaton and Man Ray. They frequented the best French restaurants, dining on fine food and expensive wines. They regularly travelled abroad and stayed in the best hotels. And Dalí guaranteed their financial future by signing lucrative contracts for his paintings. At the end of 1936 he entered into an agreement with Edward James – the wealthy Englishman who became a close friend and collector of Dalí's paintings – that James would purchase all of his work between June 1937 and June 1938 for the sum of £2,400, a substantial sum of money at that time. Along with the income that Dalí was receiving from his other activities, this is a clear indication of just how prosperous he was now becoming. Gala was seeing her dream come true.

On 7 December Dalí and Gala arrived once more in New York, aboard the *Normandie*, a luxury French liner. There, they attended an exhibition entitled 'Fantastic Art, Dada and Surrealism', which opened at the Museum of Modern Art two days later, to be followed on 15 December by an exhibition of Dalí's own paintings at Julian Levy's gallery. In the first of the two exhibitions, six of his works were included; in the second, twenty paintings and twelve drawings. Both shows brought Dalí huge success and acclamation. *Time* magazine had a photograph of him by Man Ray on its cover, and on its inside pages – apart from reviewing the exhibition at the Museum of Modern Art – observed that Dalí, more than anyone, was responsible for bringing Surrealism to the attention of the American public. His third New York exhibition thus brought him a degree of fame that he found completely intoxicating.

At the same time, the Fifth Avenue department store, Bonwit Teller's, had commissioned various surrealist artists, including Dalí, to create displays for its windows. Dalí's consisted of a female dummy, her head made of red roses, her body clothed in a black gown. From gaps in crumbling walls red arms reached out for her, attempting to touch her or offering gifts, while, to one side of her, a small table contained a bright-red lobster telephone. Needless to say, Dalí's display attracted huge crowds, but although many

of his finest works were still to come, it was already clear that concessions to fame and the material rewards that came with it were becoming more and more alluring to both Dalí and Gala. They were feted everywhere they went and Dalí himself could not venture outside without being recognised.

It was inevitable that the glamour of Hollywood, where they arrived at the end of January 1937, would prove an irresistible attraction. Dalí was already interested in making a film with Harpo Marx, whom he had met in Paris in 1936 and whom he considered the most surrealist of the three brothers. Indeed, prior to his arrival in Hollywood, he had sent Harpo the gift of a harp with strings of barbed-wire, and while there he was photographed making a drawing of Harpo holding the instrument and balancing a lobster on his head. After his return to Europe, Dalí succeeded in writing a screenplay that, though full of his personal obsessions, proved to be banal in the extreme. While his belief that the antics of the Marx brothers were in the surrealist tradition may well have been genuine enough, it is difficult to avoid the conclusion that, by making a film with a highly successful Hollywood product, Dalí was seduced by yet another opportunity to consolidate his fame and increase his bank balance.

On the other hand, the summer of 1937 found Dalí working on a poem, *The Myth of Narcissus*, and on one of his most memorable and haunting paintings, *Metamorphosis of Narcissus*, the latter title soon applied to both. In another painting, *The Great Paranoiac*, completed a year earlier, Dalí had once more expressed his intense feelings of shame in relation to his sexual habits, for around the central face of the anguished protagonist are grouped other characters, all of whom are either burying their head in their hands or looking away, while behind the head of the protagonist the male figure commanding an ashamed male to leave is strongly reminiscent of Dalí's father. To judge by this painting, it seems clear enough that, despite marriage to Gala, his masturbatory obsessions and his accompanying guilt were still very strong. Allusions to Lorca in the poem of 1937 suggest that Dalí was still extremely conscious of the homosexual tendencies within himself and which he had resisted in the face of Lorca's advances. One must also bear in mind in this context the growing importance in Dalí's life of Edward James, who was homosexual too and probably attracted sexually to the painter. Even so, the *Metamorphosis*

*of Narcissus* painting points to a movement away from narcissistic self-absorption. The figure on the left-hand side of the picture, face averted and head in hands, is the familiar male overwhelmed by guilt and shame. On the right-hand side of the picture, Narcissus has, however, been transformed into fingers holding an egg that has been split open to reveal a narcissus, equivalent to the appearance of Gala in Dalí's life and his rebirth through her. Significantly, the two figures are set against the background of Cape Creus, where the couple celebrated their newfound love.

Over the next few years, further exhibitions served to increase Dalí's fame. At the end of June 1937, *Metamorphosis of Narcissus* was included with such paintings as *Giraffes on Fire, Portrait of Harpo Marx, Epidermis of Piano*, and *Face of Mae West Which Can Serve as a Surrealist Apartment* in a show in Paris. In January 1938 he participated with other surrealists in a group exhibition at the Galerie des Beaux Arts, where his *Rainy Taxi* – a replica now stands at the entrance to the Dalí Theatre-Museum in Figueras – adorned the lobby, while his model of a girl with a toucan's head and an egg between her breasts could be found, along with wax models by other surrealists, in a long passage called 'Surrealist Street', and *The Great Masturbator* and *Giraffe in Flames* in the exhibition room. A year later, in February 1939, the Dalís were in New York again for yet another exhibition at the Julian Levy Gallery, prior to which Dalí once more created two window displays for the Bonwit Teller department store. The extraordinary display, which contained in one window a scantily dressed wax mannequin about to step into a bath from which three hands emerged, and in the other a bed on four buffalo legs on which a mannequin lay on top of live coals, both attracted and scandalised the public. When the management replaced Dalí's models with others that were more decorous, he attempted to dismantle them but in the process crashed through the window, much to the delight of the public who considered his actions to be part of the show.

The exhibition at the Levy Gallery, which contained twenty-one paintings and five drawings, was again an enormous success, dazzling the public with such paintings as *Debris of a Motor Car Giving Birth to a Blind Horse, The Great One-Eyed Cretin, The Enigma of Hitler*, and *The Endless Enigma. Life* magazine stated that no exhibition in New York had been so popular for a number of

years and that, when it closed, all but two of Dalí's works had been sold for more than $25,000. The art critic of *Art Digest* concluded:

Dalí is a bombshell in art, he can't be ignored for all the petulant ostrich-like attitudes of those who intensely dislike his art . . . the fellow is doing a real service and this is why it hurts. He is dramatising as it has not been dramatised in years the fact that the art world is a tight little field in the habit of issuing a lot of self-satisfying little dictums and ukases that ought to be upset.[20]

And in the *New Yorker*, Robert M. Coates suggested that Dalí's paintings were as much fun as art:

Dalí's work is neither so portentous nor so outrageous as it has been made out to be. It is simply a form of social satire, more oblique than most and frequently cluttered and obscure in manner, but presented with . . . suavity and skill.[21]

Before the exhibition closed, Dalí was invited to design a surrealist pavilion for the Amusement Area of the New York World's Fair, which would open in early June. His proposal was for a palace of imitation coral with an inner transparent pool intended to suggest the workings of the unconscious and containing soft watches, a sofa in the shape of Greta Garbo's lips, and female swimmers performing underwater. In the event, the proposed show was beset by endless problems and became a shadow of Dalí's original intention, but it was still a popular success. The otherwise favourable observation of a *Time* magazine journalist that there was 'plenty of Broadway in Dalí's madness' illustrates very clearly, however, the extent to which, in the pursuit of fame and fortune, Dalí was now prepared to produce work that was pure show-biz.[22]

During 1938 he had also been working on a ballet for the Ballets Russes that was finally entitled *Baccanale* and was to open in London in the autumn of 1939. The involvement of Britain in the war against Germany in September of that year meant, however, that the production was switched to the Metropolitan Opera House in New York, where the premiere was to take place on 9 November. But the event was plagued by problems. Because Dalí was still in Europe and Gala was unwilling to allow him to travel

across the Atlantic in wartime, Coco Chanel, who had designed the costumes, refused to send them to New York in Dalí's absence. In the end, substitute costumes were quickly made, Dalí did not attend the premiere, and the performance itself was affected by all kinds of technical problems, including a delay of forty minutes between Scenes One and Two. The ballet proved to be one of Dalí's major failures up to this point.

By this time the Spanish Civil War had, of course, come to an end with the victory of Franco's Nationalists, heralding a dictatorship of thirty-six years. Dalí, as we have seen, had deliberately avoided any kind of involvement, preferring to make the most of the opportunities for self-advancement that came his way, and undoubtedly waiting, with his own future in mind, to see which side would come out on top. It is hardly surprising, then, given his existing admiration for Hitler's Germany, that he should have been delighted by Franco's victory and that subsequently he should have made every effort to ingratiate himself with the regime. The revolutionary of the 1920s, the advocate of social unrest and even terrorism, had by the late 1930s become its complete opposite, a self-seeking, self-justifying opportunist whose actions and words cannot but leave a sour taste, as his reaction to Lorca's murder and his attitude to Buñuel perfectly illustrate.

As we have seen, Buñuel had attempted to persuade Lorca not to leave Madrid for Granada and was subsequently shocked by the news of his death. There is no record of Dalí's immediate reaction, but it has been suggested that, when he received the news in September 1936, he shouted '¡Olé!', the word usually used to acknowledge the skilful pass executed by a bullfighter.[23] If such a claim is true, it does Dalí little credit, given his earlier relationship with Lorca, though later, in *The Secret Life*, he seems to have regretted that initial reaction:

> At the very outbreak of the revolution, my great friend, the poet of *la mala muerte*, Federico García Lorca, died before a firing squad in Granada, occupied by the Fascists . . . In the Civil War people killed each other not even for ideas, but for 'personal reasons', for reasons of personality; and like myself, Lorca had personality and to spare, and with it a better right than most to be shot by Spaniards. Lorca's tragic sense of life was marked by the same constant as that of the destiny of the whole Spanish people.[24]

Because Dalí's real feelings are often difficult to ascertain – his writings about himself are full of revisions as well as contradictions – we cannot know with any certainty what he actually felt about Lorca's death, but there is no doubt that the influence of the great poet dramatist can often be seen in the painter's subsequent work.

## NOTES

1 For an account of the events leading up to the Civil War, see Carr, *Spain, 1808–1939*, and Thomas, *The Spanish Civil War*.

2 For a detailed account of Franco's life and his involvement in the military uprising, see Paul Preston, *Franco: A Biography*, New York: HarperCollins, 1993, in particular pp. 141–6.

3 For an account of the life of Queipo de Llano and of his radio broadcasts, see Ian Gibson, *Queipo de Llano. Sevilla, verano de 1936 (con las charlas radiofónicas completas)*, Barcelona: Editorial Grijalbo, 1986.

4 Ian Gibson has described in some detail the fall of Granada and the reign of terror which followed. See Gibson, *Federico García Lorca: A Life*, pp. 446–50; and in much greater detail, Ian Gibson, *The Assassination of Federico García Lorca*, London: W.H. Allen, 1979, pp. 69–111.

5 *¡Ayuda!*, 1 May 1936, p. 1.

6 The interview appeared in *El Sol* on 10 June 1936. See too García Lorca, *Obras completas,* vol. 3, p. 637.

7 See Gibson, *Federico García Lorca: A Life*, p. 408.

8 See my translation of the play: *The House of Bernarda Alba: La casa de Bernarda Alba*, London: Methuen, 1998.

9 Ibid., for a commentary on the play, and also Edwards, *Lorca: Living in the Theatre*, pp. 181–213.

10 In *Heraldo de Madrid*, 29 May 1936, p. 9.

11 In an interview with journalist Antonio Otero Seco in January 1936. See Gibson, *Federico García Lorca: A Life*, p. 426.

12 Buñuel, *My Last Breath*, pp. 157–8.

13 See Rafael Martínez Nadal, *Federico García Lorca: 'El público' y 'Comedia sin título', dos obras teatrales póstumas*, Barcelona: Editorial Seix Barral, 1978, p. 17.

14 The incident is described in Gibson, *The Assassination of Federico García Lorca*, pp. 115–17.

15 Ibid., p. 179.

16 Gerald Brenan, *The Face of Spain*, London: the Turnstile Press, 1950, p. 145.

17    Buñuel, *My Last Breath*, p. 153.
18    Ibid., p. 154.
19    Ibid., pp. 158–70.
20    *Art Digest*, 1 April 1939.
21    *New Yorker*, 1 April 1939.
22    'World's Fairs. Pay As You Enter', *Time Magazine*, 26 June 1939.
23    See Parinaud, *The Unspeakable Confessions of Salvador Dalí*, 1977.
24    Dalí, *The Secret Life of Salvador Dalí*, p. 361.

# 9

# AFTER LORCA

∞

THE ATROCITIES THAT had characterised the three years of the Civil War did not end with the termination of hostilities; in the years that followed, the victorious Nationalists, as might be expected in such inflamed circumstances, subjected the defeated Republicans to punishments ranging from executions and long periods of imprisonment to the suppression of any opposition through the media and the blighting of many a career through administrative procedures. Through the 1940s and early 1950s, economic conditions in the country were extremely bad, both as a result of the war itself and also because of a resolution taken in 1946 by the United Nations to impose a trade boycott on a country now ruled by a right-wing dictator. In the countryside, where working conditions had always been dire and where income had been very low, poor peasants were obliged to live off boiled grass and weeds. In the towns and cities, cats and dogs were frequently eaten, and in Madrid and Barcelona there were daily cuts in the electricity supply. Those European countries who had been involved in the Second World War, and which were now in the process of recovery, saw no reason to assist Spain.[1]

The UN boycott came to an end in 1950, but conditions in the country remained much the same, and it was not until the end of the decade that the situation began to improve as the result of serious attempts to tackle inflation and redress the catastrophic deficit in the balance of payments. Between 1961 and 1973, the economy grew at 7 per cent a year, people were much better off,

foreign investment increased, and, from around 1959, the tourist industry began to flourish as never before. By the time General Franco died, on 20 November 1975, it was perfectly clear that a decisive era in Spanish political and social life had come to an end. What the next step would be was anyone's guess. Would Franco's control of the country continue in the hands of someone else? Would there be a movement towards a more democratic system? Prince Juan Carlos, grandson of the former King Alfonso XIII, had been groomed by Franco to take his place. In the event, the young man recognised the people's desire for a democratic system, and by 1979, when general elections finally took place, the political structure of forty years had been dismantled, and the country had returned, somewhat ironically, to the beginning of the 1930s and the triumph of the Second Republic. The rest, as the saying goes, is history.

The fortunes of Lorca's work between 1936 and the present day mirror in many ways the fortunes of Spain during that period. Between the end of the Civil War and the early 1960s, when the Franco regime was at its most harsh, Lorca's plays were not performed there, partly because of the Lorca family's opposition, but also, no doubt, because the regime was well aware of Lorca's left-wing views and of the furore that his murder had caused both at home and abroad. The first production of *The House of Bernarda Alba* took place, therefore, in Buenos Aires on 8 March 1945, where it was staged, appropriately, by the company of Margarita Xirgu, with the actress in the leading role. It proved to be a total triumph, and at the end of the performance Xirgu addressed the audience with the following words: 'He wanted this play to be premiered here, and so it has been, but he wanted to be present and destiny has prevented it. A destiny which causes many to weep. A curse on war!'[2] Subsequently, the play would be performed throughout South America, but was not staged in Spain for another nineteen years.

The first production of a Lorca play in Spain, which coincided with the relaxation of the early rigours of the dictatorship, was not of *The House of Bernarda Alba* but of *Yerma*, which opened at the Teatro Eslava in Madrid on 3 October 1961 and was much praised by the critics. *Blood Wedding* followed a year later at the Teatro Bellas Artes, and *The House of Bernarda Alba* in 1964, both productions also in Madrid. While there were later productions of all three plays, there have also been major presentations of the other plays, some many years after they were written or first

performed. *When Five Years Pass* and *The Public* were staged for the first time in 1978 and 1987 respectively, and *Doña Rosita the Spinster* in 1980, forty-five years after its first production. After the Civil War, Lorca's name was associated as much with the nature of his death as with his theatre, but, over time, increasing recognition has been given to the quality of his work, in terms of both its power and its impressive variety. Indeed, the productions of his plays have over the years revealed the extent to which they lend themselves to different and often highly imaginative interpretations.

While the productions of the early 1960s were largely characterised by their naturalism, combined with a degree of stylisation, those of more recent times have often been distinguished by bold innovation. In 1971, for example, the Argentinian director Victor García staged *Yerma* at the Teatro de la Comedia in Madrid in a manner that departed markedly not only from previous productions but also from Lorca's own stage directions. The set, designed by García and Fabià Puigserver, consisted of a huge five-sided metal frame that filled the stage and across which was stretched a canvas containing numerous locking points to which cables could be attached, allowing the canvas to be raised or lowered into shapes suggesting hills and valleys. When the actors walked around the side of the metal frame, they did so in a normal way, but as soon as they stepped onto the canvas, their movements acquired a bobbing character, as on a trampoline. In short, the set suggested two different worlds: the solid frame evoking the real world in which the characters normally live, the canvas the insubstantial inner world of dreams and desires in which Yerma literally floats. Needless to say, this was a production that divided the critics, both in Spain and at the Edinburgh International Festival where it was performed in 1986 and where the great Spanish actress, Nuria Espert, played the role of Yerma, as she had done fifteen years earlier. Of the Madrid production, José Monleón concluded:

Victor García's production has arrived at a moment when performances of Lorca's plays are being characterised everywhere by a rejection of naturalism and by a focus on different levels of reality which had never before been present in the staging [of his plays].[3]

Equally innovative was the first professional production of *The Public*, a collaboration between the Piccolo Teatro di Milano and Madrid's Teatro María Guerrero, that opened in Madrid in the winter of 1987, directed by Lluís Pascual. Like García, Pascual abandoned Lorca's stage directions in favour of a much more daring staging, transforming the whole of the theatre's ground-floor area into a vast circular space suggesting the inner world of the unconscious and in which the actors could walk, run and leap with complete freedom. Frequent changes of lighting emphasised the shadowy recesses of the mind, and the highly choreographed movement of the characters within that setting were perfectly and powerfully matched by the delivery of Lorca's markedly stylised language. Lorca would undoubtedly have approved of the freeing of the action from the restrictions of the proscenium arch that largely dominated the earlier productions of his plays.[4]

As far as the appearance of the plays in print is concerned, the first editions were published not in Spain but in South America, where the Argentinian publishing house, Editorial Losada, brought out all the major plays, apart from *The Public* and *Play Without a Title*, in the 1940s. Subsequently, the *Obras completas* (*The Complete Works*), which also contain his poetry, were first published in Spain in 1954 by the Madrid publishing house, Aguilar, and since then have been reprinted many times, later editions including the complete text of *The Public* and fragments of other works that had previously been either undiscovered or not available for publication. As time has gone by, many other Spanish publishers have also produced editions of the plays, often with detailed commentaries and explanatory notes. The appetite for Lorca's work and the recognition of its quality and fascination has undoubtedly grown with the passing of time and the greatly changed political situation in Spain.

As far as the English-speaking world is concerned, the earliest production of a major play in translation was that of *Blood Wedding*, which was staged in 1935, only two years after its Madrid premiere, at the Neighborhood Playhouse in New York, in a translation by José Weissberger. Given his almost total lack of English, it is difficult to see to what extent Lorca contributed to the translation, though he is known to have done so. The performances ran for three weeks and had a somewhat mixed reception from the critics. The difficulty of translating Lorca's language into

13. Production of Lorca's *Doña Rosita the Spinster*, at the Theatre Royal, Bristol, 1989

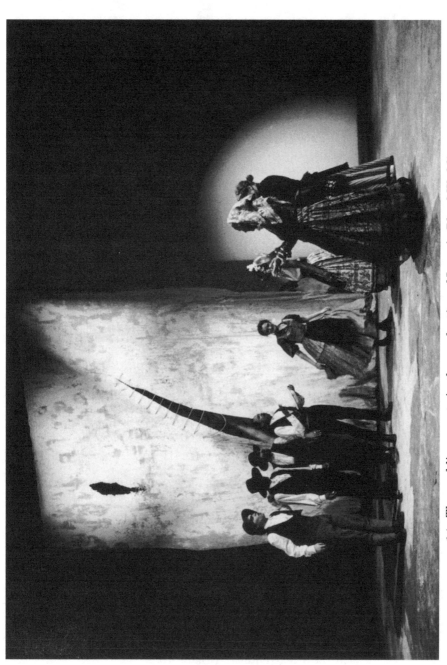

14. The wedding guests in the production of Lorca's *Blood Wedding*, directed by Anthony Clark, at Contact Theatre, Manchester, 1987

a form of English that not only captures the meaning of his lines but can also sound convincing in the mouths of actors evidently affected this early translation, and has continued to affect many others since then. It also accounts for, together with problems of copyright and the difficulties of staging a Lorca play away from its homeland, the relative lack of English-language productions until 1986, fifty years after Lorca's death and the ending, temporarily at least, of copyright restrictions.[5]

The first English-language professional production of a Lorca play in Britain seems to have been that of *Blood Wedding*, which was directed by a young Peter Hall at the Arts Theatre, London, in 1954. Two years later it was staged at the Nottingham Playhouse, and in 1973 at the Leeds Playhouse. In the same year *The House of Bernarda Alba* was performed at the Greenwich Theatre, London, in a translation by Tom Stoppard and with Mia Farrow in the role of Adela. A much-publicised production of the same play, with Glenda Jackson as Bernarda Alba and Joan Plowright as the housekeeper, began life at the Lyric Theatre, Hammersmith, in 1986, transferring subsequently to the West End. Between 1986, the fiftieth anniversary of Lorca's death and the end of copyright restrictions in England, and 1996, when they were extended by another ten years, a number of new translations of various plays were undertaken, many of which were published and led subsequently to further productions at venues ranging from the National Theatre to regional theatres such as Contact Theatre, Manchester, the Haymarket Theatre, Leicester, and the Mercury Theatre, Colchester.[6] Since the reintroduction of copyright restrictions, there have been further productions of Lorca's plays, but it has to be said that, with a few exceptions, British directors have little idea of what is required to bring them alive on stage, as was the case in the National Theatre's production of *The House of Bernarda Alba* in 2005, in which the set, rather than suggesting a house in rural Spain in the early twentieth century, was described by one critic as a 'faded Eastbourne hotel', and the actors were reminiscent of the products of an elegant finishing school.[7]

The productions mentioned above, as well as many in the United States, suggest that, even if some were unsuccessful, Lorca's theatre has the same vibrancy and interest today, both inside and outside Spain, as it had during his lifetime. While some directors and theatre critics believe that the Spanishness of his

plays cannot be captured in translation, the truth of the matter is that what ultimately prevails is their universal appeal, together with their power and passion. In addition, Lorca reveals himself to be, from play to play, a dramatist who constantly experiments, who always attempts to do something new, who never rests on his laurels. The freshness of his work is, therefore, one of its abiding qualities and one of the major reasons why it continues to surprise and attract. The same is true, of course, of his poetry, from *Poem of Deep Song* and *Gypsy Ballads*, with their deeply Spanish preoccupations, to the strikingly avant-garde *Poet in New York*. Volumes of Lorca's poetry, both in the original Spanish and in translation, have been published regularly for many years. Furthermore, if the preceding pages have focused on his work in English translation, it should not be forgotten that his theatre and poetry has a worldwide circulation and has been translated into many other languages. He is truly one of the great writers of the twentieth century.

Had Lorca's life not come to an end when he was only thirty-eight years of age, his vivid imagination and his innovative nature make it highly likely that he would have produced more outstanding work. In 1934, for example, he had informed the journalist Alonso Prats that he intended to follow *Yerma* with *The Drama of Lot's Daughters*, the first act of which was subsequently written but which has since disappeared. In 1935 he referred to a play about incest, *Blood Has No Voice*, which was probably never written, and in the autumn of that year he was talking about *The Black Ball*, a play in which the main character is homosexual, and of which only four manuscript pages exist. At around the same time he also referred to two other plays he was planning, the first entitled *The Soldiers Who Don't Want to Go to War*, the second about St Teresa of Avila.[8] In short, Lorca's mind was full of exciting ideas, his enthusiasm unbounded. His death at such an early age meant, of course, that his connection with Dalí and Buñuel, which had existed until then to a greater or lesser degree, was now broken, though, as we shall see, he continued to be a presence, especially in some of Dalí's work. As for Buñuel, he and Dalí never again worked together after the exchange of ideas for *L'Age d'or*. They would meet on only two occasions, and the only connection that remained would be one of rancour on Buñuel's part for someone he came to despise.

ベのう

When the Civil War came to an end, the Dalís, although by now admirers of Franco, feared that if they returned to Spain they would fall into the hands of Republicans bent on punishing traitors. They therefore returned to the United States, where, as we have seen, the lure of fame and wealth proved irresistible. They arrived in 1940 and stayed for eight years, installed initially in a mansion in Virginia owned by Caresse Crosby, an extremely rich and sexually liberated American woman whom the Dalís had previously encountered in Paris. Hampton Manor stood in five hundred acres of woodland and fields and, not surprisingly, was much to Dalí's taste. During his stay there, he worked on his so-called autobiography, *The Secret Life of Salvador Dalí*, in which fact and fiction were closely interwoven, much truth was deliberately excluded, and the main purpose was, among other things, to present Dalí as the saviour of modern art, Gala as his only muse, and America as the promised land. The book finally appeared in print towards the end of 1942, but received mixed reviews. Some of the reviewers saw quite clearly that much of Dalí's account was pure narcissistic fantasy, others considered that it was the work of a schizophrenic and a sadist. George Orwell, who had been deeply involved in the Spanish Civil War, hated it, referring to its 'direct, unmistakable assault on sanity and decency', its 'sexual perversity and its necrophilia', its 'pansified drawings of youths', and decrying the fact that Dalí, in escaping from France ahead of the German invasion, had behaved 'like a rat'.[9] Few reviewers appreciated the book's wild humour.

Between 1941 and 1947 Dalí had a number of exhibitions of his paintings in New York and was also involved in many lucrative commercial activities. The first of the exhibitions took place at the Julian Levy Gallery during April and May 1941. In order to demonstrate Dalí's announced return to classicism, the nineteen new paintings on display were placed in antique frames, but in reality contained familiar images, such as figures hiding their face in shame and echoes of *The Great Masturbator* of 1929. Indeed, many critics did not accept Dalí's claim of a return to classicism, and the reviews were lukewarm. In the *New York Sun*, Henry McBride observed: 'Salvador Dalí has gone classical. Did you know that? So he says. But you'd never notice it. As far as you and I

are concerned, it's the same old Salvador.'[10] The exhibition, for the first time in the painter's experience, was not a sell-out.

November of the same year saw a joint retrospective at the Museum of Modern Art of the work of Dalí and Miró. The Dalí part of the exhibition consisted of forty-two oils and contained many of his famous paintings from the past, such as *The Persistence of Memory* and *Illumined Pleasures.* The show was more successful than the earlier exhibition, and was followed by a tour of eight cities, once more consolidating Dalí's reputation in the United States. But there were also critics, such as Robert M. Coates, who described the painter's work as somewhat shallow and repetitive and who refused to accept his claim that only he had represented Surrealism.[11]

Between 1941 and 1947 there were two more exhibitions. Dalí was now painting the portraits of wealthy Americans that, in 1943, were exhibited at the Knoedler Gallery in New York to unenthusiastic reviews. Four years later an exhibition in New York's Bignou Gallery contained fourteen recent oil paintings, among which *Leda Atomica* revealed very clearly the importance that Gala had acquired in Dalí's life. After fifteen years at her side, he considered her to be both his soul mate and his saviour. In the traditional myth, Leda is seduced by Zeus in the form of a swan, but in Dalí's painting the erotic implications of the myth are replaced by a sense of adoration, for the swan is no longer entwined with Gala in a sexual act; rather, it floats in the air, as does she, both transformed into an idealised vision in which she in particular is worshipped by the painter.

Even though Gala was such an influential presence in his life, Dalí could not forget Lorca, perhaps feeling guilt at the way in which he had greeted his death but also recalling the close relationship they had once enjoyed. In 1938, for example, Dalí completed three paintings in which the head of Lorca appears, as it had done in the paintings of the late 1920s: *The Endless Enigma, Invisible Afghan Hound with the Apparition on the Beach of the Face of García Lorca in the Form of a Bowl of Fruit with Three Figs*, and *Apparition of Face and Fruit Dish on a Beach.* In the first of these paintings, the head of Lorca is placed in the right-hand half of the scene. The rocky background is, of course, the coastline of Cadaqués, where he and Dalí had spent time together in the mid-1920s and where a homosexual relationship had probably developed, despite the painter's denials. The head of Lorca, now upright, recalls the earlier depiction of the head in *Still Life by Moonlight, Little Ashes,*

and *Honey is Sweeter than Blood*. Furthermore, the head of Gala, significantly smaller than Lorca's, can be seen at the right-hand edge of the painting, almost excluded from it but staring angrily towards him. It suggests that the resentment that she sometimes felt towards Lorca on account of his closeness to Dalí continued even after his death. In the title of *Invisible Afghan Hound . . .* , Lorca's name is, of course, mentioned, and in this, as well as in *Apparition of Face and Fruit Dish on a Beach*, the face is even larger. In both paintings the coastline of Cadaqués is also present. It is as if the memory of Lorca haunted Dalí and that, given the dreamlike nature of these paintings, the poet-dramatist's face appeared to him as he slept.

In 1943, Dalí wrote a novel called *Hidden Faces* in which one of the most prominent faces concealed in the tale is again that of Lorca. The female protagonist of the work is Solange de Cléda, a female form of Dalí's Saint Sebastian and the personification therefore of an erotic self-denial that, in reality, points to Dalí's impotence. But, as we have seen, Saint Sebastian had also been a preoccupation of Lorca, and it is not surprising to come across many veiled allusions to him in the novel. There are, for example, lines such as 'A fresh craving for contours and solidity', which recall Lorca's *Ode to Salvador Dalí* and his reference to the painter's Cubist-inspired love of objectivity and precision. At one point, Dalí has one of his characters say 'Green! How I hate you green!' – a joke at the expense of the opening line – 'Green, how I want you green' – of Lorca's poem, 'Sleepwalking Ballad'. Another line in the Dalí book – 'What are you doing with your body?' recalls a similar line in another Lorca poem, 'Ballad of the Black Anguish'. And Solange de Cléda's detailed consideration of the nature of her death and burial, including 'the juices of her decomposition', is clearly evocative of Dalí's memory of Lorca's performance at the Residencia de Estudiantes and afterwards of his own death and decomposition.[12]

Although it would not be completed until 1969–70, Dalí's painting *The Hallucinogenic Toreador* also reveals the extent to which Lorca continued to find a place in Dalí's thoughts. The top of the painting reveals a series of arches that bring to mind the work of Giorgio de Chirico, as well as the Spanish bullring and Lorca's poem of 1934 on the death of his bullfighter friend, *Lament for Ignacio Sánchez Mejías*. The crescent moon to one side of the

picture is also reminiscent of Lorca's use of the moon as an image of fate and death in many of his plays and poems. There are echoes too of the rocks around Cadaqués where Lorca and Dalí spent time together. The painter, then, continued to think of his friend more than thirty years after his death.

During his time in America, Dalí was also making money from his involvement in commercial products: oils to improve the female complexion; women's hosiery; perfumes; ties; and book illustrations, all decked out with the characteristic Dalinian motifs of soft watches, deserted beaches, and telephones. He also included such motifs in the stage designs for various ballets: *Labyrinth*, with music by Schubert, at the Metropolitan Opera House, New York, in 1941; *Sentimental Colloquy* at the International Theater in 1944, and Dalí's own *Baccanale*, also in New York two months later. But many critics now believed that Dalí, in both his paintings and stage designs, was merely repeating himself. In 1945 and 1946, he was involved in two film projects that came to nothing. Although he was commissioned to design the dream sequences for Alfred Hitchcock's *Spellbound*, starring Gregory Peck and Ingrid Bergman, the studio abandoned one ambitious sequence involving grand pianos suspended from a ballroom ceiling, and changed others without informing him. And his intended six-minute contribution to a Disney film became a sequence of only fifteen seconds before, a few months later, the entire project was jettisoned.

After eight largely successful and financially profitable years in America, Dalí and Gala returned in July 1948 to a Europe suffering the consequences of war and a Spain now in the control of the Franco dictatorship. It was not long before Dalí began to express his admiration for Franco and his allegiance to the Catholic Church, in this respect following his atheist father, who had also changed direction. Making the most of the religious dimension his life was now apparently taking, he painted in 1949 *The Madonna of Port Lligat*, in which Gala, as the Madonna, floats above a throne placed against the background of the Costa Brava seascape. In order to prove his Catholic credentials, he succeeded in November 1949 in obtaining an audience with the Pope, hoping to receive papal approval for the painting. It seems unlikely that he did, although, in typical Dalí style, he claimed that the Pope had greatly admired the painting. Left-wing sympathisers, includ-

ing Dalí's former surrealist associates – and doubtless Buñuel – were appalled by his religious and political 'conversion', as well as by his obsession with wealth. In a new edition of his *Anthology of Black Humour*, André Breton memorably coined the anagram 'Avida Dollars' as an appropriate description of the new money-obsessed Dalí, observing that:

> The rustle of paper money, illuminated by the light of the moon and the setting sun, has led the squeaking patent-leather shoes [Dalí's] along the corridors of Palladio into that soft-lit territory of Neo-Romanticism and the Waldorf Astoria. There in the expensive atmosphere of *Town and Country*, that megalomania, so long passed off as a *paranoiac intellect*, can puff up and hunt its sensational publicity in the blackness of the headlines and the stupidity of the cocktail lounges.[13]

Dalí was apparently amused by Breton's new description of him.

Dalí's paintings over the next twenty years or so reveal both particular trends and a steady decline in the quality of his work. Claiming now that he had abandoned the sacrilegious nature of his past life in favour of mysticism and adopted in his painting the classical manner imbued with spirituality, he completed a larger version of *The Madonna of Port Lligat* in 1950 and followed it in 1951 with *The Christ of Saint John of the Cross*, *The Angel of Port Lligat* in 1952, *Nuclear Cross* in the same year, *Assumpta Corpuscularia Lapislazulina* in 1952–3, and *Saint Helen of Port Lligat* in 1956 – this, like *The Angel of Port Lligat*, a portrait of Gala.

During the 1950s Dalí acquired two new obsessions: the rhinoceros and DNA. The gift of a rhinoceros horn in 1950 began a process whereby he began to see rhinoceros horns, with their phallic implications, indoors and outdoors. One example in his paintings of this time is the strikingly entitled *Young Virgin Auto-Sodomized by the Horns of her Own Chastity*, which also reveals Dalí's continuing fascination with shapely buttocks. His interest in DNA and hereditary factors may have stemmed from his grandfather's paranoia, which Dalí feared he might inherit. At all events, both rhinoceros horns and the molecule appear in 1954 in the astonishingly named *Dalí Naked Contemplating Five Regular Bodies Metamorphosed into Corpuscles in Which Suddenly Appears Leonardo's Leda Chromosomized by the Face of Gala*.

The often empty character of Dalí's work in these years is illustrated in particular by the large paintings on religious and historical subjects that he completed in the second half of the 1950s: *The Last Supper* in 1955, *Saint James the Great* in 1957 (measuring 400 by 300 centimetres), and in 1958–9 *The Discovery of America by Christopher Columbus*. It was followed in 1960 by his last and possibly worst religious painting: *The Ecumenical Council*. Critical reaction to these works may be gauged by the fact that, after *The Last Supper* had been purchased by a private buyer and presented to the National Gallery of Art in Washington, it was moved from its initially prominent position to a quiet corner of the building. Paul Tillich, Professor of Philosophy at the Harvard School of Theology, observed that the central figure of Christ looked like a 'very good athlete on an American baseball team'.[14]

This gradual decline in quality was also accompanied by the appearance in Dalí's life of a succession of individuals who managed his administrative and financial affairs, some of whom indulged in extremely dubious practices. Peter Moore, an ex-army man who liked to use the title of 'captain', became Dalí's business manager in 1959 and was subsequently involved in the reproduction of watercolours signed by the artist and sold to private buyers as original works. He made large amounts of money for Dalí and for himself. By the early 1960s, moreover, Dalí was himself signing blank sheets of paper on which prints could be placed and sold without any involvement by the artist. By the time Moore left Dalí's service in 1974, he claimed to have sold 37,500 pre-signed sheets of paper. His replacement, Enric Sabater, continued the process, and by 1981 the matter had become an international scandal. Although Dalí's father had left him only a small amount of money when he died in 1950, it hardly mattered in terms of the painter's steadily increasing wealth.

Just as Dalí's financial success went hand in hand with a grow-ing lack of artistic inspiration, so, from the 1950s, his and Gala's sexual activities became more perverse. Dalí had met the beautiful Nanita Kalashnikoff, who was originally of Andalusian origin, in New York in 1955. He was strongly attracted to her, but his inhi-bitions probably excluded a sexual relationship, even though they were close and she posed naked for him. In 1956 Dalí and Gala were married by the Church in a private ceremony, but this in no way altered the course of their sexual lives. In the mid-1960s Dalí

developed a fascination for Amanda Lear, a nightclub performer known as Peki d'Oslo, who had undergone a sex-change operation from male to female. Again there is unlikely to have been sexual contact between them, even though Dalí liked to pretend that she was his lover and liked to be seen with her in public. He was doubtless intrigued by the boy-to-girl transformation. His sexual preferences, as he grew older, leaned much more towards voyeurism, and he increasingly surrounded himself with androgynous types, particularly with young men who looked like girls. He often arranged erotic games in which, as a kind of master of ceremonies, he instructed them to masturbate or sodomise young women while he looked on.

Gala, always sexually predatory, became even more so as she aged. In the early 1960s, when she was in her late sixties, she became infatuated for several years with William Rotlein, a twenty-two-year-old drug addict she had met during one of her stays in New York. By 1966 she had grown weary of the affair and ended it, shortly after which Rotlein died of an overdose. But there were many other young men, and in 1973 she began a relationship with an American actor, Jeff Fenholt, who had played the lead role on Broadway in *Jesus Christ Superstar*. For seven years he regularly stayed with her in Spain, in the castle in the village of Púbol that Dalí had bought for her, and profited greatly from the paintings she gave him as presents, as well as from a house on Long Island that she bought for him and which was apparently worth $1.25 million. Later, Fenholt became a television preacher in California and denied that his relationship with Gala had been sexual.

By 1974, the Dalí Museum in the painter's hometown of Figueras, now one of the most popular tourist attractions in the whole of Spain, had been completed. As we might expect, the opening was a flamboyant occasion, but by this time Dalí was becoming affected by increasing health problems. An operation for a hernia in 1974 was followed in 1977 by another for an enlarged but benign prostate. Subsequently subject to frequent colds and bouts of flu, he often became depressed and was provided by Gala with alternating doses of sedatives and amphetamines, which only led to other complications, including a trembling of the hand, extreme tiredness, and difficulty in walking. Her unsupervised medical treatment led some to suspect that she was attempting to poison him. Dalí and Gala were also, by 1981, abusing each other

physically, and in early 1981 she was diagnosed with two broken ribs after he had dragged her from her bed. Not long afterwards she began to suffer from gall-bladder problems. An operation proved to be successful, but in March 1982 she fell and broke her femur, recovered once more, but then fell into a deep depression, refused to eat, and died on 10 June.

After Gala's death, Dalí decided to remain in the castle at Púbol. He was by this time in extremely poor health, cadaverous in appearance, physically and mentally exhausted, and increasingly depressed. When a fire broke out in his bedroom on 30 August 1984, he suffered first and second degree burns to 18 per cent of his body. After a six-hour skin-grafting operation at the Pilar Clinic in Barcelona and a six-week stay there, he was well enough to be taken home, on this occasion to the Torre Galatea, which adjoined the Figueras Theatre-Museum. He remained there for five more years, never returning to either Port Lligat or Púbol; his physical decline continued. Admitted to Figueras Hospital at the end of November 1988 and suffering from lung and heart complications, he recovered sufficiently to be able to leave two weeks later, but was subsequently readmitted twice, the last occasion being 18 January 1989, when he had further heart problems and pneumonia. He died five days later and was buried, not alongside Gala in Púbol, but in his beloved Theatre-Museum in Figueras. His last years were indeed a tawdry spectacle.

After the Civil War, Buñuel, as we have seen, went to America, where he remained until 1946. By his own admission, he was in love with the country even before he made his first visit in 1930, an opinion that his arrival confirmed as he travelled by train to Los Angeles:

> I loved everything – the styles, the customs, the movies, the skyscrapers, even the policemen's uniforms ... As we sped across the country, America seemed to me the most beautiful place in the world . . . When my first salary checks arrived, I thought Hollywood, and Los Angeles in general, close to paradise.[15]

In this respect, his experience was clearly very different from Lorca's generally pessimistic impression, though it has to be said that that was largely based on the headlong rush of New York

and the self-interest of its financial sector. And even when Buñuel looked back from the vantage point of old age, he still had happy memories:

> Today, when I think back over this period in my life – the smells of spring in Laurel Canyon, the Italian restaurant where we drank wine camouflaged in coffee cups, the cops who once stopped my car because they thought I was transporting liquor and then escorted me to my door because I was lost, my friends Frank Davis and Kilpatrick – when I remember that strange way of life, the California heat, the American naiveté, I still have the same good, warm feelings as I did then.[16]

Given the above, it seems more than ironic that, when Buñuel had moved to New York in 1939 and found stable employment in the Museum of Modern Art, his job and financial security should have been taken from him by none other than Dalí. In *The Secret Life of Salvador Dalí*, published in New York and in London in 1942, the painter had written that the communist Buñuel had been solely responsible for the virulent anti-Catholicism of *L'Age d'or*. It was, of course, a red rag to those who were anti-communist – of whom there were many – to those who were strongly Catholic, and to those who were eager to curtail the film activities of the Museum. Such was the pressure placed on the Museum that Buñuel soon felt obliged to resign his position. Dalí was, of course, also in New York at the time, and he and an enraged Buñuel met in a bar, an encounter vividly recalled many years later:

> After my resignation, I made an appointment to meet Dalí at the Sherry Netherland bar. We ordered champagne, and I was beside myself with rage. He was a bastard, I told him, a *salaud*; his book had ruined my career.
> 'The book has nothing to do with you', he replied. 'I wrote it to make *myself* a star. You've only got a supporting role.'
> I kept my hands in my pockets so as not to strike him; and finally, soothed by the champagne and old memories, we parted almost friends. The rupture was nonetheless a serious one, and I was to see him only once more.[17]

In stating that Buñuel had only a supporting role, Dalí was doubtless taking revenge for having been denied the role he

believed he himself merited in the making of *L'Age d'or*. Although they had collaborated closely on *Un chien andalou*, the subsequent connection between them was not as close as the emotional bond between Dalí and Lorca, even after the latter's death. When in 1966 Dalí wrote to Buñuel with the suggestion that they make a sequel to *Un chien andalou*, the now highly successful filmmaker replied by quoting a Spanish proverb: 'Agua pasada no rueda molino' – 'When the water's passed by, the mill won't work anymore.' It doubtless gave Buñuel great satisfaction.

Jobless in New York, with money running out, and afflicted by painful sciatica, Buñuel was, in 1944, given the opportunity to return to Hollywood, where he was employed by Warner Brothers and put in charge of dubbing American films into Spanish for the Latin American market. He held the position for two years, hoping to be involved in the making of feature films, but his only contribution in this respect, though even this is not certain, may have been the sequence of the severed hand in Robert Florey's *The Beast with Five Fingers*, completed in 1947. The severed hand had, after all, appeared in *Un chien andalou*, and would reappear in almost identical fashion in 1962 in Buñuel's *The Exterminating Angel*.

Much more important in terms of its influence on his career as a filmmaker was Buñuel's decision in 1946 to move to Mexico, where he would live for the rest of his life, becoming a Mexican citizen in 1949. In many ways, the transition from America to Mexico was as propitious for Buñuel as Lorca's escape to Cuba had been in 1930, for he encountered once more the language with which he was familiar, the physical types, the passion, the social structure, and the Catholic background that is so central to his later films. For several years, the family – there were now two children, Juan Luis and Rafael – lived in rented apartments, but in 1952 he built a two-storey house in Colonia del Valle, then a quiet suburb beyond the noise and dust of Mexico City. As was Buñuel's wont, the house was simply furnished, his bedroom on the second floor as austere as a monk's cell, his bed consisting of wooden boards. The interior of the house was later described by Carlos Fuentes as being 'as impersonal as a dentist's office'.[18] Buñuel's lifestyle in general followed this pattern, for it was both unostentatious and characterised by strict routine, which meant that he rose at dawn, went to bed at nine o'clock, and insisted that meals were

taken at exactly the same time every day. His taste in food was also simple and, by his own admission, he preferred fried eggs and sausage to more sophisticated French cooking. As far as alcohol was concerned, he drank a good deal but preferred to do so in quiet bars, often alone, and he avoided publicity at all costs, including appearances at film festivals. His sister's comment during the shooting of *Viridiana* in 1960 that, 'As always, Luis lived like an anchorite,'[19] aptly sums up his monk-like existence, so different from the idle and self-indulgent lifestyle of his bourgeois father and at the opposite extreme, of course, to Dalí's materialistic excesses.

As far as his marriage was concerned, Buñuel changed little, if at all, during his lifetime. And while sexual activity was doubtless as restricted as other aspects of his life, he was also guilty of the jealousy and possessiveness which, at least in the past, characterised many a Spanish male and which has been described earlier in relation to the incident concerning Gustavo Pittaluga. It was an aspect of his behaviour that was observed by visitors to the house, such as the Mexican film actress Silvia Pinal, who noted that 'At home he was like Hitler. Like Othello.'[20] Displaying too that element of male superiority known as *machismo*, he seems to have demeaned his wife in other respects – the very opposite to Dalí – controlling the household finances, making all the decisions regarding mealtimes, the furnishing of the house and the children's education, and excluding her from conversations and discussions with his male friends. It was, though, an incident concerning her piano that best represents his thoughtlessness. The piano, of which she was extremely fond and which she played daily, had been given to her by a woman friend, Jeanette Alcoriza. One evening, when Buñuel had drunk rather too much, the daughter of a family friend suggested to him that he give her the piano in exchange for three bottles of champagne.[21] To Jeanne's horror, Buñuel agreed to the deal and the piano was taken away the following day. Although he subsequently felt guilty about the incident and attempted to compensate for it, one of the gifts he bought for her was, rather significantly, a sewing machine – an embodiment of the domestic chores to which he felt women should be consigned.

The film industry in Mexico was extremely active, as the shooting of seventy films in 1943 alone suggests, but it was also a predominantly commercial business that turned out films quickly and cheaply, did not over-concern itself with quality, and sought

above all to appeal to a not-too-discerning public. Between 1946 and 1964, Buñuel made some twenty films of varying kinds. Some of them are melodramas involving powerful conflicts and relationships, as in the case of *Susana, Daughter of Deceit* (1950) and *Woman Without Love* (1951). Others, such as *Stairway to Heaven* (1951) are popular comedies; there were also farces. But although the straitjacket of purely commercial cinema restricted his ambition as a filmmaker, Buñuel usually succeeded in introducing into these films a characteristic degree of social comment, psychological preoccupations, and black humour. And he also managed to make a number of movies that reveal him at his very best.

There can be no doubt that the films in which he had more freedom to express himself are much more autobiographical, and in that sense the connection between his work and that of Lorca and Dalí is very clear. In particular, these films reveal Buñuel's sexual preoccupations no less than the works of Lorca and Dalí revolve around theirs, and also the attack on the bourgeoisie that we often see in Lorca. The assault on the Catholic Church, on the other hand, is, although sometimes present in Lorca, much more uniquely Buñuelian.

Of the Mexican films, *He* is especially relevant in relation to Buñuel's sexual concerns, and in that context it is revealing that he should have regarded it as one of his most personal films. Its protagonist, Francisco, is a bourgeois in whom erotic desire and religion are closely interwoven, his religious background having deeply affected his sexual relationships with women. As well as this, he suffers from extreme jealousy and possessiveness. Married to Gloria, he soon becomes insanely and irrationally jealous of her innocent relationship with a male friend, and, having already fired a gun at her – admittedly, it contains blanks – later creeps into the bedroom at night intent on sewing up her vagina. Even though his marriage is, to say the least, unsatisfactory, he suffers from that pathological possessiveness that will not allow his wife to have the kind of contact with other men that might impinge on his own domain. In this respect, it is clear enough that Buñuel's wife had her husband in mind when she singled out *He* as a film in which he 'deals with the theme of extreme jealousy'.[22]

While *He* is also a criticism of bourgeois values to the extent that Francisco shares them, Buñuel's assault on the bourgeoisie

is at its sharpest in the later and more mature *The Exterminating Angel*, made in 1962. After an evening at the opera, a group of sophisticated individuals are invited to dinner at his house by Nobile. When, at the end of the evening, they attempt to leave, they find that they cannot and remain trapped in the drawing room for several weeks. Deprived of food and water, the mask of sophistication soon begins to be stripped away, elegant clothes are cast aside as the temperature rises, compliments become insults, the expensive furniture of the drawing room is reduced to a smoking bonfire, and its inhabitants become little better than animals in their unmitigated savagery towards each other. When they finally succeed in escaping, they attend church in order to give thanks for their salvation, only to discover that they are trapped there too, as much the prisoners of religion as of their bourgeois way of life. Echoing the sequence at the house of the Marquis of X in *L'Age d'or*, *The Exterminating Angel* is a sustained and corrosive mockery of one of Buñuel's favourite targets.

His assault on the Catholic Church lies at the heart of *Nazarín*, completed four years earlier. Rejected by the Catholic Church, represented here by a number of pompous and hypocritical individuals, the priest Nazarín sets out to do good works in the world at large but is constantly thwarted in his efforts and systematically taken advantage of by the poor, the hungry, and the downtrodden whom he wishes to help. In short, the well-intentioned priest is revealed to be as ineffective in changing the world as the official Church is seen to be self-centred, exploitative and hypocritical, and Buñuel's message, as in some of his other films, is that, because human nature cannot be changed, it has to be accepted for what it is.

To the extent that these films express Buñuel's sexual, social and religious preoccupations, little was to change in the eight remaining movies that he made in Spain and France between 1961 and 1977. By 1960, as we have seen, the iron grip of the Franco dictatorship had relaxed somewhat, and, after twenty-one years away from his native country, Buñuel was able to return for the shooting of *Viridiana*. In some ways it continues the religious theme of *Nazarín*, for, like the priest, the novice nun of the title, believing that she has been raped by her uncle and cannot therefore take her vows, decides to perform good works in the outside world. She is, of course, taken advantage of by the beggars she seeks to

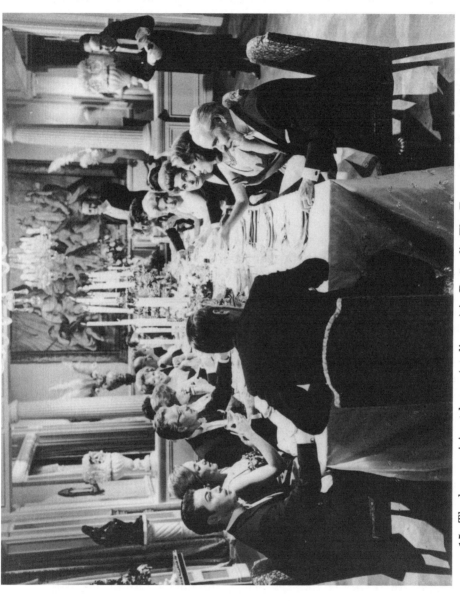

15. The bourgeoisie at home (at dinner) in Buñuel's *The Exterminating Angel*, 1962

help and protect, as well as mocked by her womanising cousin. In the end she learns to accept the world as it is and becomes her cousin's lover, sharing him with the family servant.

Like *He*, *Viridiana* also contains strong autobiographical elements. Viridiana's uncle, Don Jaime (played by Fernando Rey, who would also star in *Tristana* and *That Obscure Object of Desire*), reflects Buñuel's sexual inhibition, for, given the opportunity to have sexual intercourse with Viridiana after he has drugged her and placed her on his bed, he unbuttons her dress and half exposes her shapely breasts. But as he prepares to touch them, he is overcome by a guilt so strong that he finally draws back. Viridiana too withdraws her hand when she is invited to grasp the phallus-like teat of a cow, and later faints when she grasps the equally phallic handle of the skipping rope worn as a belt by the beggar who attacks her. At the Cannes Film Festival in 1961 *Viridiana* was awarded the Palme d'or but Buñuel's film scandalised both the Spanish censorship and the Vatican as much as *L'Age d'or* had the right wing thirty years earlier. *Viridiana* remains, though, one of Buñuel's very best films.

As a result of the hostile reaction to *Viridiana*, Buñuel made only one more film in Spain: *Tristana* in 1970, and it too is strongly autobiographical. After the death of her parents, the young Tristana is cared for by her guardian Don Lope who, professing liberal ideas, uses his young and innocent ward for his own sexual gratification. She later falls for a young artist and leaves Don Lope's house, but, when her leg is amputated as the result of a tumour and her lover loses his enthusiasm for her, she returns to the older man and agrees to marry him. No sooner are they married, however, than Tristana informs her new husband that they will sleep in separate rooms – a clear and resonant echo of Buñuel's instruction to his wife when she first arrived at their apartment in Madrid many years earlier. Tristana's subsequent relationship with Don Lope is marked by increasing bitterness and hostility on her part, to the point where, instead of calling the doctor when Don Lope is seriously ill, she opens the window of his bedroom in order to let in the icy wind and ensure his death. Her revenge on the man who has sought to use and dominate her in so many ways may well point to Buñuel's acknowledgement of the fact that he too had behaved deplorably towards his wife, who, had she been as determined as Tristana, could well have punished him. In

effect, Jeanne took her less drastic revenge in her autobiography, published after her husband's death.

In 1963 Buñuel met the French producer Serge Silberman, an encounter that provided him with the financial resources and the artistic freedom to make five of the six films – the only exception was *Belle de jour* – that he made in France between 1964 and 1977. The majority of these films again revolve around Buñuel's lifelong preoccupations: *Diary of a Chambermaid*, released in 1964, is a coruscating study of the superficial elegance and the sexual fetishes and desires of a provincial bourgeois family, as well as of their servants' attempts to ape them. In *Belle de jour*, made two years later, Séverine seeks to escape the stifling nature of bourgeois life with her husband, initially in erotic fantasies – we recall Buñuel's – and then by working each afternoon in a brothel, where her repressed sexual feelings are finally released. *The Discreet Charm of the Bourgeoisie*, made in 1972 and for which Buñuel won an Oscar, is a much lighter film in which he makes fun of his bourgeois characters in two ways: in their constantly frustrated attempts to arrange a dinner – food as a substitute here for sex – and in the way they are terrified by their dreams and nightmares. In his final film, *That Obscure Object of* Desire, released in 1977, the central character, the ageing Mathieu, is yet another frustrated bourgeois, constantly failing and exposed to ridicule in his attempts to possess the beautiful and much younger Conchita. In these two later films, even though the bourgeoisie is still the target, the ferocity of much of Buñuel's earlier work has undoubtedly given way to a mellower, more amused tone, and the same is true of *The Milky Way*, made in 1969, and *The Phantom of Liberty*, made in 1974, whose themes are respectively religion and freedom. In the first of these, a close examination of inflexible Catholic dogma creates some witty and hilarious situations, and in the second individual freedom is seen to be denied by the absurd demands of social mores, religious attitudes, and sexual desire.

The success and popularity of the French films, in particular *The Discreet Charm of the Bourgeoisie*, finally brought Buñuel the financial rewards that he had never before enjoyed, though they did not change his way of life or his outlook as they did Dalí's. By the time he made *That Obscure Object of Desire*, his health was, however, in decline, and he would make no more films. For

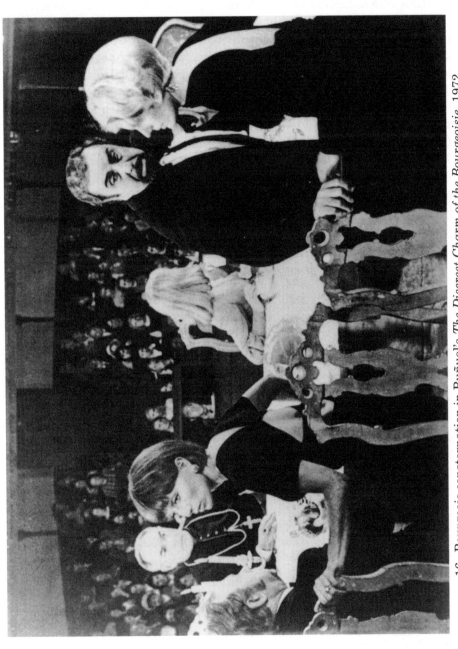

16. Bourgeois consternation in Buñuel's *The Discreet Charm of the Bourgeoisie*, 1972

many years he had been plagued by sciatica, increasing deafness – rather like his fellow countryman Goya – and by diabetes, which now began to affect his sight and strength. He was subsequently diagnosed with cancer of the bile duct and the liver, by 1983 needed constant medication and nursing care, and grew progressively weaker, becoming as dependent on Jeanne as had Don Lope on Tristana in the film made thirteen years earlier. During his last months he became, somewhat ironically, friendly with a Catholic priest, Father Julian Pablo, with whom he sometimes discussed the finer points of Catholic dogma. He died in hospital on 29 July 1983, six years before Dalí and almost half a century after Lorca.

## NOTES

1    John Hooper, *The Spaniards. A Portrait of the New Spain*, Harmondsworth: Penguin Books, 1987, p. 23.

2    See Antonina Rodrigo, *Margarita Xirgu y su teatro*, Barcelona: Editorial Planeta, 1974, p. 271.

3    See José Monleón (ed.), *Yerma*, Barcelona: Aymá Editora, 1973, pp. 26–9.

4    For a detailed analysis of the play, see Edwards, *Lorca: Living in the Theatre*, pp. 29–60.

5    On the problems of translating Lorca into English, see Gwynne Edwards, 'Lorca on the English Stage: Problems of Production and Translation', *New Theatre Quarterly*, no. 4, 1988, pp. 344–55.

6    See, for example, Edwards, *Lorca Plays: One*; *Lorca Plays: Two*; and *Lorca Plays: Three*.

7    Susannah Clapp, *Observer*, 20 March 2005.

8    Gibson, *Federico García Lorca: A Life*, p. 422.

9    George Orwell, 'Benefit of Clergy: Some Notes on Salvador Dalí', in *The Collected Essays, Journalism and Letters of George Orwell*, Harmondsworth: Penguin Books, 1971, vol. 3, pp. 185–95.

10   Henry McBride, 'The Classic Dalí. Not so Very Different from Dalí the Surrealist', *New York Sun*, 26 April 1941.

11   Robert M. Coates, 'The Art Galleries. Had Any Good Dreams Lately?', *The New Yorker*, 29 November 1941.

12   Salvador Dalí, *Hidden Faces*, trans. Haakon Chevalier, London: Nicholson and Watson, 1947.

13   André Breton, 'Avida Dollars', *Arson*, no. 1, 1942.

14   Paul Tillich, *Evening Star*, November 1956.

15   Buñuel, *My Last Breath*, pp. 128–9.

16   Ibid., p. 135.

17   Ibid., p. 183.

18   Carlos Fuentes, 'The Discreet Charm of Luis Buñuel', in Joan Mellen (ed.), *The World of Luis Buñuel: Essays in Criticism*, New York: Oxford University Press, 1978, pp. 62–4.
19   Buñuel, *My Last Breath*, p. 235.
20   See John Baxter, *Buñuel*, London: Fourth Estate, 1994, p. 225.
21   Rucar de Buñuel, *Memorias*, p. 58.
22   Ibid., p. 108.

# CONCLUSION

⁊⁊⁊

A S THE PRECEDING account suggests, the lives and the work of Lorca, Buñuel, and Dalí were quite extraordinary, both in terms of their personal experience and of the times through which they lived. In a general sense, the first half of the twentieth century was by any standard a truly dramatic period, marked on the one hand by the terrible conflicts of the First World War, the Spanish Civil War, and the Second World War; on the other, by enormous cultural upheavals that, embracing such movements as Dada, Futurism, Cubism, Fauvism, and Surrealism, signified a wholesale rejection of past values. The three creative artists studied here were all affected by these cultural events and, to a greater or lesser degree, by the political happenings around them. All this, together with the distinctive and unusual nature of their personalities and talent, combined to produce work that is now universally acclaimed for both its individuality and its universal appeal.

While the lives of Buñuel and Dalí embraced most of the twentieth century, Lorca's was, at thirty-eight years, relatively short, but, like his mostly ebullient and dazzling personality, dynamic and highly creative. Beginning to write plays in 1920 and poems a few years earlier, he completed a dozen or so full-length plays, a number of shorter pieces, and half a dozen collections of poetry in the space of roughly eighteen years. The turmoil that stemmed from his homosexuality, exacerbated by the intolerance of the strongly Catholic beliefs of Spanish society as a whole, lies at the heart of much of his work, investing it with an anguished passion that resonates across the years. At the same time, Lorca's socialist beliefs, which allied him with the Republicans in the 1930s and which brought about his murder at the beginning of the

Civil War, reveal a compassion for the unfortunate and a hatred of oppression that also strike a universal chord. Of the three individuals in question, Lorca is arguably the most appealing as a person.

Taken as a whole, his work is also the most experimental, ranging from his use of the traditions of puppetry and farce in *The Shoemaker's Wonderful Wife*, *The Love of Don Perlimplín*, and *The Puppet Play of Don Cristóbal*, to folklore and history in *Mariana Pineda*, to Surrealism in *The Public* and *When Five Years Pass*, to the framework of Greek tragedy in *Blood Wedding*, *Yerma*, and *The House of Bernarda Alba*, and to political drama in *Play Without a Title*. In each successive play he attempted something new and different, and the same is true of his poetry, from the gypsy/flamenco inspired *Poem of Deep Song* and *Gypsy Ballads*, to the Surrealism of *Poet in New York*, and the Arab influence on *Diwan of the Tamarit*. Furthermore, Lorca's work reveals not only a constant experimentation but also a steady progression throughout his life that distinguishes it from that of Buñuel and Dalí.

Although Buñuel shared Lorca's political views to a large extent, he undoubtedly possessed a very different personality: tough, uncompromising, and aggressive. On the other hand, as we have seen, his relationship with women, both before and after his marriage, was deeply influenced by his schooling by Jesuits, which left him with a sexual inhibition at odds with his otherwise tough exterior. All these factors played their part in his embracing of Surrealism, both in its emphasis on the inner self and its total rejection of and assault on traditional bourgeois values and the rigid dogma of the Catholic Church. As for his work, it can be divided into three phases: a blazing opening period marked by the early surrealist *Un chien andalou*, *L'Age d'or*, and *Las Hurdes*; the middle Mexican period in which many rather ordinary films were combined with a few others as outstanding as *The Forgotten Ones* and *The Exterminating Angel*; and the final period in which in Spain and France he made the films for which he is best known and which include *Viridiana*, *Tristana*, *Belle de jour*, *The Discreet Charm of the Bourgeoisie*, and *That Obscure Object of Desire*. In terms of their technical quality, the films of the later period are, of course, more polished than the earlier ones, and they are also, particularly in the case of *The Discreet Charm* and *That Obscure*

*Object,* more mellow and teasing in their treatment of the bour-
geoisie, lacking the ferocity of Buñuel's earlier assaults. Even
so, having left the official Paris surrealist group in the 1930s,
he embraced the fundamental surrealist ideals throughout his
life, interweaving in his films mockery of the well-to-do and the
Catholic Church with dream sequences that, as in *Belle de jour*
and *The Discreet Charm,* vividly reveal the underlying longings,
fears, and anxieties of the characters, as well as in many cases his
own. In this respect, Buñuel's cinematic output tends to consist of
variations on a small number of themes, as indeed does Lorca's,
but, as we have seen, Lorca's work contains a strong element of
experimentation from first to last, while Buñuel's most innovative
and unusual films are those with which he began his career.

In comparison with Lorca and Buñuel, Dalí is the most extraor-
dinary in almost every respect. The decision to be as different
as possible from his dead brother lay at the heart of his rebel-
lious nature, while an adolescent fear of venereal disease largely
prompted his life-long aversion to physical contact with women in
favour of masturbation and voyeurism. The turmoil of his inner
life, as well as left-wing political views initially inherited from
his father, made him, like Buñuel, a natural advocate of Surreal-
ism. The revelation of the unconscious is therefore much to the
fore in his collaboration with Buñuel on *Un chien andalou,* while
a political and social emphasis is much greater in their second
film, *L'Age d'or.* In the paintings of the same period, which rep-
resent Dalí's most fruitful work, the emphasis falls consistently,
though, on his sexual obsessions, anxieties, and sense of shame.
Subsequently, marriage to Gala and increasing wealth and fame
changed the direction of his life and undermined the quality of his
earlier work. In the first place, he engaged in acts of ever more
eccentric self-publicity, and, secondly, the accumulation of wealth
led to a desire for even more and, eventually, to quite fraudulent
activities concerning reproductions passed off as originals and the
large-scale signing of blank sheets of paper to art dealers.

In conjunction with this process, Dalí's earlier political views,
which had even favoured social revolution, were transformed into
an alliance with fascism, no doubt to curry favour with General
Franco's dictatorship and thus avoid being marginalised, as Buñuel
was. Dalliance with Catholicism also led to an extraordinary
change in the direction of Dalí's painting, whereby Gala began to be

represented as the Madonna and a number of extremely large but inspirationally empty paintings focused on religious subjects. And finally, a marriage in which normal sexual relations may never have taken place became characterised by a series of liaisons with young men on her part, increasing voyeurism and sexual perversions on his, and growing bitterness between them. In short, the long life of Dalí was also a long and insidious process of decline in the nature of his life and the quality of his art, in inverse proportion in that respect to the work of both Lorca and Buñuel.

The connections and links between the three individuals were, of course, rather different at different points in their lives. Before they encountered each other at the Residencia de Estudiantes in the early 1920s, the similarities between them lay in their relatively privileged backgrounds, which contributed to their left-wing views even in adolescence, as well as in the fact that, in relation to their sexual attitudes, they were influenced by the Catholic environment in which they grew up – Lorca and Buñuel probably more so than Dalí. Their time together at the Residencia clearly created very close connections that were both personal and cultural, ranging from the emotional ties between Lorca and Dalí, which fed into their work, to the collaboration between Dalí and Buñuel on the two early surrealist films, and to the exposure of all three to the important cultural movements of the time. When Lorca was murdered in 1936 and Buñuel and Dalí went their different ways, the connections necessarily became more tenuous, but Lorca continued to be a presence in some of Dalí's work, while Buñuel's autobiography, written more than forty years after Lorca's death, reveals, in its praise of Lorca and its condemnation of Dalí, the permanent effect that all three had on each other. In the end, it is fair to say that the fact that these three creative artists coincided when they were all at a highly creative point in their lives led to a flowering of genius the like of which Spanish cultural life has not experienced since.

# SELECT BIBLIOGRAPHY

## ON FEDERICO GARCÍA LORCA

Adams, Mildred, *García Lorca: Playwright and Poet*, New York: George Braziller, 1977.

Binding, Paul, *The Gay Imagination*, London: GMP Publishers, 1985.

Byrd, Susanne, *'La Barraca' and the Spanish National Theatre*, New York: Ediciones Abra, 1975.

Doggart, Sebastian, and Michael Thompson (eds), *Fire, Blood and the Alphabet*: *One Hundred Years of Lorca*, Durham: University of Durham, 1999.

Edwards, Gwynne, *Lorca: The Theatre Beneath the Sand*, London: Marion Boyars, 1980.

—— *Dramatists in Perspective: Spanish Theatre in the Twentieth Century*, Cardiff: University of Wales Press, 1985.

—— 'Lorca on the English Stage: Problems of Production and Translation', *New Theatre Quarterly*, no. 4, 1988, pp. 344–55.

—— *Lorca Plays: One* (trans. and ed., with Peter Luke), London: Methuen, 1987.

—— *Lorca Plays: Two* (trans. and ed.), London: Methuen, 1990.

—— *Lorca Plays: Three* (trans. and ed., with Henry Livings), London: Methuen, 1994.

—— *Lorca: Living in the Theatre*, London: Peter Owen, 2003.

García Lorca, Federico, *Obras completas*, ed. Arturo del Hoyo, Madrid: Aguilar, 1966.

—— *Obras completas*, ed. Miguel García Posada, 4 vols, Barcelona/ Valencia: Galaxia Gutenberg/Círculo de Lectores, 1996.

—— *Deep Song and Other Prose*, trans. and ed. Christopher Maurer, London: Marion Boyars, 1980.

—— *Gypsy Ballads*, trans. and ed. Robert G. Havard, Warminster: Aris and Phillips, 1990.

—— *Blood Wedding*, trans. and ed. Gwynne Edwards, London: Methuen, 1997.

—— *The House of Bernarda Alba*, trans. and ed. Gwynne Edwards, London: Methuen, 1998.

—— *Yerma*, trans. and ed. Gwynne Edwards, London: Methuen, 2007.

—— *Doña Rosita the Spinster*, trans. and ed. Gwynne Edwards, London: Methuen, 2008.

García Lorca, Francisco, *In the Green Morning: Memories of Federico*, trans. Christopher Maurer, London: Peter Owen, 1989.

Gibson, Ian, *The Assasination of Federico García Lorca*, London: W.H. Allen, 1979.

—— *Federico García Lorca: A Life*, London: Faber and Faber, 1989.

Havard, Robert, G. (ed.), *Lorca: Poet and Playwright*, Cardiff: University of Wales Press, 1992.

Johnston, David, *Federico García Lorca*, Bath: Absolute Press, 1998.

Morris, C.B, *Son of Andalusia. The Lyrical Landscapes of Federico García Lorca*, Liverpool: Liverpool University Press, 1997.

Rodrigo, Antonina, *Margarita Xirgu y su teatro*, Barcelona: Editorial Planeta, 1974.

Stainton, Leslie, *A Dream of Life*, London: Bloomsbury, 1998.

## ON LUIS BUÑUEL

Aranda, Francisco, *Luis Buñuel: A Critical Biography*, trans. David Robinson, London: Secker and Warburg, 1975.

Baxter, John, *Buñuel*, London: Fourth Estate, 1994.

Buache, Freddy, *The Cinema of Luis Buñuel*, trans. Peter Graham, London: Tantivy Press, 1973.

Buñuel, Luis, *Mi último suspiro*, Barcelona: Plaza y Janes, 1982.

—— *Mon dernier soupir*, Paris: Robert Laffont, 1982.

—— *My Last Breath*, trans. Abigail Israel, London: Jonathan Cape, 1984.

Durgnat, Raymond, *Luis Buñuel*, London: Studio Vista, 1967.

Edwards, Gwynne, *The Discreet Art of Luis Buñuel: A Reading of His Films*, London: Marion Boyars, 1982.

—— *Indecent Exposures: Buñuel, Saura, Erice & Almodóvar*, London: Marion Boyars, 1995.

—— *A Companion to Luis Buñuel*, London: Tamesis, 2005.

Evans, Peter William, *The Films of Luis Buñuel: Subjectivity and Desire*, Oxford: Clarendon Press, 1995.

Evans, Peter William, and Isabel Santoalalla (eds), *Luis Buñuel: New Readings*, London: BFI, 2004.

Higginbotham, Virginia, *Luis Buñuel*, Boston: Twayne Publishers, 1979.

Mellen, Joan (ed.), *The World of Luis Buñuel: Essays in Criticism*, New York: Oxford University Press, 1978.

Rucar de Buñuel, Jeanne, *Memorias de una mujer sin piano* (written by Marisol Martín del Campo), Madrid: Alianza Editorial, 1990.

Sandro, Paul, *Diversions of Pleasure: Luis Buñuel and the Crises of Desire*, Columbus: Ohio State University Press, 1987.

## ON SALVADOR DALÍ

Ades, Dawn, *Dalí and Surrealism*, New York: Harper and Row, 1982.

Bosquet, Alain, *Conversations with Dalí*, New York: E.P. Dutton, 1969.

Dalí, Salvador, *Diary of a Genius*, New York: Doubleday, 1965.

—— *The Secret Life of Salvador Dalí*, London: Vision Press, 1968.

—— *Dalí by Dalí*, New York: Harry N. Abrams, 1970.

Descharnes, Robert, *The World of Salvador Dalí*, London: Macmillan, 1972.

—— *Salvador Dalí, The Work, The Man*, New York: Harry N. Abrams, 1984.

Etherington-Smith, Meredith, *Dalí*, London: Sinclair-Stevenson, 1992.

Gibson, Ian, *The Shameful Life of Salvador Dalí*, London: Faber and Faber, 1997.

Lake, Carlton, *In Quest of Dalí*, New York: Putnam, 1969.

Morse, A. Reynolds, *Dalí: A Study of his Life and Work*, Greenwich: New York Graphic Society, 1958.

Parinaud, André (as told to), *The Unspeakable Confessions of Salvador Dalí*, New York: Quill, 1981.

Secrest, Meryle, *Salvador Dalí: The Surrealist Jester*, London: Weidenfeld and Nicolson, 1986.

Soby, James Thrall, *Salvador Dalí*, New York: Museum of Modern Art, 1941.

## GENERAL

Breton, André, *Manifestoes of Surrealism*, trans. Richard Seaver and Helen R. Lane, Ann Arbor: University of Michigan, 1972.

Carr, Raymond, *Spain, 1808–1939*, Oxford: Oxford University Press, 1966.

Havard, Robert G., *The Crucified Mind: Rafael Alberti and the Surrealist Ethos in Spain*, Woodbridge: Boydell and Brewer, 2001.

—— (ed.), *A Companion to Spanish Surrealism*, Woodbridge: Tamesis, 2004.

Hooper, John, *The Spaniards. A Portrait of the New Spain*, Harmondsworth: Penguin Books, 1987.

Hopkins, David, *Dada and Surrealism: A Very Short Introduction*, Oxford: Oxford University Press, 2004.

Thomas, Hugh, *The Spanish Civil War*, 10th edn, Harmondsworth: Penguin Books, 1986.

# INDEX